The
Mississippi River
in 1953

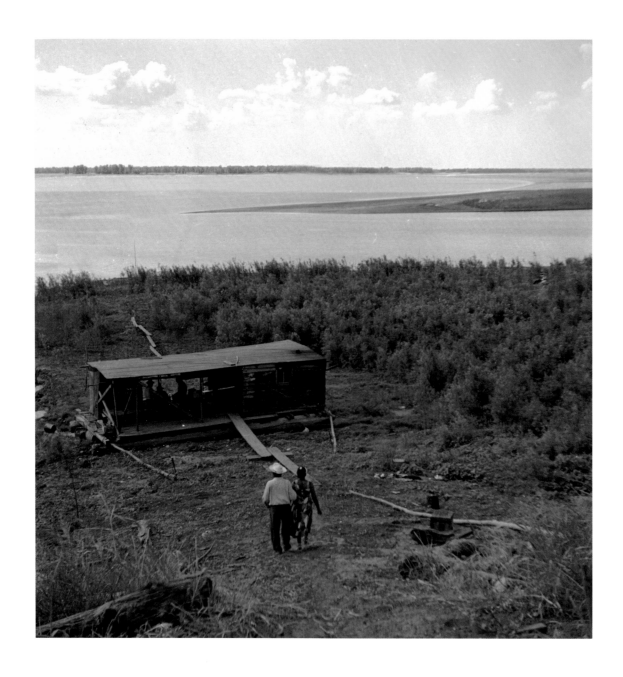

The Mississippi River near Rosedale, Mississippi.

The
Mississippi River
in 1953

A PHOTOGRAPHIC JOURNEY
FROM THE HEADWATERS TO THE GULF OF MEXICO

by Charles Dee Sharp
with essays by John O. Anfinson

Center for American Places
Santa Fe, New Mexico,
and Staunton, Virginia

PUBLISHER'S NOTES: This book was issued in an edition of 500 hardcover and 2,200 paperback copies with the generous support of Frank and Beckie Meyer and the Friends of the Center for American Places, for which the publisher is most grateful. It appears as the inaugural volume in the new series *Center Books on American Places*. For more information about the Center for American Places and the publication of *The Mississippi River in 1953: A Photographic Journey from the Headwaters to the Gulf of Mexico*, please see page 222.

Published 2005. First edition.
Printed in China on acid-free paper.

Center for American Places, Inc.
P.O. Box 23225
Santa Fe, New Mexico 87502, U.S.A.
www.americanplaces.org

Distributed by the University of Chicago Press
www.press.uchicago.edu

9 8 7 6 5 4 3 2 1

Library of Congress Cataloging-in-Publication Data is available from the publisher upon request.

ISBN 1-930066-26-0 (hc)
ISBN 1-930066-27-9 (pbk)

For my grandchildren, Jessica and Jacob

Contents

PREFACE
ix

THE JOURNEY
The River Beckoned
by Charles Dee Sharp
3

CONCLUSION
by John O. Anfinson
159

APPENDIX
The River's Geology
by John O. Anfinson
183

NOTES ON THE PHOTOGRAPHS
187

SELECTED BIBLIOGRAPHY
219

ACKNOWLEDGMENTS
220

ABOUT THE AUTHOR AND THE ESSAYIST
221

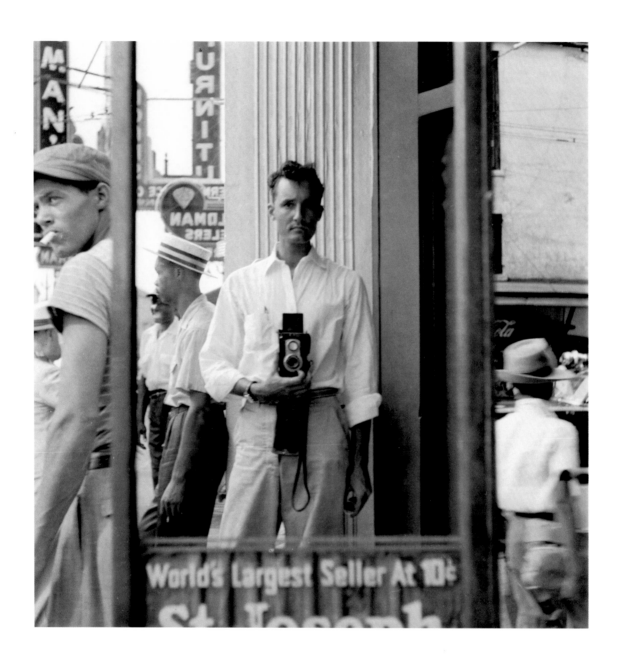

The author, July 1953
Memphis, Tenessee

Preface

ONCE, WHEN I WAS YOUNG and just out of the Army and the world was coming unglued, I had a great idea: make a documentary film of the Mississippi River. It was an idea that began in earlier years when hitchhiking west I first saw the Great River sparkling majestically in the morning sun.

Had anyone ever done it—filmed the river from top to bottom, the entire 2,350-mile length of it? Maybe. But what had almost certainly never been done was film a real-life couple who get married on the banks of the Mississippi River in Minneapolis, then board their honeymoon raft (the narrative hook) and float down the length of the river to New Orleans.

Was that not a fantastic idea? Just imagine the glories and the perils; the loving and the spats; the myths and the realities—it would be a documentary of documentaries. A sure Academy Award winner and a historic document. It was an absolutely, unbelievably wonderful idea.

In the spring of 1953 Patti Page is singing "How Much is that Doggie in the Window" on the nation's juke boxes; Senator Joe McCarthy is accusing the Army of harboring communists; vigilante groups picket the "subversive" films of Charlie Chaplin; Julius and Ethyl Rosenberg are executed for spying for the Soviet Union; Stalin dies, creating turmoil in the Kremlin; General Eisenhower, implying he will end the war in Korea, is inaugurated President. Meanwhile, in Nepal, Edmond Hillary and Tenzing Norgay conquer Mt. Everest; in England the structure of DNA, the molecule of life, is discovered by Crick, Watson, and Wilkins; and in Madison, Wisconsin, Ralph Dummit, who, like myself, had been a cub news reporter before being drafted, joins me in placing ads in the university newspaper for engaged couples (three show up for interviews); trips to junkyards (barrels for the raft), and meetings at the Johnson and Scott-Atwater outboard motor companies. Potential sponsors are lavish in their praise of the idea but, alas, decline to fund it. I write my elder brother, a cabinetmaker, for advice and help in building a raft, but he replies that he's very busy and, although he wishes me luck, adds that he thinks it would not be a disaster if I decided to work for a living instead of pursuing crazy ideas.

Dummit, his funds depleted, departed the project with regrets.

I still had a few hundred dollars in my pocket (earned in the Army by taking portraits of new recruits), and having been made aware that something more was needed than just an idea and some rusty barrels, I determined to take photographs the length and breadth of the river by both land and riverboat so that potential sponsors could see the historic scenery against which the honeymoon raft trip would take place. I headed for Lake Itasca, the river's source near the Canadian border. Afterwards, in St. Paul, Minnesota's capital, I introduced myself to Dorothy Warren, a *St. Paul Pioneer Press* river columnist. She, in turn, introduced me to the captain of a Pure Oil towboat that was leaving the next day with a tow of empty oil barges to New Orleans and then on to Houston via the Intra-Coastal Waterway Canal. The boat's captain, looking me up and down, said I was welcome to come along. (It is remarkable how in one's youth one thoughtlessly assumes one's good fortune as the natural order of things.)

Arriving in New Orleans ten days later, I bade goodbye to Captain Carole "Rip" Ware and his crew, hitchhiked back to the Twin Cites, retrieved my car, and in the following days and nights, with my weary Studebaker sedan serving as both transport and bedroom, zigzaged back and forth across the river and down its length to the Gulf of Mexico, taking photographs all the while.

My "honeymoon raft movie" was never made. It's probably a good thing. The project could well have ended in catastrophe —one does not engage great rivers without intensive preparation. Yet in my heart of hearts I still think my idea, if only as an idea, was a wonderful one. And so perhaps it was, not for a movie that never got made but for the still photographs that the idea made necessary, images evocative of a river —and a nation—that serve to redefine, more than half a century later, the present.

It's a given that we can't step into the same river twice. And so we cannot. When I made these pictures that edgy pre-Civil-Rights, Reds-hunting summer of 1953, the natural world had not seemed arrogated into personal or corporate "property"—casino boats and their attendant parking lots did not dominate riverfronts; floodwalls that separate towns from the river had not been built; historic nineteenth-century buildings had not evaporated; Hannibal, Missouri, had not been Disneyfied. The Mississippi River has much changed. And yet . . .

The Mississippi River (*a strong brown god . . . unpropitiated by worshippers of the machine, but waiting, watching, and waiting*, in the words of T. S. Eliot) is still there. My grandson and I drove to it only recently, sparkling majestically in the morning sun.

The
Mississippi River
in 1953

A Note to the Reader: All but a handful of the photographs in this book come from the author's original 1953 journeys by towboat and automobile. But in cases where the author lost his 1953 negatives or they were later damaged, he replaced them with photographs taken from subsequent visits to sites in the 1960s and in 2002; dates are noted in those cases. Entries from the 1953 journal that the author kept while making his trips are reproduced throughout the photographic sequence and are self-evident, as each one is set in *italics*. Extensive notes on many of the photographs appear on pages 187–218.

Down the Yellowstone, Milk, the White, and
 Cheyenne,
the Cannon Ball, the Muscle Shell, the James, and
 the Sioux,
down the Judith, the Grand, the Osage, and the
 Platte,
the Skunk, the Salt, the Black, and Minnesota,
down the Rock, the Illinois, the Kankakee, the Allengheny,
 the Monongahela, the Kanawha, and the Muskegon,
down the Miami, the Wabash, the Licking, and the
 Green,
the Cumberland, the Kentucky, and the Tennessee,
down the Washita, Wichita, the Red, and Yazoo,
down the Missouri—three thousand miles from the
 Rockies,
down the Ohio—a thousand miles from the
 Alleghenies,
down the Arkansas—fifteen-hundred miles from the
 Great Divide,
down the Red—a thousand miles from the Texas,
down the Great Valley—twenty-five hundred miles
 from Minnesota,
carrying all the rivers that run down two-thirds of
 the continent,
the Mississippi runs to the Gulf.

—Pare Lorentz, from the New Deal film *The River* (1937)

The Journey: The River Beckoned

Charles Dee Sharp

I'VE STOPPED TRYING TO UNDERSTAND WHY, individually and as a nation, we have such esteem for the Mississippi River. For me it says "America" as nothing else does or can. It is what makes me an American. Were the Mississippi River not to exist, America would be a very different nation and I would be a very different American son. I do not just sense this. I know it.

All these things I felt when, sixty-eight miles south of the Canadian border, a pilgrim more than a research-photographer, I took my first picture at Lake Itasca, Minnesota, the river's source (Figure 1). Here the Mississippi River is a mere stream that you can skip across in half a dozen steps.

Through pristine forests of white-barked birch trees, I followed the river as it flows north from Lake Itasca, east to Bemidji (Figures 2 and 3), south to Brainerd and Little Falls and on down to the Twin Cities (Figures 4, 5, and 6) where, thanks to Dorothy Warren of the *St. Paul Press*, I met and was invited to join Captain Carole "Rip" Ware (Figure 89) on the towboat *R. H. McElroy* (Figure 88). He had arrived in Minneapolis two days before with loaded oil barges. Now he was captaining the *McElroy* and the six barges back to Houston. Emptied of oil, each as long as a football field and cabled together in pairs, the barges thrust out from the *McElroy* ninety-six feet wide and 1,000 feet long.

While flanking the *McElroy* and the tow out from Minneapolis's Washington Street docks, Captain Ware's attention was focused on matters at hand and I contented myself by sitting (enthralled) up on the sofa at the rear of the pilothouse. A farmer's son from Indiana, I had been a cub reporter, had a few years of college at the universities of Arizona and Wisconsin-Madison, had toured Europe on a bicycle, been drafted two years in the Army; and now, twenty-four-years- old, I was researching a film I hoped to make of the Mississippi River. Watching Captain Ware and gazing slack-jawed at the passing scenery on either side, acutely aware of living an adventure, I thought how other men must have started out in just this poignant way— Hemingway and Steinbeck and Thomas Wolfe and John Huston and, well, all kinds of really

terrific men. I tried to take in everything at once. An official-looking sign posted above my head read:

ATOMIC ATTACK PROVISIONS FOR MERCHANT VESSELS IN PORT
When an Atomic attack is imminent You Shall do the Following. . .
After an Atomic Burst Follow Instructions Issued by Controlling Authorities. . .

Suddenly, with the towers of Minneapolis falling behind and the spires of St. Paul coming up in the distance, Captain Ware barked over his shoulder, "What'd you say your name was?"

I answered him.

"Well, come up here and talk to me."

So it was that over the next ten days I became acquainted with a quintessential Mississippi River towboat captain, a refulgent man who, now fifty-plus years later, remains so vividly in my mind as to make me think that my encounter with him was no more than a month ago.

Captain Ware was a thick-armed, barrel-chested, ruddy-faced man with no-nonsense eyes. A "good ole boy" from Batesville, Mississippi, his hair cut so short that you could see the rides of his scalp, he'd been on the river all his working life, starting out as a teenage deckhand. Now a captain of twenty years, he held pilot licenses for the Mississippi, Illinois, and Ohio rivers, and the Intra-Coastal Canal to Houston. I guessed he was in his early forties.

The first and most obvious thing I learned from Captain Ware was that piloting a prodigious transport down the backbone of America is no small thing: captaining your vessel as though it's an extension of your own body, constantly reading the river's moods, correctly comprehending the geometry of your tow and its cargo relative to the river and its current, to the locks and dams, the wing-dams, the wind and the weather, the high fast water and the low stagnant pools. "The run-off from the rain they had up here last week's dragged that starboard channel buoy up ahead there out of place," explained Captain Ware in my first introduction to riverine navigation, "the channel's not really where that buoy says it is." Early on, I was made to know that captaining a large towboat and its tow, if not a science, is most certainly an art.

The towboat *R. H. McElroy*, commissioned in 1950, 110 feet long, with a draft of 8.5 feet (towboats are misnamed; they do not pull their cargo but push it) was powered by twin diesels developing 2,200 horsepower. Its crew, with Captain Ware commanding, was comprised of a relief captain, first and second mates, four deckhands, first and second cooks, two engineers, and two orderlies. The fourteen men and women worked around the clock, six hours on, six hours off. They were sometimes on the river for months, never less than weeks, at a time. For every day worked, they received pay for a day off.

They were a hard-working, amiable crew (the *McElroy* was clean—once a week Captain Ware somewhere made an oily spot with his thumb; it was up to the crew to find it). All the crew came from southern states bordering the river. Some hadn't much to say. Others told fabulous stories. I ate very well. Very well indeed: fresh fruit and vegetables, and, as one might guess, barbecued pork, chicken and dumplings, chicken-fried steak, catfish, fried okra, greens, hushpuppies, beans and cornbread. . . .

I was aware, even as I was living the trip, of the profound impression the river was having on me, an impression that would stay with me forever, just as it had with Mark Twain. Several times during the trip I heard Captain Ware say with obvious contentment, "A riverman's no better off than a convict—neither of you can quit."

Where did this dream of the river begin? Who has never been affected by it? From ashore you can hear the primordial voice of a loon—its call haunting, like a foretelling of something indefinable and inevitable, beyond human comprehension. The night sky, and the wide moonlit lake, makes everything seem ancient and yet alive; I've a gratified sense of feeling small in nature's immensity . . . of being in the presence of creation itself.

Somewhere, way off, I can hear the wha-ooo of a whooping crane. I think I cannot live without wilderness.

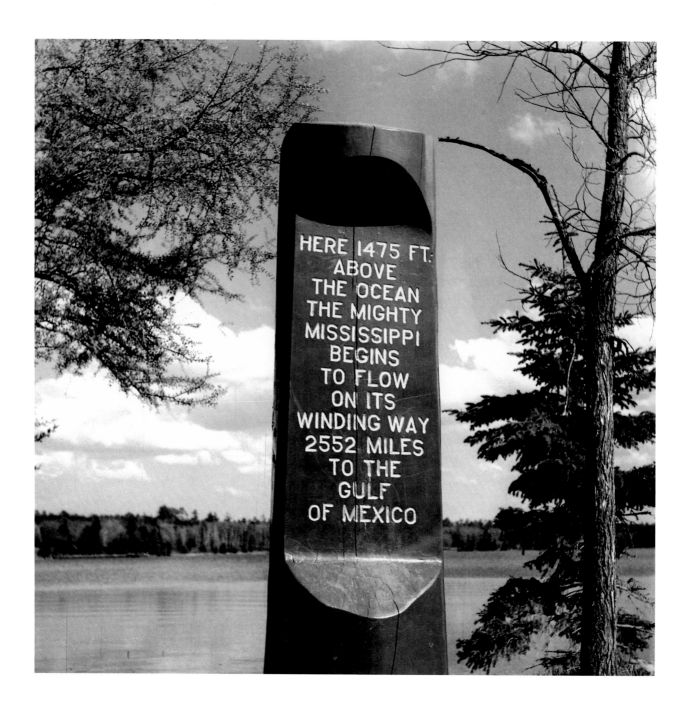

Figure 1: The river the Chippewa Indians called *Mee-zee-see-bee* (Father of Waters) begins at Lake Itasca, Minnesota, now a state park adjacent to the White Earth Indian Reservation.

The river in the afternoon light is glassy, like a stilled lake.
An osprey, and then a red-wing black bird, glides by.

The water craft with which the white boys and the Indian boys alike traversed the river, rough
or smooth, and explored every creek, bayou, and slough for miles around, were "dug-outs"—
canoes hollowed out of white pine tree trunks from six to eight feet long, and just wide
enough to take in a not too-well-developed lad; but then, all the boys were lean and wiry.
It thus happened that . . . pairs and trios ranging from fourteen years down to seven, were pretty
generally abroad from the opening of the river in the spring until its closing in the fall, hunting,
fishing and exploring, going miles away, up or down the river . . . and camping out at night,
often without previous notice to their mothers. With a "hunk" of bread in their pockets,
some matches to kindle a fire, a gun and fishlines, they never were in danger
of starvation, although always hungry.

— George Byron Merrick,
from *Old Times on the Upper Mississippi: Recollections of a Steamboat Pilot
from 1854 to 1863* (1905)

Figure 2: Upstream from Bemidji: The river makes you think about
who you are, what you're doing, where you're going.

. . . it took five giant storks, working in relays, to deliver Paul to his parents. A lumber wagon, drawn by a team of oxen, was Paul's baby carriage. By the time Paul was one year old, his clothing was so large he had to use the wagon wheels for buttons. In the year of the "blue snow" when it was so cold the geese flew backward, Paul found a baby ox; Paul named him Babe. Like Paul, Babe grew fast and soon was seven ax handles and a plug of tobacco wide between the eyes. For a between meals snack, Babe would eat thirty bales of hay, wire and all. . .

from the folktale, *The Legend of Paul Bunyan*

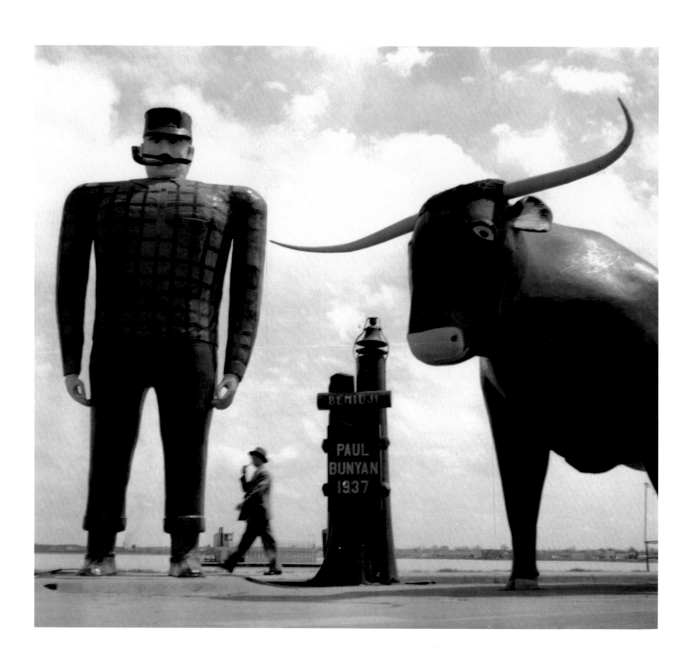

Figure 3: Giant statues of Paul Bunyan, the legendary hero of early logging days, and his Blue Ox, *Babe*, stand along the shore of Lake Bemidji.

"Your tow never wants to go straight. You can count on that.
Movin' into a lock, it's like tryin' to herd frogs," says Captain Carole Ware.

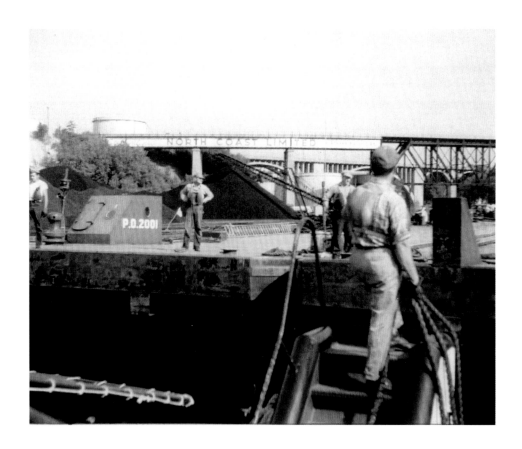

Figures 4 and 5 (following page): Towboats and their barges arriving or departing Minneapolis pass through the narrowest gorge on the Mississippi River. Lock and Dam No. 1 has the third largest drop or lift (thirty-six feet) of all river's twenty-nine dams and locks built and operated by the U.S. Army Corps of Engineers. The Upper St. Anthony Falls Lock has a 49.2-foot lift and Lock and Dam No. 19 at Keokuk, Iowa, a thirty-nine-foot lift.

Manipulating barges into and out of a lock is a challenge requiring deftness, knowledge, teamwork. Artistry as well as craft is involved. And physicalness. After a difficult locking, a pilot will often-times find himself sweating as much as the deckhands pulling lines across the barges' steel decks in the middle of August.

Today, between Minneapolis and St. Louis, there are twenty-nine locks and dams on the Mississippi River. (In 1953 there were twenty-three.) This is how it works: The McElroy eases its four forward barges into the lock chamber, disengages them from the two rear barges, then backs out, allowing the upriver lock gate to close and the four forward barges to be lowered in the lock chamber. As in the army, it's hurry up and wait: for the lock chamber to drain to the lower river level (each draining and filling of the lock chamber takes twelve to fourteen minutes), for the lower lock gates to open and the barges to be leveraged out to the downriver guard wall; for the lower lock gate to close and the lock chamber to refill, allowing the upper gate to open and the two aft barges and the McElroy to enter the lock chamber; for the water in the lock chamber to again drop to the river's downriver level, the downriver gates to open and the rejoining then of the McElroy to the two aft barges and to the four forward barges, and the continuation of our journey.

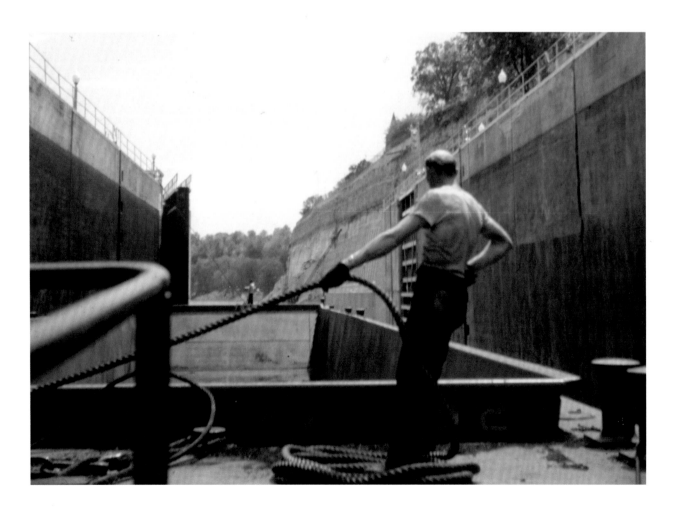

We pass between St. Paul's narrow Robert Street Bridge piers without incident, then turn south with the river. Suddenly downtown St. Paul is astern, an early summer haze shrouding the spires of its great cathedral and the prancing array of golden horses atop the state capitol building, whose dome is remindful of St. Peter's basilica in Rome. Contrasted with the unornamented modernity of its twin city, Minneapolis, St. Paul has a kind of fin-de-siecle harmoniousness about it, its skyline inducing images of holiday gayeties, of girls in fur coats and raucous boy-friends aware of an unrecoverable innocence.
Later, I remember that F. Scott Fitzgerald grew up in St. Paul.

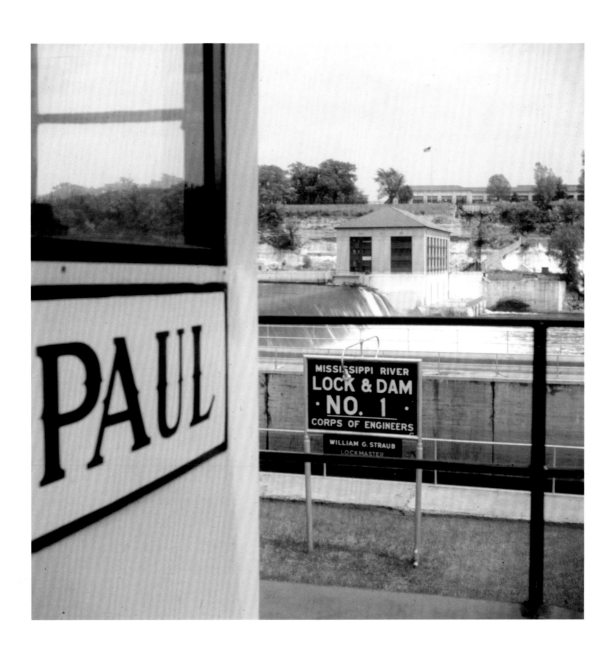

Figure 6: Built by the U.S. Army Corps of Engineers, Lock and Dam No. 1 is six miles below the Falls of St. Anthony.

Off the starboard a lone fisherman sits in a rowboat in the shadows of Prescott Island. In the afternoon light, it's an idyllic scene, perfectly composed and lighted, one with the limerock headlands beyond.

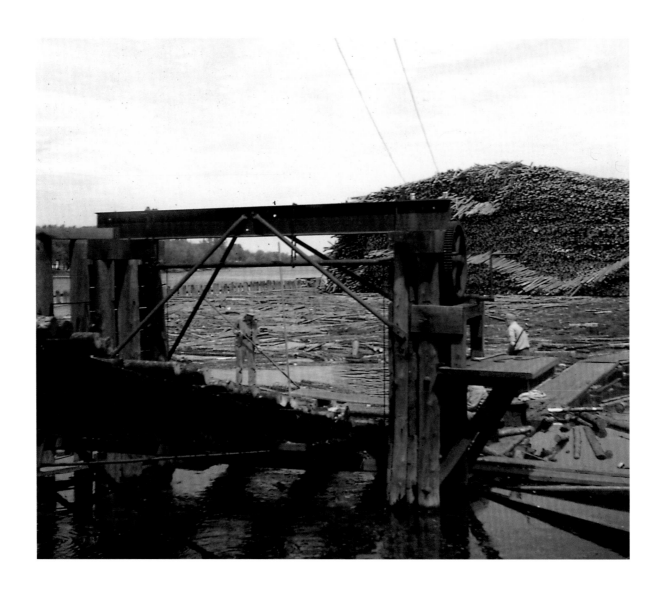

Figures 7 and 8 (opposite): The men working at a lumber boom in Prescott, Wisconsin, do the same hard dangerous work that lumbermen of the early-to-mid-nineteenth century did when massive rafts of logs were sent down the river.

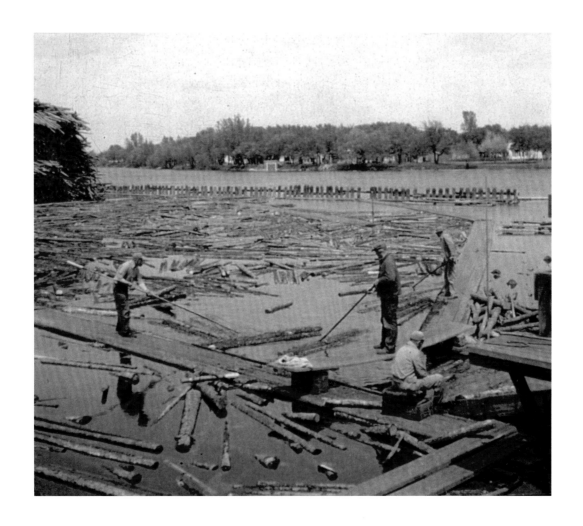

Black spruce and Norway pine,
Douglas fir and Red Cedar,
Scarlet oak and Shagbark hickory,
Hemlock and aspen . . .
There was lumber in the North . . .
Lumber enough to cover all Europe.
Down from Minnesota and Wisconsin,
Down to St. Paul;
Down to St. Louis and St. Joe . . .
Lumber for the new continent of the West.
Lumber for the new mills.

—Pare Lorentz, *The River* (1937)

From the marshes on the portside of the river the whump! whump! of shotgun fire
can be heard, then the cawing of crows. Suddenly the shoreline erupts with blackbirds
flying out over the river and the barges, forming into a wheeling mass towards shore again,
then circling and coming back directly over the McElroy, filling the sky, the sound of
their wings beating down on the pilothouse. Then, as quickly as they appeared, they are
gone, disappearing black dots scattered on the horizon.

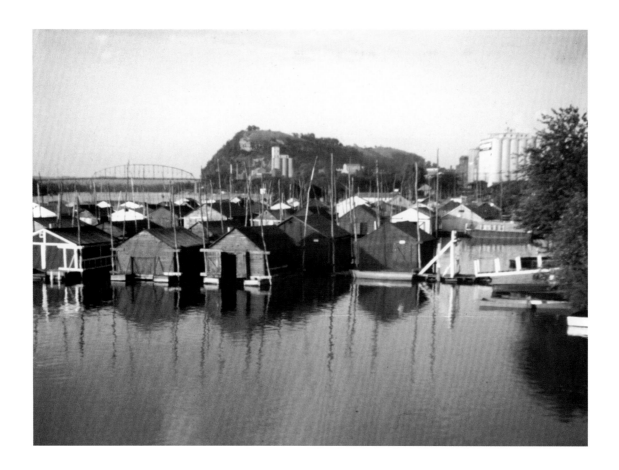

Figure 9: Red Wing, Minnesota, situated about four miles upstream of Lake Pepin, is one of the prettiest towns on the Upper River, especially at sunset when its harbor waters turn royal blue and the quirky boathouses and the moored boats and flexing gin poles reflect on the water impressionistically.

I sit at the bow of the tow on a coil of line beneath the jackstaff, listening to the water gurgling, rhythmically slapping beneath the barges' rakes, the steel of the barges still warm to my feet from the day's sun. An oddly shaped shadow moves on the water thirty yards out from the starboard shore. After a moment I realize what it is—the head and antlers of a deer bobbing, swimming on Lake Pepin's serene eventide.

Figures 10 and 11: A naturally occurring expanse on the Mississippi, Lake Pepin is three miles wide and twenty-two miles long. It was here in 1922 that water skiing was invented.

Captain Hollings, the relief captain, turns on one of the arc-lights, illuminating church steeples protruding above the riverbank trees of Fountain City, Wisconsin. The dome of a Greek Orthodox Church seems to fluoresce in the arc's passing light, the black shadows that follow the retreating light modeling the dome, causing its Byzantine shape to stand out extra-dimensionally against the night sky.

Figures 12, 13 and 14 (opposite): Images from Fountain City, Wisconsin, taken during the author's road trip, following within weeks of his towboat journey.

Beyond Lock and Dam No. 5-A the lights of Winona are vivid as neon. They seem to float against the sky and the heliotrope river as in a bell jar. All across the eastern horizon mountainous clouds are seen, jagged and darkly purple. The sky has become luminous and joltingly beautiful, and I think that, instead of standing on the McElroy's pilothouse deck waiting for the lock gates to open, I could be standing outside the Youth Hostel in Zermat, Switzerland, again, looking out at the Jungfrau.

By the time we move out of the lock there is ground fog lying all along Winona's shoreline, but above the fog the town's church spires are rose-red and the cool morning air sweet. Captain Ware nods at a black-can buoy, coming up off our starboard bow, that is out of line with the other black buoys stretching far out ahead.

"See that little silvery line way down there?" he asks. "Somethin's causin' that. Way out the other way, see that slack water? I'm tryin' to catch it, that's good sailin' through there. Except on this river, you can't tell, we might be fixin' to scoop up a few rocks instead."

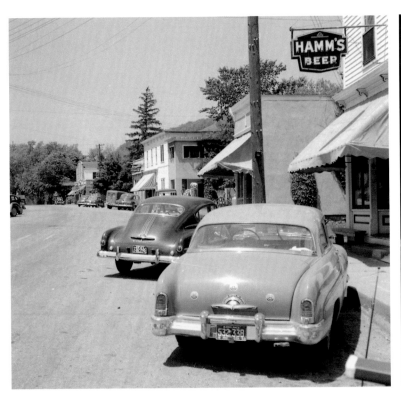
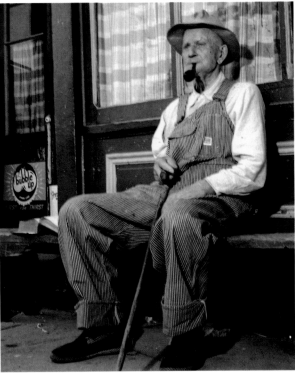

"Over there—that's where it was supposed to be." Captain Ware nods toward the starboard shore. Rolling Stone, he explains, was to be a paradise, some 400 easterners, deeds in hand had been promised in the 1850s. But the sojourners, none with experience on the frontier, used to regular meals and unused to hungry bears, had been swindled: There never was such a place. When the hard Minnesota winter came many of the greenhorns, city types all, made further payment with their lives.

One of the boldest-faced swindles I ever heard of was the so-called Rolling Stone colony. In the spring of 1852, some three or four hundred people, chiefly from New York City, came to seek their purchased lands in Rolling Stone. They brought with them beautiful maps and bird's-eye views of the place, showing a large greenhouse, lecture hall, and library. Each colonist was to have a house lot in town and a farm in the neighboring country. The colony had been formed by one William Haddock, and none of the members had the faintest shadow of experience in farming. Boarding steamers at Galena, they expected to be put off at the Rolling Stone levee, for the views represented large houses, a hotel, a big warehouse, and a fine dock. But the steamboat officers had never heard of such a place. Careful questioning, however, seemed to locate the site three miles above Wabasha Prairie, on land then belonging to the Sioux Indians. As they insisted on landing, they were put off at the log cabin of one John Johnson, the only white man within ten miles. They made sod houses for themselves, or dug shelter burrows in the river banks; sickness came; many died during the summer and autumn; and when winter set in the place was abandoned. The people suffered severely, and the story of Rolling Stone makes a sad chapter in the early history of Minnesota.

—George Byron Merrick,
from *Old Times on the Mississippi: Recollections of a Steamboat Pilot from 1854 to 1863* (1905)

Figures 15 and 16: La Crosse, Wisconsin, situated on the Mississippi just below the mouths
of the Black and La Crosse rivers, was started as a trading post by seventeenth-century
French fur traders seeking commerce with the Winnebago Indians.

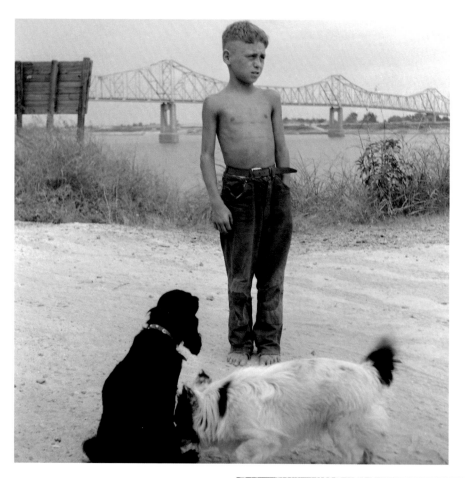

Figure 17: A boy and two of his best friends at La Crosse.
Figure 18: A La Crosse yo-yo club.

The moon was up. The river was empty.

We'd seen no one else on the river for the last two hours.

On the short-wave we listened to the conversations of pilots communicating

with other pilots—peers who, like ourselves, were shepherding their tows

somewhere in the night up river, down river, their voices,

whispers in an anteroom, sounding both near and far away:

"His boat was smokin' so much I thought the fog was rollin' in—"

"Awh, we're jus' tip-toin' along down here, watchin' the moon

cloudin' over. Ain't makin' but 'bout four knots. We goin' by on two whistles are we? Over—"

"You hear 'bout that new vaccine they got for polio?

No more iron lungs, they say."

"Fantastic. Guess the March of Dimes'll be done with, won't it?"

"I was about to lose my stern when the wind changed

and saved my tow—saved my butt, I'll tell ya."

"There's a big bar tryin' to form below Lock 18—"

*"What picture you talkin' about—*The Robe? *It was in Cinemascope.*

I saw it. Victor Mature's kisser was forty feet wide."

"Stella? That who you're talkin' about? That ole gal's so fat now

you can't tell which wrinkle she'll open to talk. Over."

"Yeah, gotcha OK. But she's a good ole girl, ain't she?"

In the afternoon sun the black stump fields on either side of the channel are flecked with gold; the shorelines outlining the blue of the sky and darker blue of the river into the far horizon so distinctly as to make the shoreline trees, the sparkle on the water and the slowly passing buoys appear extra-dimensional, as though you're seeing everything through a stereoscope.

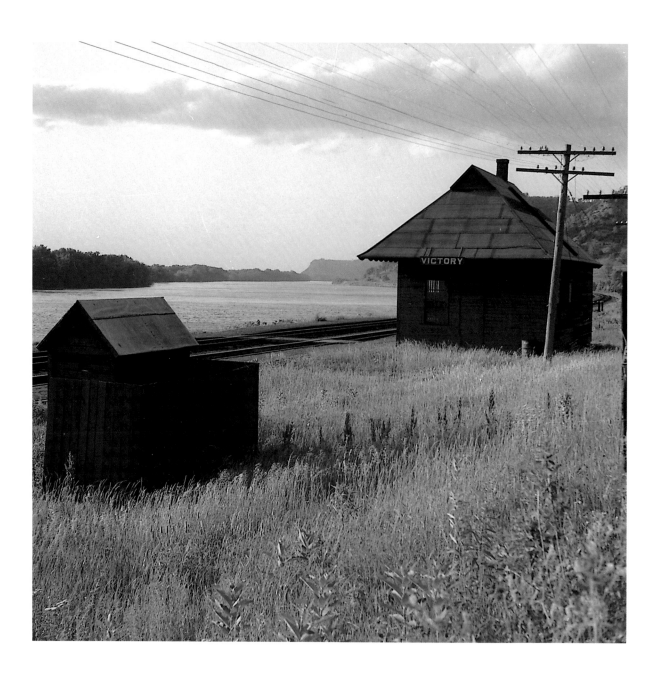

Figures 19 and 20 (opposite left): An abandoned train station at Victory, Wisconsin, overlooks Battle Island, the largest of twenty islands along this stretch of the Mississippi, where in 1832, at the mouth of the Upper Iowa River, the murderous Battle of Bad Axe was fought during the Black Hawk War, an ongoing effort to drive the Sac and Fox Indians out of Illinois.

Captain Ware turned the short-wave radio low and turned up the volume on a commercial FM station. Passing slowly off our portside is a scruby land mass called Henderson Island. Ahead, four small islands are lined up in the middle of the river like ships in formation. Foreshortened when looking at them through the binoculars, they gradually lose their separateness and become a single uninteresting land mass. But standing in the McElroy's pilot house next to Captain Ware, the afternoon sun streaming through the windows and tow extended far out ahead—a cyclopean barque gliding serenely with the curve of the channel buoys to the starboard side of the islands— and Bach's haunting Air on the G String *playing from the FM, if someone would ask me just now to describe paradise, I think I'd be able to.*

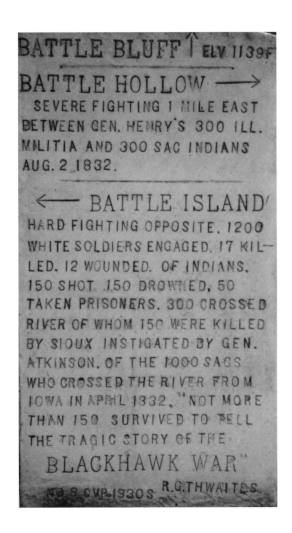

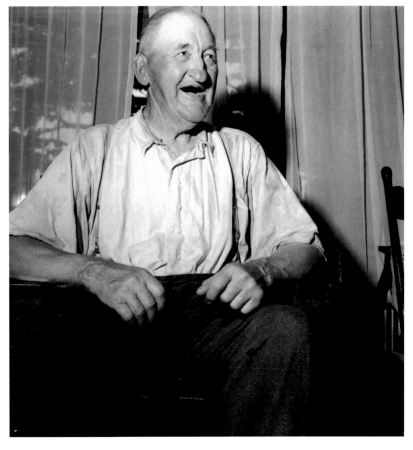

Figure 21 (right): The author encountered many characters along the way, including this fun-loving Swede.

Compared to the sensory/emotional experience of being on the river, following the river by automobile is an exercise in frustration. On boats larger than a rowboat with sleeping facilities and sustenance readily at hand, it allows you to be enjoined to the river. Not so by automobile where there isn't anything that doesn't require your concentrated attention: driving the roadway, checking the map, looking for scenic turnoffs so that you can actually see the river, getting directions to specific places (rural as well as town), finding a parking space, securing your belongings, finding a grocery store, a restaurant, a place to sleep (even if it's the front seat of your car).

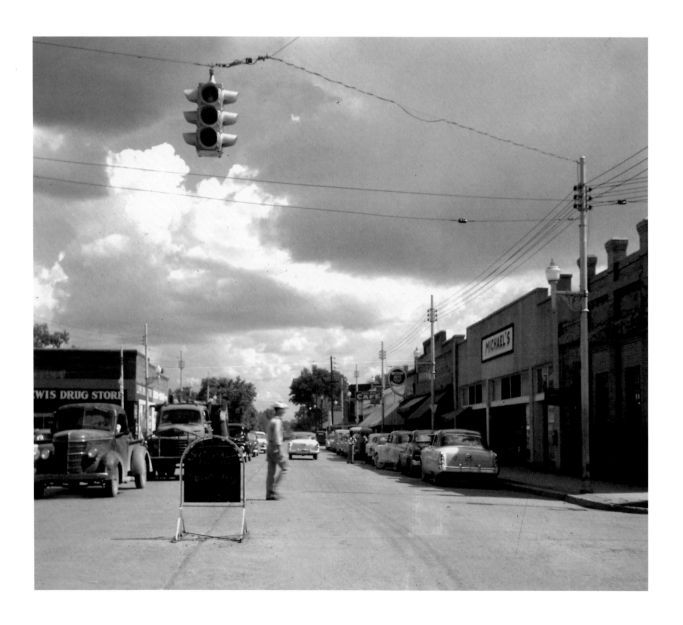

Figure 22: "Notice" reads the hand-written sign in downtown Lansing, Iowa, "Soft-Ball Practice To Night (Fri.) 7:30 p.m."

*Lynxville, Wisconsin, tucked in a valley with high bluffs on either side,
is calendar pretty. Beyond the village, a pasture field, pea-green in color,
slopes steeply upward. At the top of the field, five-hundred feet or more above
the river, a white house and petite red barn are so charmingly sited,
so startlingly early-American in appearance, as to suggest that Grandma
Moses painted them there.*

The McElroy *and the aft two barges are being lowered through Lock and Dam No. 10 when,
after supper, on my way to my cabin, I noticed a rowboat off the stern locking through with us.
An old man was sitting alone on the rear seat of the rowboat. His face was red from sunburn,
his thatched hair and busy eyebrows yellowish white. In the rowboat are various pieces
of camping equipment—stove, tent, sleeping bag, clothing, groceries—*
"Hello," I say.
*"I had to wait until one of you big tows came along," the old man answers my greeting.
"In these big locks they won't let just a little boat go through by itself."*
"My name's Charlie," I say. "What's yours?"
"Norman," the old man answers.
*His head, turned up at me, seems unusually shaped—like a wren house,
flat in front and sloping to the rear.*
*"Yesterday I almost got sucked under the front of one of these big barges,"
says the old man. "I did, you know. I broke my oar pushing away."*
I can see the broken oar lying at his feet.
"I was supposed to get married this summer. To Sophie. But my mother stopped it."
I wasn't sure I'd understood. "What did you say?"
"Sophie was waiting at the alter but my mother locked me in the bathroom."
"Oh. Oh, really?" I say.
*"By the time I got to the temple Sophie and all the guests were gone.
She did, she locked me in the bathroom."*
"Good grief—"
*"It was the second time she did that," says the old man. "The first time she hid my suit.
And the wedding ring, too."*

"Good grief," I say a second time.

"Sophie blamed me, not my mother."

"That doesn't sound fair. Not at all," I say.

"No, it wasn't."

"Well—so here you are now."

"Yes—"

"Don't you have to be careful? On this big river, in that little boat? It's got to be dangerous."

"It's so pretty. I always dreamed of going down the Mississippi River."

"I know. You and a whole lot of us."

"I ran away. I picked up my Social Security check first though, I did."

"You ran away?"

*"I like to fish, but I fooled her this time. I didn't take my favorite fishing pole so
she wouldn't know. She always thinks I'm sick and that I never want to take my pills.
She keeps saying, 'My son, he's so good, he doesn't go with girls, he doesn't go to bars,
my sweet son's so good—'"*

"Your mother doesn't know where you are—you haven't called her?"

*"I can just hear her—'Where's my son? Where's my son?—I'm so alone, now, I'm so all alone.'
I mean she always thinks I'm dead even though I never am."*

"This was just something you had to do?"

"Yes, it was—is."

"And Sophie? What about Sophie, Norman?"

*The old man fell silent. He busied himself rearranging odds and ends on his seat.
The downriver lock gates started to open. He unslung the rope securing his rowboat
to the lock wall; he did not look up to answer my impertinent question but stared down
the lock wall towards the open river ahead.*

We clear Lock and Dam No. 11 in a drizzling rain. Coming up off the starboard are the lights of Dubuque, Iowa. Through the blur of rain you can make out the dimly lit yellow-domed city hall that sits near the summit of a cone-like hill and, closer, part way down the hill, the lights of the Dubuque Star Brewery. In the foreground, amidst abandoned warehouses stands a lead shot tower, a relic from the Civil War. The top of the tower was once painted red but through the intervening years it's become faded and from out here on the rain-dark river the historic old artifact looks not so much erect as sad, like a spent phallus.

Ghostly patches of mist lie all across the river. Captain Ware leans forward between the rudder control arms, slow-belling the McElroy, *debating if he should ease the tow to shore and tie up. For fleeting moments shrouds of mist appear, swirl about the pilothouse so completely as to create a whiteout, then dissipate, and, again, you can see the jackstaff at the bow of the tow, the open river and the bluffs on either shore. One of them*

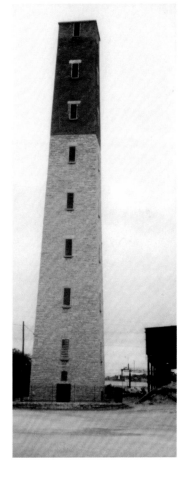

is Tête de Mort—*Death Head Bluff—the bluff, Captain Ware says, where early last century the French drove a band of Indians to starve or jump to their deaths. ("We told the Indians to stop bein' what he was and be someone else. Man can't do that. Communists 're findin' that out.") Tie up to shore or continue on—Captain Ware can justify either decision. There hasn't been a complete whiteout for the past several minutes and he decides we will continue on, slow-belling our way down the middle of the river where a ribbon of mist created by changing air temperatures has collided with the deeper, cooler center of the river, stretching between the channel buoys to the river's nonexistent, then vaguely distant, horizon.*

Figure 23: An 1856 lead-shot tower stands as an anachronism on the waterfront at Dubuque, Iowa, testament to the town's once thriving lead trade, and where, during the Civil War, the tower produced at its peak two to eight tons of lead-shot per day for the Union army.

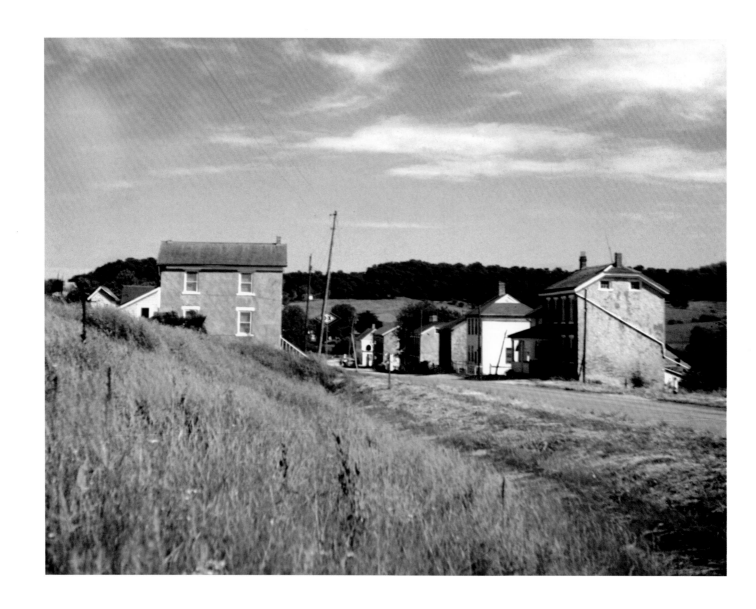

Figures 24, 25 and 26 (opposite): Fifteen miles south of Dubuque, on U.S. 52, two miles west of the Mississippi, is a remarkable village—a hamlet, really—called St. Donatus, Iowa, settled by immigrants from Olm, Luxembourg, in the 1830s, who brought their faith with them and built houses in the old way, of stone.

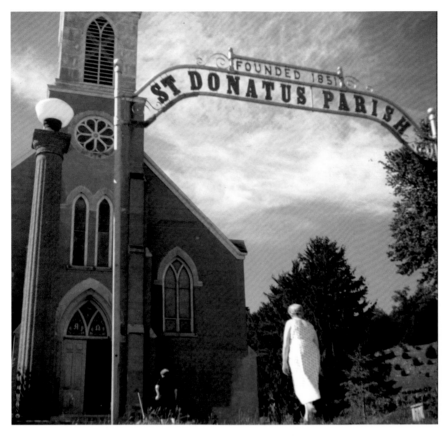

"All right, Mr. Charles," says Captain Ware, "where do you suppose the Mississippi's the widest?"
"Oh," I answer, "down south, I guess. Below Cairo somewhere."
"Why you don't know anythin' 'bout this river, do you? It's just ahead, above Clinton, Iowa.
She's five miles wide there. Up at Eagle Point Park you can see how wide the river is
better'n we can down here on it."

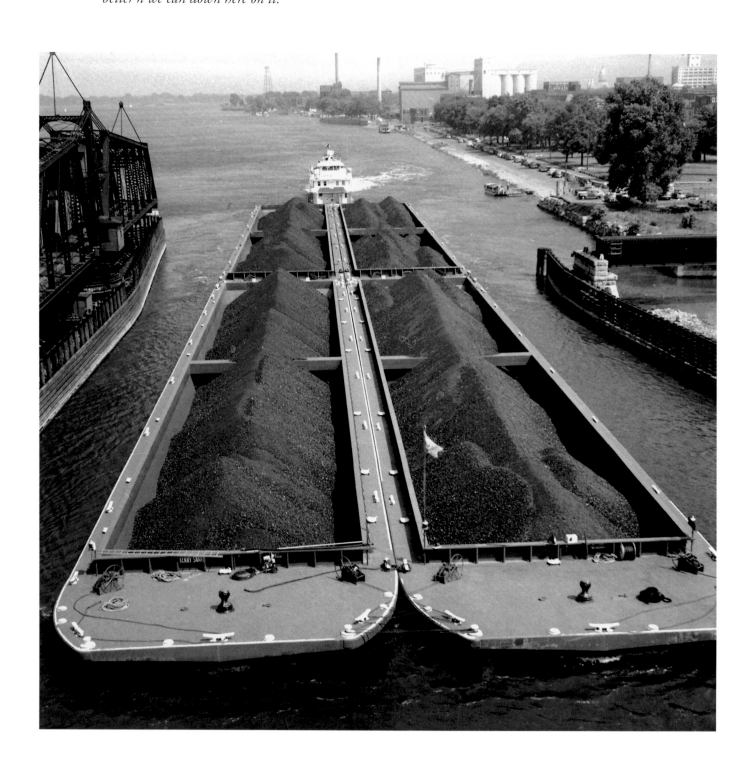

Figure 27: A tow of coal destined for the Twin Cities passes through the railroad drawbridge at Clinton, Iowa.

"This northern river's allurin'," says Captain Ware. "And there's people. . .
Down on the lower river you don't see nobody. You go for fifty-, hundred-mile stretches,
a day and a half sometimes, you won't see nobody. That river's wide down there—
vast, desolate. It stretches beyond the grasp of your imagination.
If you got any crazyness in you, it'll bring it out.
You got to know who you are down there."

Figure 28: A few miles north of the Rock Island Rapids is the bucolic town of Le Claire, Iowa.

The 1950s, uneased by the Cold War and The Bomb, was also a time of conformity and "square-ness," a kind of felt abyss in everyday life. Not so, however, for Captain Carole "Rip" Ware. "There's a riverside park up north," he said to me one afternoon (when the river and sky ahead were broad and wide as eternity itself), "where on weekends you always see the unleashed apartment dogs and the little wiener-roast fires and the scrawny badminton setups and broad-beamed women in their shorts and white legs . . . that makes me, I admit it, feel . . . uhm . . . superior. You know what I mean? To be out here and not over there ashore: It's like they're all just goin' through the motions over there. Pretendin'."

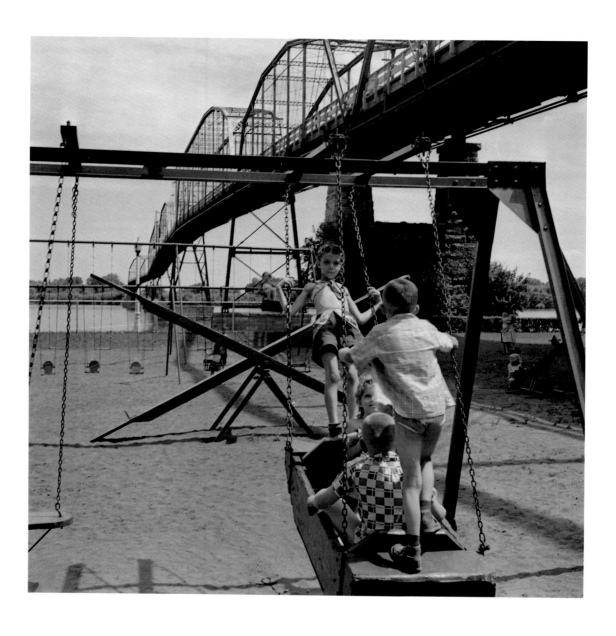

Figure 29: Playtime below the bridge at Bettendorf, Iowa.

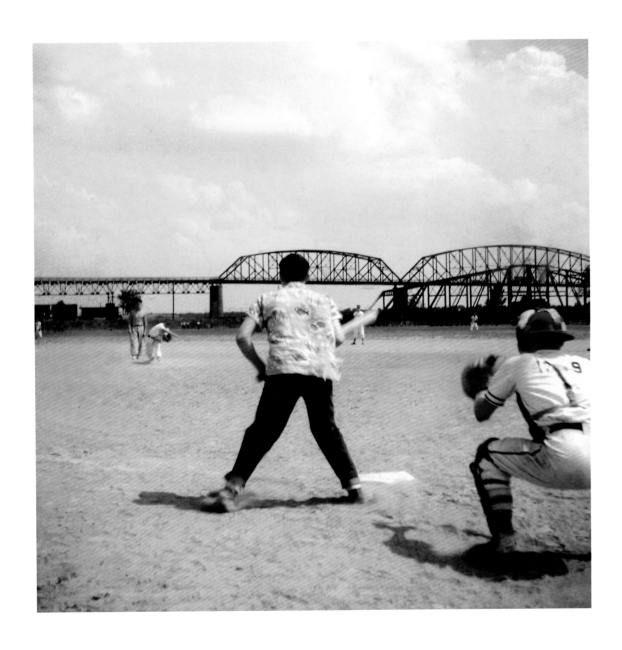

Figure 30: In Bettendorf, Iowa, baseball truly was America's favorite pastime, especially for these boys. ("Yeah, well, sure. Someday I'll get there, too. You better believe it!")

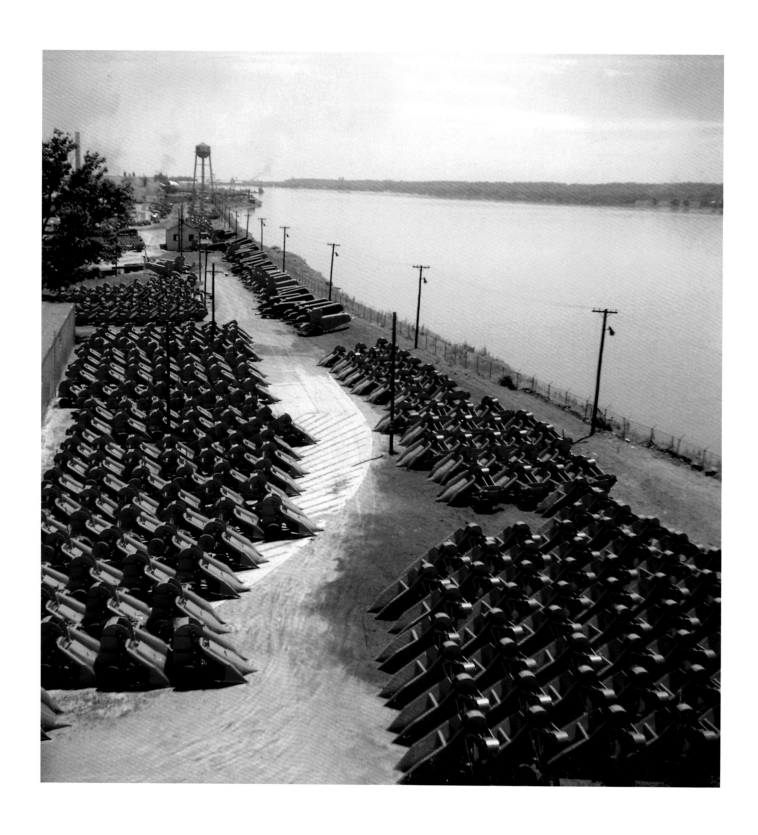

Figure 31: Rows of John Deere double-row corn-pickers stand ready for the autumn harvest in Moline, Illinois, home of the John Deere Company.

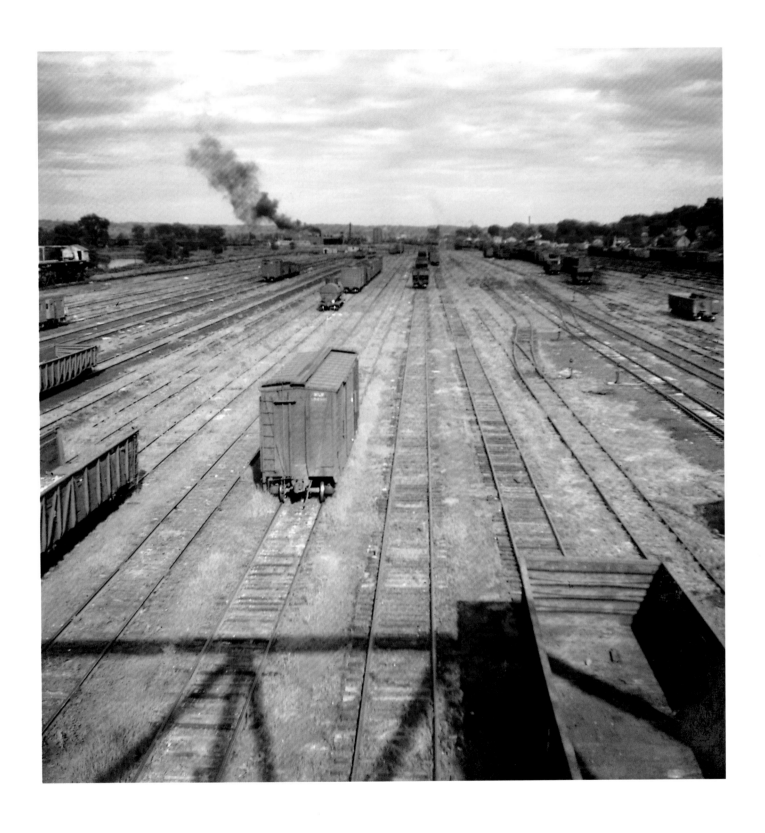

Figure 32: The rail yard in Rock Island, Illinois, with its shadow of a bridge across the tracks, evokes an era in the city's history when steamboats and railroads vied for commerce and preeminence.

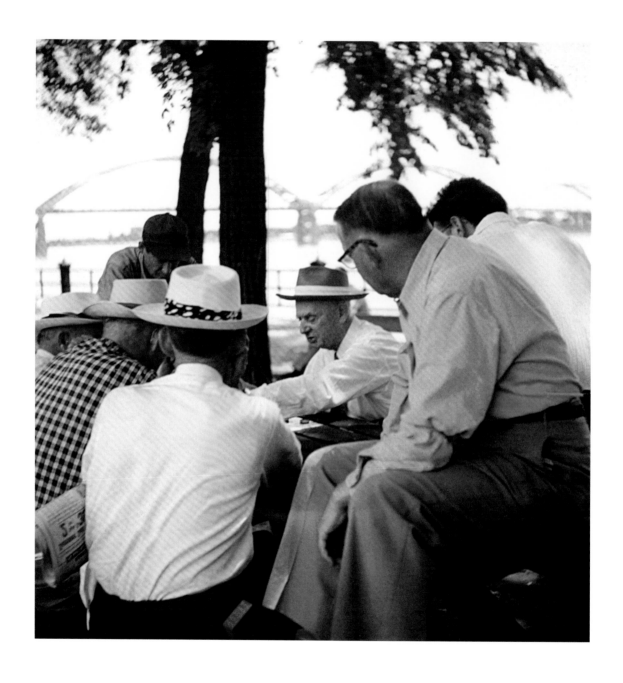

Figures 33, 34 and 35 (opposite): Contrasted to these leisurely afternoon scenes in Davenport, Iowa, a visitor in 1876 described a town of "thronged streets and a populace full of the affairs of the moment, without time or inclination for the idle curiosity of the villager."

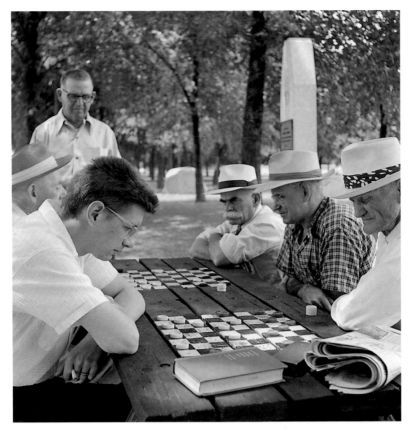

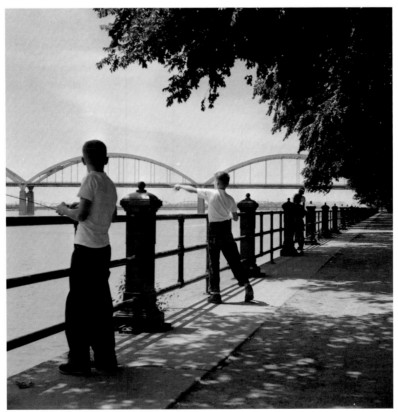

Through the binoculars I look ashore at a man waxing his car in his driveway, a woman hanging her wash on a clothesline, an elderly woman gathering flowers from her garden; at turn-of-the-century homes with sun porches and stained-glass windows, with bicycles and lawn chairs and collapsed beach umbrellas strewn about; at paint-needy summer cottages with stenciled names over their front doors: The Four of Us, Dinghy, Evening Colors, Clarke Gables . . . One of the cottages still has a Christmas wreath hanging on its front door.

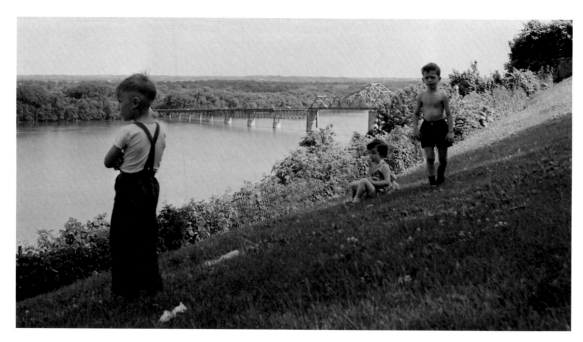

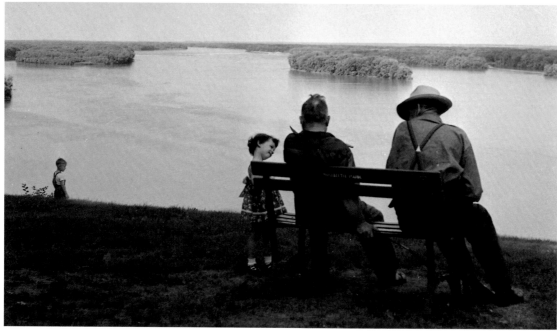

Figures 36 and 37: On the bluffs above the river at Muscatine, Iowa.
"Well, now you see, young lady, this is how it happened . . ."

The sun is clouded over and the river looks mottled, like moiré silk. We are in the wide bend
between Turtle and Ziegler Islands. Two miles ahead, you can make out the Norfolk
and Western Railway bridge. Captain Ware pulls the whistle rope, signaling
our approach. He hands me the binoculars and after a time I can see a crack
of daylight appear at either end of the bridge's draw-span.
Ponderously, the swing action of the old iron bridge continues to open wide.

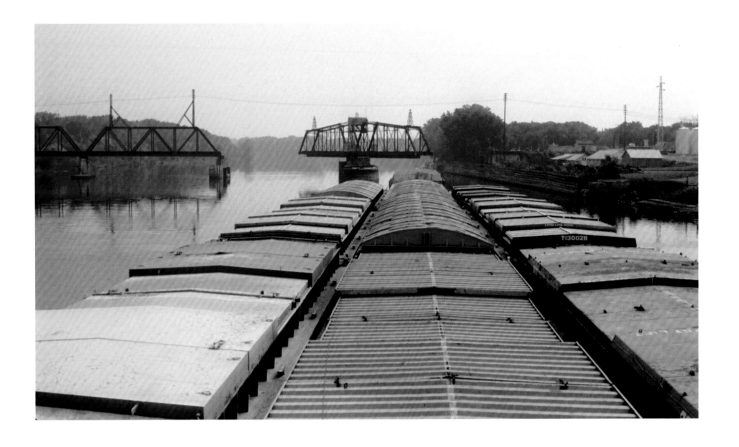

Figure 38: The 1892 double-track swing-span bridge in Burlington, Iowa,
replaced an 1868 single-track bridge, the first all-metal one to cross the river.

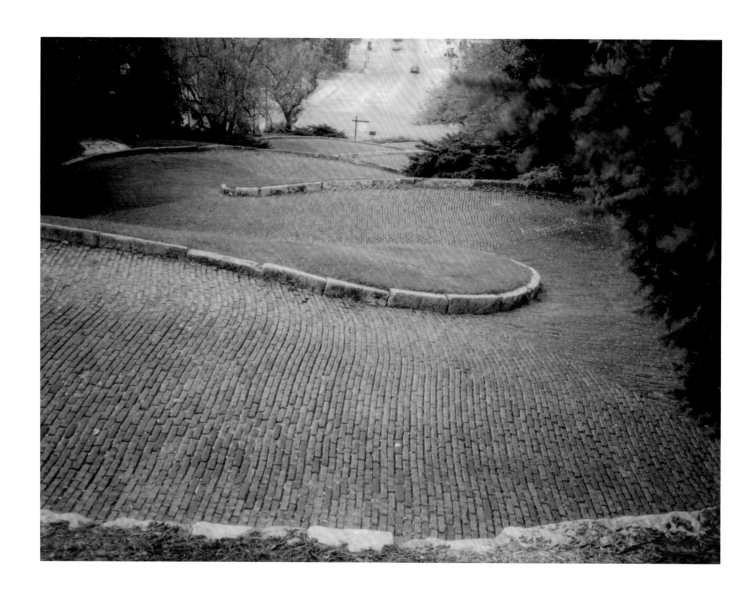

Figure 39: Burlington's Snake Alley, which the town claims is the "crookedest street in the world," was constructed in 1894. It descends fifty-nine feet from Burlington's residential area to the city's downtown business district in five half-curves and two quarter-curves. (2002 photo)

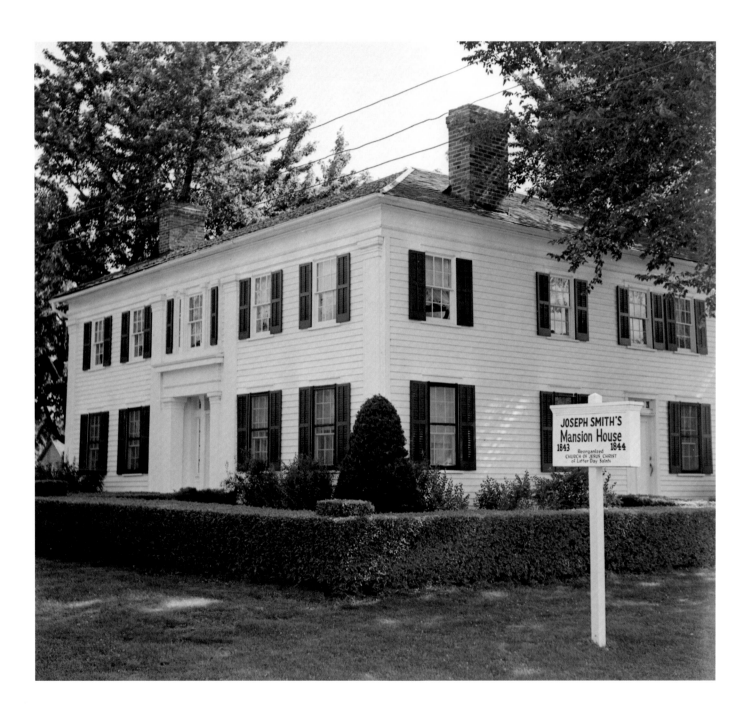

Figure 40: The last residence of Joseph Smith, polygamist founder of the Church of Jesus Christ of Latter-day Saints or Mormons, who settled his followers in Nauvoo, Illinois, in 1839, after they were violently driven from a settlement in Missouri.

"Over there's where the Mormons were, the Latter-day Saints, before they took off for Utah," Captain Ware informs me.

Up on the hill off our portside the lights of modern-day Nauvoo, Illinois, are bright against the night sky, but down on the river the historic part of Nauvoo is dark. Captain Ware turns one of the McElroy's arc-lights onto the cobblestone street that leads up from the river past neatly trimmed hedges and idyllic white clapboard houses to the Joseph Smith mansion.

"That Joe Smith," says Captain Ware, "they say his voice was unusual, like the sound of many waters. They say besides the four he married, he liked women. Claimed he had revelations from God, that God was sexually active. Guess you know the Book of Mormon's a religious history of ancient civilizations in America? Before and after Christ came here?"

"Here?" I ask.

"That's right, Jesus Christ was here in America, and when He comes back the new Zion'll be here, too. In Kansas City. Ole Smitty taught there's more'n one god, a whole bunch of 'em, that Mormons can become gods themselves. Also the end of the world's at hand. What you see over there, Smitty named it Nauvoo. In Hebrew he said it meant "Pleasant Land." Thing is though, there's no such word. Smitty made it up.

"Saw a meadow in the middle of the sky, didn't he?" Captain Ware continues. "Tried to make Nauvoo into a state with its own militia. He even ran for President. They say he liked to dictate what was what—he'd gone from a toothpick to lumber yard so, when some dissidents criticized him in a rival newspaper, he didn't take kindly to that and burned down their paper. The law put him in jail, his brother Hyrum, too. Then a mob stormed the jail. Shot him dead. That's when Brigham Young took over and the Mormons went west. Turned a religion into a people. An American Moses.

"But listen here," Captain Ware adds, "those Mormons, they know how to work. They tithe, they don't smoke or drink coffee. At eighteen, their kids go out and do public service. It's a peculiar religion. Most religions are when you study 'em. They wear special underwear and don't acknowledge any other Christian religions 'cause ever'body else's got it wrong. But maybe you got to look at what they've accomplished and all, they're right up there for accomplishment with the Japs and the Jews."

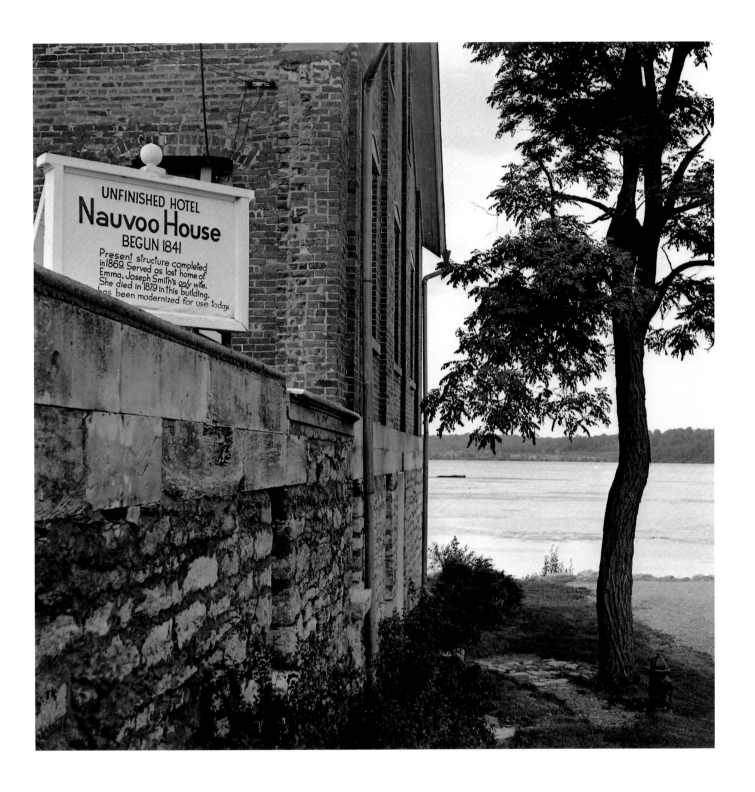

UNFINISHED HOTEL
Nauvoo House
BEGUN 1841
Present structure completed
in 1869. Served as last home of
Emma, Joseph Smith's *only wife*.
She died in 1879 in this building.
...has been modernized for use today.

Figure 41: The last residence of Emma Hale Smith, Joseph's first wife who strenuously objected to his revelation concerning "spiritual wifery" (or polygamy). She passed away here in 1879, long after the Mormons had resettled in Salt Lake City.

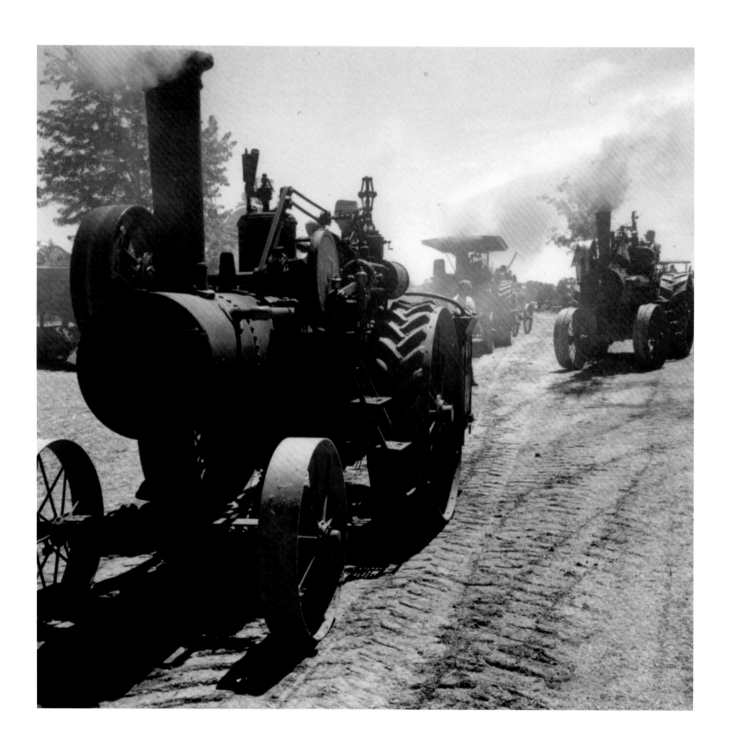

Figure 42: The Iowa Steam Engines and Threshers Annual Fair, but the author is unsure of the location.

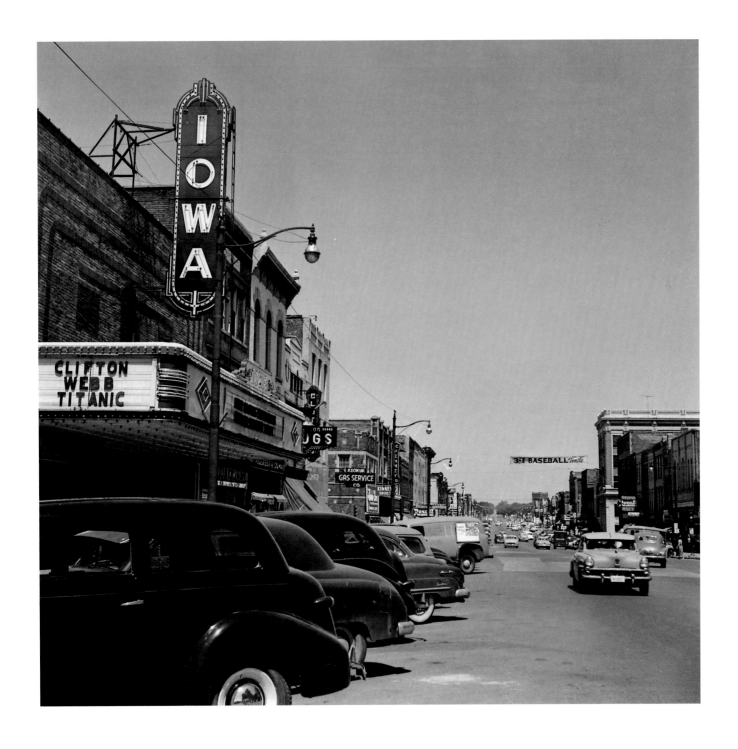

Figure 43: "BASEBALL Tonite" reads the banner hanging across Keokuk, Iowa's main street.

Lowered in the lock chamber, only the McElroy's *superstructure, all glossy white and tiered like a wedding cake, could be seen above the lock walls.*

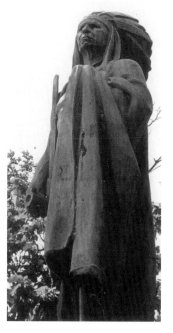

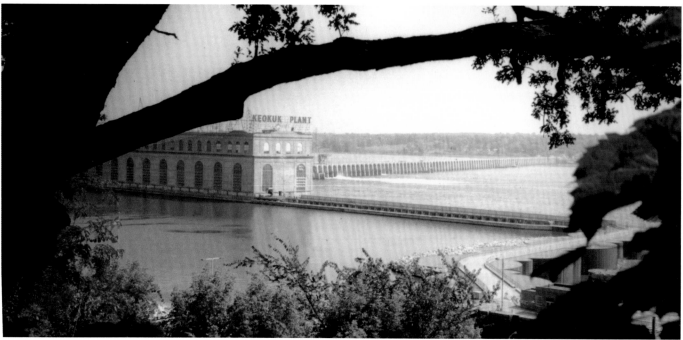

Figure 44: Chief Keokuk ("One who moves about alert"), born near Rock Island, Illinois, a contemporary of Black Hawk, was also a chief of the Sac Indian tribe. Unlike Black Hawk, with whom he struggled for dominance, Keokuk (1788[?]-1848[?]) pursued a policy of accommodating the U.S. government and European-American settlement in the region.

Figure 45: Keokuk Lock and Dam No. 19, besides allowing passage over what once was an often-impassable section of river, was built contiguous to the 1913 Mississippi River Power Co., which in its day was the largest single power plant in the nation. Reminiscent of Roman aqueducts, the arches of the Keokuk dam reach gracefully across the half-mile-wide river.

Bridges, as you pass beneath them, because of the traffic passing overhead, have variously affective sounds. Some have a musical, soprano sound. Others rumble, moan, hiss, whine Some have an apocalyptic sound. The apocalyptic ones are the bridges with wood planking.

An automobile slows on the macadamed state road paralleling the western shoreline—we are the reason. The driver of the car is poking along, taking us in. It will not surprise the crew if the driver speeds up, drives a mile or so ahead, pulls to the side of the road and waits for us to reappear. Mrs. Johnson says that out here on the river you see someone with an awakened dream like that just about every trip or so.

Figure 46: The village of Hamilton, Illinois, directly across the river from Keokuk, was settled in 1844. In 1968, a disaffected teenager destroyed Hamilton's wood-covered bridge.

"There was a crippled lady married to a retired Chicago police captain," says Captain Ware. "Lived up on the cliff at Alton. You'd be comin' along down past Alton mindin' your own business and all of a sudden a big light'd be shinin' down on you and somebody with a bullhorn be callin' 'Hey, there—Captain Ware, Captain Ware!' and you'd go out on the deck and this voice'd be tellin' you, 'The channel's over that wayyy!' Got so you'd look forward to comin' down past Alton, 'specially at night. Here'd be this little old lady up there with a bullhorn in one hand and wavin' a white hankie in the other tellin' you which way the channel was. Henrietta, her name was. Guess she musta died."

Figure 47: There wasn't much to Hamberg, Illinois, the author recalls, when he passed through, other than a sign indicating a population of 150 and these beached boats.

"When you're pushin' empties like we got out there you got to be real careful," says Captain Ware. "Specially these oil and gas barges. You rub a barge up against a bridge or another barge and the friction sparks it: Man, can't imagine what it's like. Rocking explosions—the whole center of the river goes up with the barges and just hangs there. Then there's the heat, you can't get anywhere near even if you had hoses. Flames hundreds of feet high—black boilin' smoke. Up there on the Ohio a tow hit one of the dams and stuck in the spillway. The river was on fire for five miles. Down there at Lake Charles a tow caught fire and the explosions blew all the windows in town out. Worst time I know about was above New Orleans. Tow up ahead of us run into a freighter, the Star of India, outbound for Australia. When we got there, the Star was aground. You ever heard a grown man pleadin'? 'I got passengers,' he kept cryin' on the radio, 'I don't know where they are—' A helicopter came over and lowered a lift and got some of 'em, but a lot died, blown overboard or they jumped and drowned or got burned bad from the flames on the water. It was noon 'fore they had it under control. I saw a deckhand out on the tow. He was on fire. I saw him through the binoculars. He kept runnin' one way then another 'til he melted in a lump. I've seen it. It ain't make believe, you know."

Figure 48: Quincy, Illinois.

49

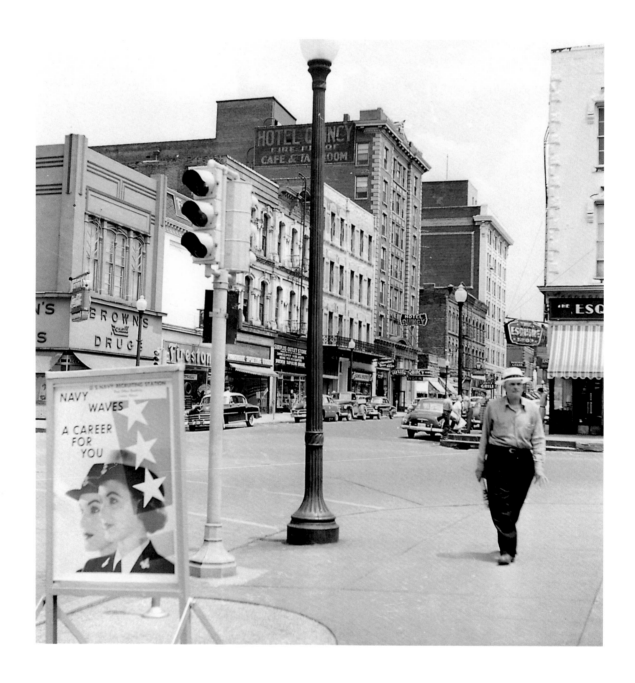

Figure 49: Downtown Quincy, Illinois, named in 1822 for President John Quincy Adams, has buildings dating back through every decade to the 1850s, when Quincy established itself as a railhead.

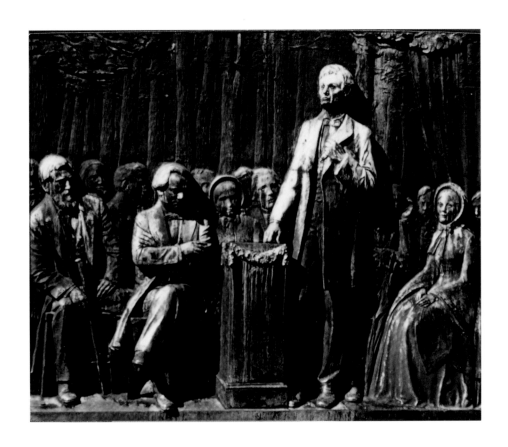

Figure 50: This 1936 Lorado Taft bas-relief sculpture commemorates the sixth of the seven Lincoln-Douglas debates that took place in 1858, with some 15,000 people attending, in Quincy's original public square, Washington Park.

Figure 51: On the bluff overlooking Hannibal, Missouri, and its train yard.

Figure 52: Tourists from across the U.S. and the world come to inspect Hannibal's brick levee, where packet steamers once arrived daily from St. Louis and Keokuk, dropping off passengers and taking on others, along with freight and cords of wood to fire their boilers.

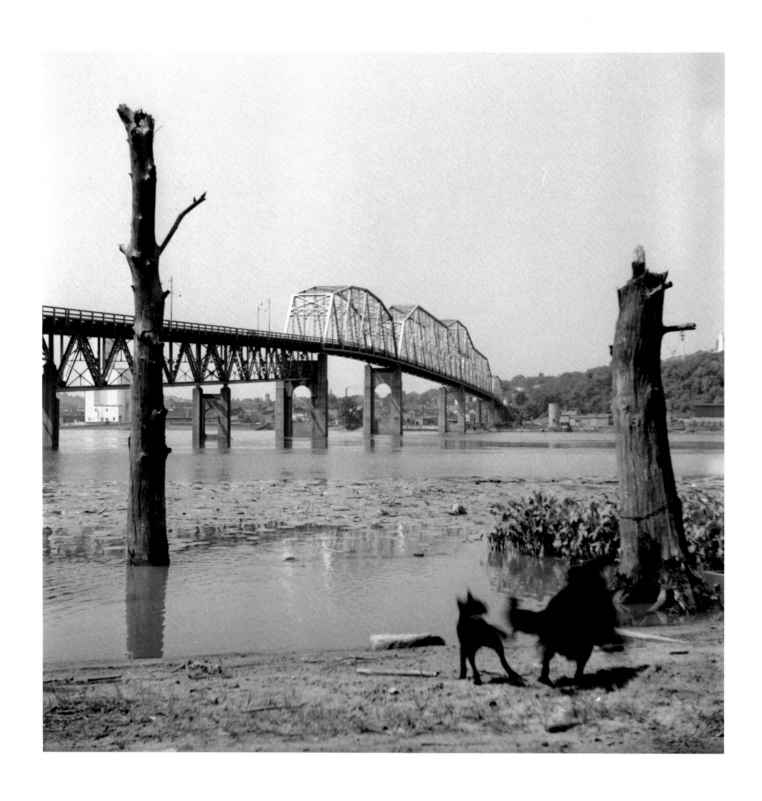

Figure 53: Spanning the river at Hannibal, Missouri, is the Mark Twain Memorial Bridge.
Named in honor of Hannibal's famous author, the bridge, dedicated by President Franklin Roosevelt
in 1936, replaced an 1871 Wabash Railroad bridge that had also served vehicles and pedestrians.

*The first time I saw the statue of Tom and Huck was in my fourth-grade geography book—
the expressions on the faces of the two barefooted boys, their fishing poles in hand,
were little different from those of Monk Hazlett and me. Monk and I were exactly
the same, I'd thought then, even though Tom and Huck were famous and lived a century earlier
and Leader's Creek was in Indiana and scarcely thirty feet wide, the least of the tributaries to
the Great River. We were the same though—Tom and Huck, Monk and me. I knew we were.*

Figure 54: Standing at the base of Cardiff Hill, the famous statue of Tom Sawyer
and Huckleberry Finn was sculpted by Frederick Hibbard in 1915.

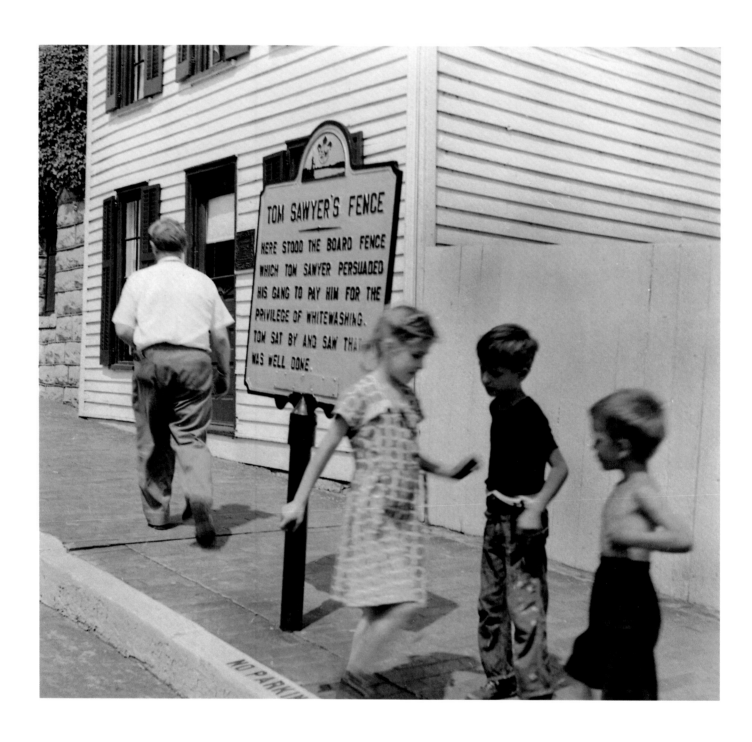

Figure 55: Twain's boyhood home and the board fence that Tom Sawyer
persuaded his gang to pay him for the privilege of whitewashing.

We move on, beyond Hannibal, past Shucks Island and Glasscox Island and Kings Island—
the latter being where, literary sleuths believe, Huck and the runaway slave Jim hide
while the Hannibal townsfolk searched for Huck's body, thinking he had drowned.
It was also where Jim let Huck know what a terrible thing Huck had done by lying to him
and causing him to grieve terribly when he'd thought his rebellious young friend was dead.
Half a mile long and uninhabited, the island, unlike most of the northern river overwhelmed
by the forces of civilization, I don't think can have changed much since Huck's and Jim's day. The wild
trees and underbrush and the wide, silent river flow past and the infinitiveness of things.

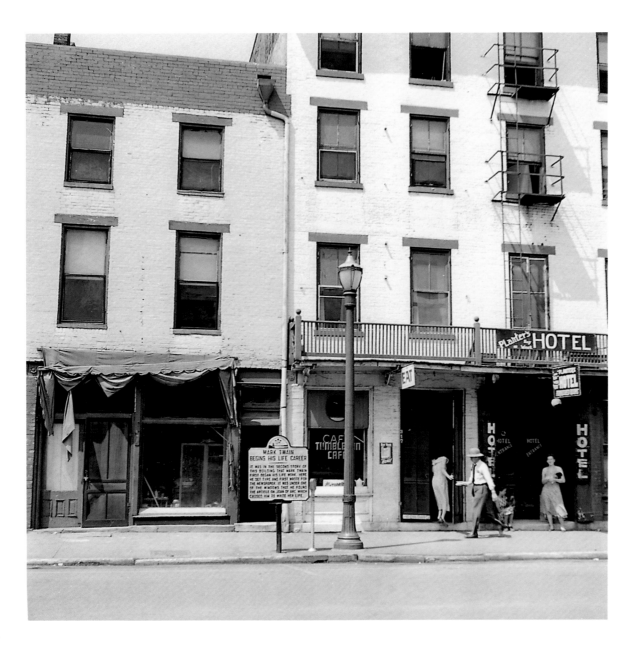

Figure 56: Hannibal's Planter's Hotel is where Mark Twain began his writing career. Tourists wishing to visit
this site today will be disappointed: The hotel and adjoining Tumbledown Cafe have been demolished.

The Eastern Star is still visible but there is a streak of sapphire in the east now. The pewter-gray horizon begins to glow, and in the first light of dawn the Mississippi River transforms itself from darkness to light, radiating, visibly taking its geographical shape again. "Bliss was it in that dawn to be alive," said the poet.

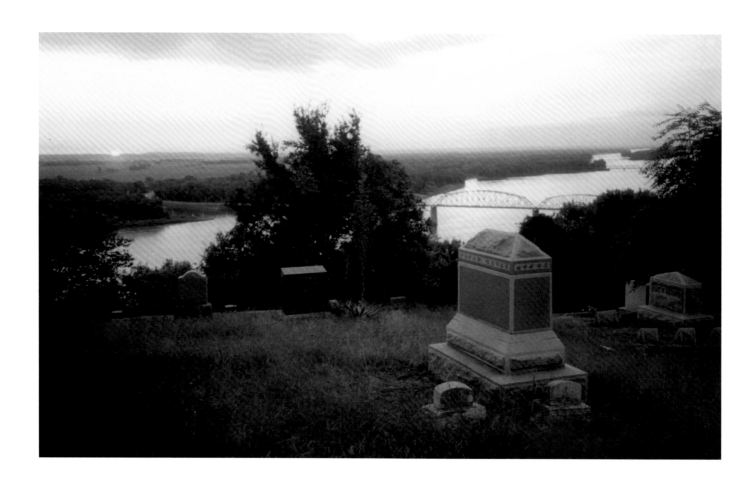

Figure 57: The road between Hannibal and Louisiana, Missouri, the author says, winds up and down and around through an area that early French explorers called *la terre des collines dorees* ("land of the golden hills"). It's fun to drive, but if it's a view of the Mississippi you're interested in, the only time you get to see it is at two or three turnouts that the Missouri highway department created. They are really some terrific views though.

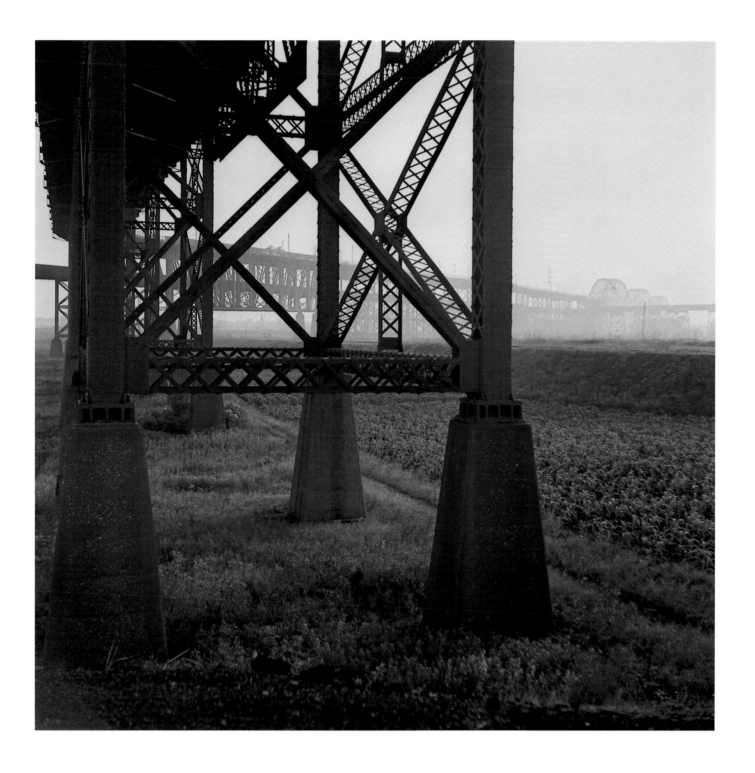

Figure 58: The McKinley Highway and Railroad Bridge at St. Louis, Missouri.

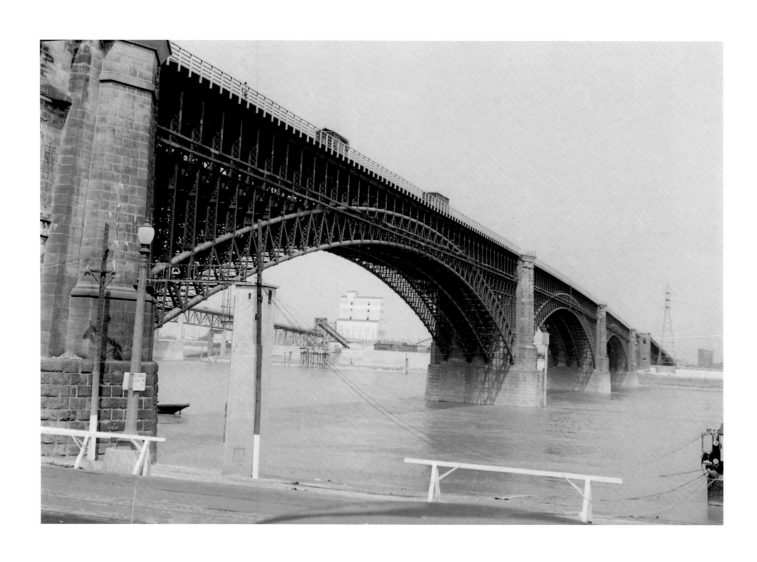

Figure 59: When completed in 1874, the Eads Bridge, still used today, was the largest span of its time.
"A structure of perfection and beauty unsurpassable," Walt Whitman wrote of it.

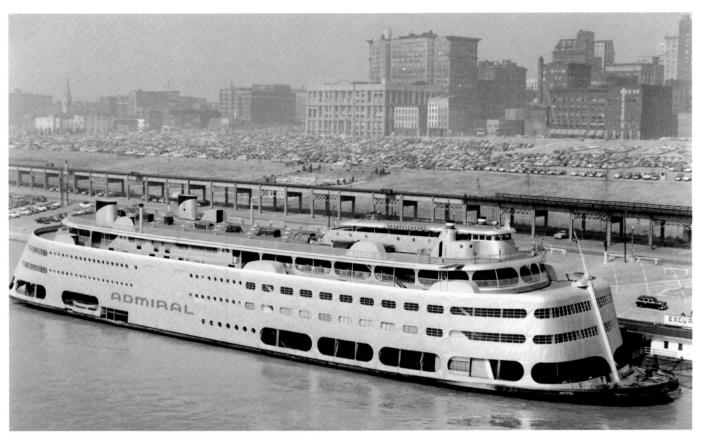

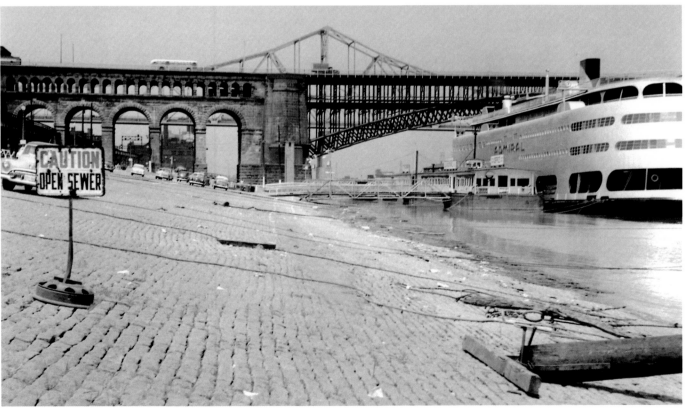

Figure 60: The tourist excursion boat *Admiral*.
Figure 61: The *Admiral* and the Eads Bridge.

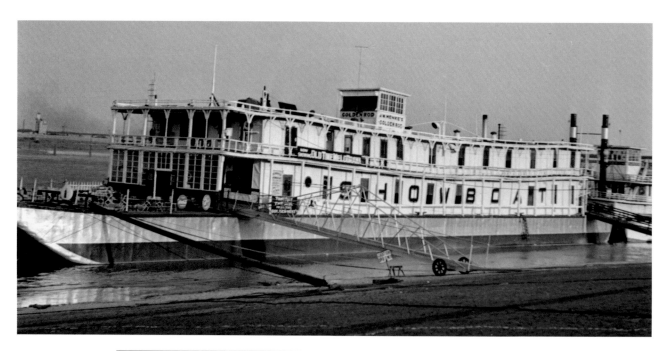

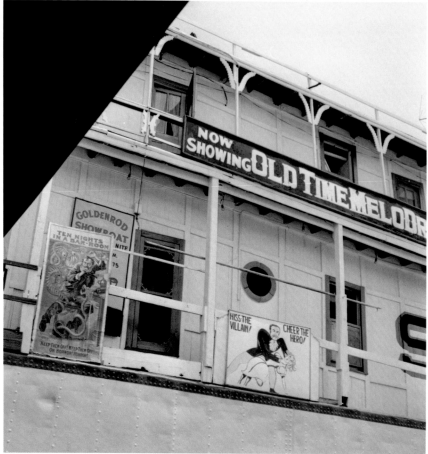

Figures 62 and 63: Old Time Melodrama on the showboat *Goldenrod*, featuring
Ten Nights in a Bar-Room. (Hiss the villain! Cheer the hero!)

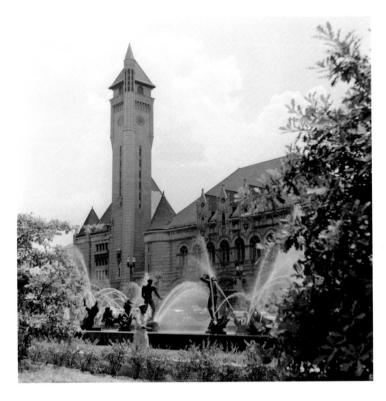

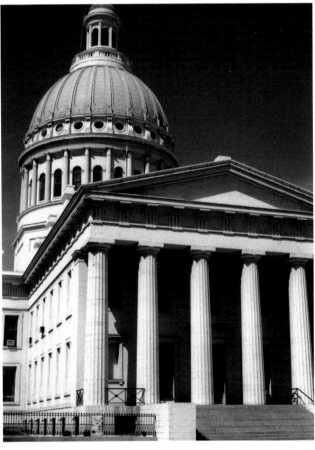

Figure 64: Against the soaring campanile of St. Louis's Union Station, Carl Milles's mythical Tritons and naiads celebrate the confluence of the Mississippi and Missouri rivers in his sculptural fountain, *Meeting of the Waters.*

Figure 65: St. Louis's Old Courthouse, with its cast iron neo-Renaissance dome, was still under construction when the 1847 and 1850 trials of Dred Scott were held.

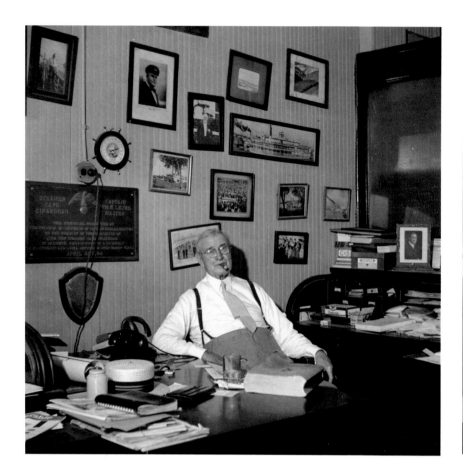

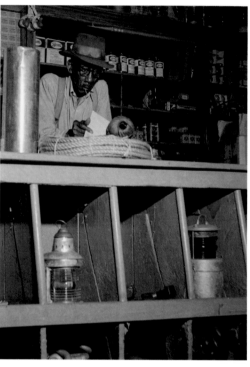

Figure 66 (left): In St. Louis, the author met Captain William Leyhe, who was master of the steamer *Cape Girardeau* for thirty years before retiring and opening his St. Louis Laclede Landing marine supply office.

Figure 67: A clerk in Captain Leyhe's marine supply office awaits rivermen's needs.

Through patches of dusty thistle and wild sunflowers I walked through the St. Louis Gateway Barge Company yard past stacks of steel plate and hoists elevated high in the air where half a dozen barges were under construction. Standing beneath the mammoth barges, I felt as though I were about to be smashed to the ground.

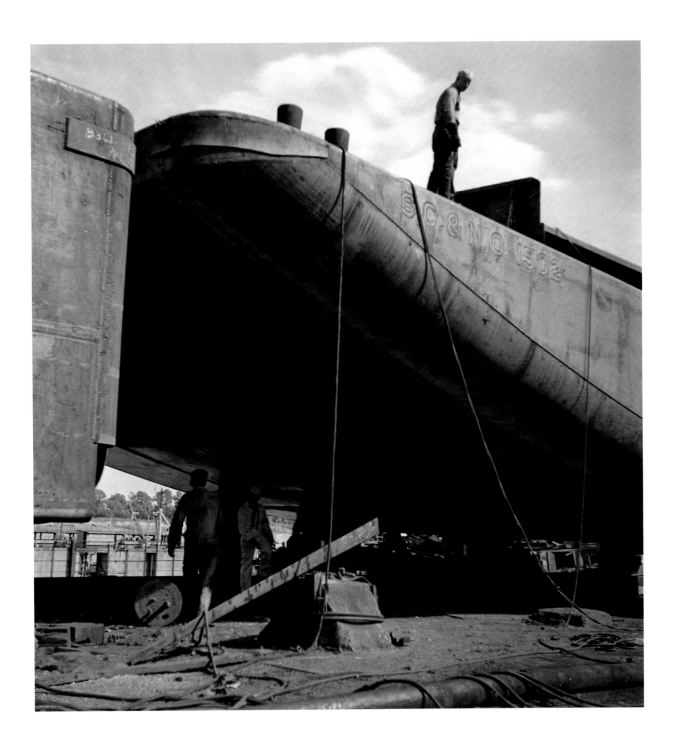

Figure 68: The St. Louis Gateway Barge Company yard.

I sit at the bow of the tow watching the crimson rays of the sun finger majestically up from the western horizon; continue watching as the sun drops below the horizon and the vibrant reflections on the river devolve into mother-of-pearl, to cinder, to slate in the west, gray to crystal, to silver in the east, the reflections on the water imperceptibly washing away into dusk.

On any great river, ten feet from shore you're in another world. That's in the daytime. At night you're in another galaxy. Within minutes the black Mississippi-Missouri River waters envelope the McElroy *and the tow. The lights of St. Louis fall behind and there's a sense of moving into another dimension, that all of us on the* McElroy *are in control of our destiny but not entirely; that everyone knows what's ahead but not entirely.*

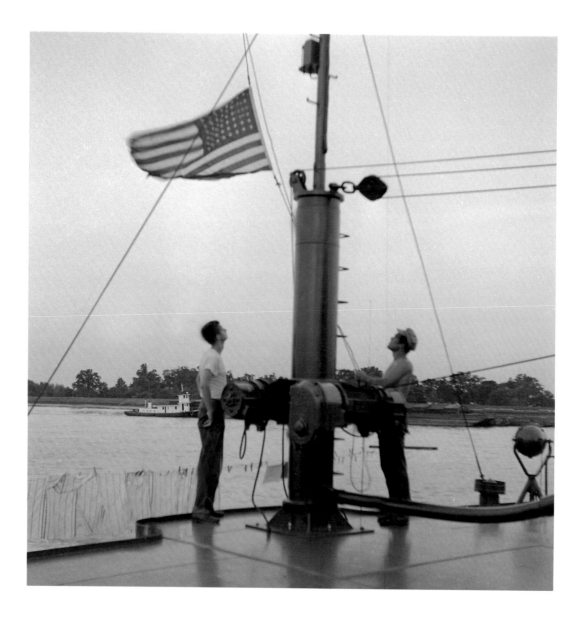

Figure 69: Sunset and lowering the Stars and Stripes on board the *R. H. McElroy.*

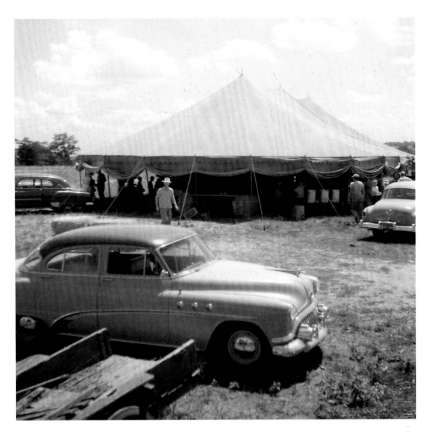

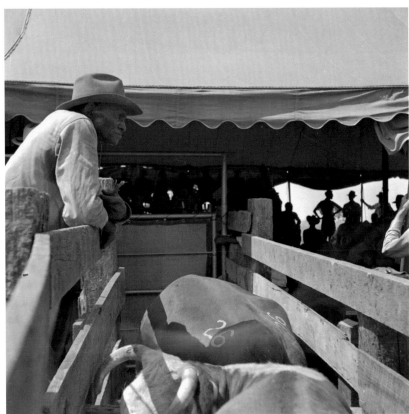

Figures 70 and 71: A Missouri tent cattle auction.

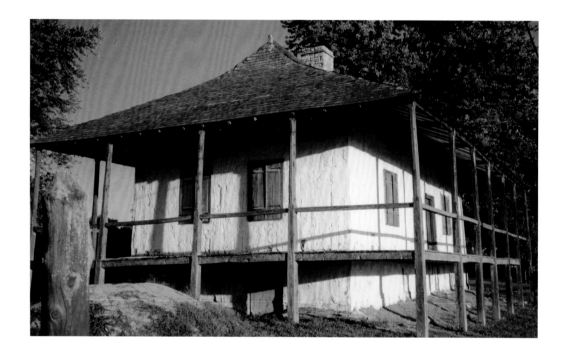

Figure 72: Ste. Genevieve was the first permanent European site settled—by the French circa 1735—in what is now the state of Missouri. Of the twenty-four buildings in the area that date from between 1785–1824, the Bequette-Ribault House (circa 1789) is a superb example of French vernacular architecture.

There is no moonlight. The shorelines merge with the sky as we move on downriver, past shapeless black islands and miles-long stretches where neither houses nor roads nor other signs of human habitation can be seen.

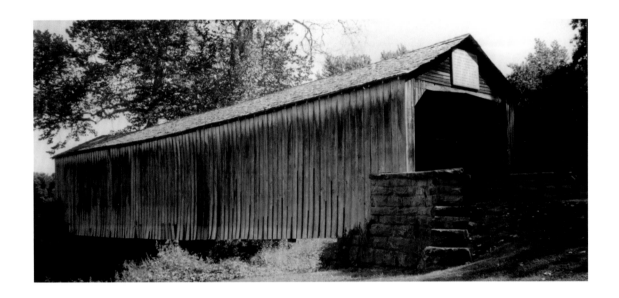

Figure 73: Mary's River Covered Bridge, in Chester, Illinois, was built in 1854 as part of a planked toll road enterprise.

When there's no moon, when the arc-lights are off and the night wholly envelops the river and your sense of movement derives not from the remote thrum of the McElroy's diesels but from a solitary, distant shorelight, there is a kind of taking it on faith, not empirical evidence, that the great tow of barges thrust out before us is even out there.

Figure 74: In the winter of 1838–1839, 13,000 Cherokee Indians, expelled at gunpoint from their Georgia homelands, made camp at Ware, Illinois. Thousands died here from starvation, exposure, and disease.

Figure 75: Welcoming family members of the towboat *McElroy*'s crew look out expectantly from the levee at Cape Girardeau, Missouri.

Figure 76: Husband and wife crewmembers of the *R. H. McElroy* take their shore leave at Cape Girardeau.
Towboat crews worked thirty-day stretches, six hours on and six hours off, earning a day off for every day served.
It's nice to come back home in a pretty red dress and stay for a while.

The 179-mile stretch of river from St. Louis to Cairo is called the Middle River. It used to be called "the Graveyard." On average, there was a steamboat wreck here every mile.

Figure 77: The Thebes, Illinois, Courthouse—completed in 1848; built of local sandstone, hewn timbers, hand-sawed boards, and plaster; and featuring a spilt shingle roof—sits on a bluff overlooking the Mississippi River. Fugitive slave Dred Scott was imprisoned here in the couthouse's dungeon while awaiting trial in St. Louis.

Captain Ware put down the binoculars and pulled the whistle rope. A single answering whistle sounded from the downriver tow.

"Looks like the Jack Good*," says Captain Ware. "I wanna talk to ole Preacher Captain."*

Captain Ware picks up the short-wave microphone. "WJ 9464 Pure Oil R. H. McElroy to upcoming tow at Mile 43. Over."

From the console speaker, a voice answers, "WJ 8263 Jack Good. Go ahead, Cap."

"This Preacher?" asks Captain Ware.

"Gotcha OK," the voice answers. "Naw, this' Tom. This big ole Rip Ware?"

"When you 'spect to get up to Minneapolis with that load, Tom?" asks Captain Ware.

"Awh, that's too far away to even think about," answers Tom. "We got eight barges of coal goin' along here four miles an hour. Don't make no difference whether we got five barges or twelve or none, jus' got one speed—jus' lookin' for sundown and payday."

"Gotcha OK," says Captain Ware. "You still as old lookin' as you always was?"

"'Fraid so," answers Tom. "That's what I hear."

"You know where the sand point is down there at Mile 841 below Dorena where the cut-off is where she sucks down?"

"Gotcha OK," says Tom.

"Mose Mundel last month, I guess it was, lost his barges crossin' through there. He got 'em back, but several smashed pretty bad. Don't know how it happened. Maybe from slidin' around from the hot water down there. River was just a roarin' aroun' the bend down there at Vicksburg, they say."

"Gotcha OK," says Tom. "When I talked to Mose he said he was goin' along with his eight empties just a whistlin'. Said he was flankin' just so pretty when all of a sudden his head quit and she busted up. Scared hell out of the fish, I guess."

"Gotcha OK," says Captain Ware. "Your Preacher Captain still chewin' that tobacca of his?"

"Yeah, Cap's downstairs asleep now. Prob'ly due up any time though. He's got that number ten can of his here. Right under the rudder arms. I'm always kickin' it. Sometimes I step in it."

"He's still spittin', is he?"

"Who's this? Big ole Rip Ware?" Another voice now.

"Watcha say there, Preacher Captain?"

"Just woke up. Dinner always puts me asleep. Thought I'd come up and see what's goin' on and here you are comin'."

"Yeah, rowin' along lookin' for Eden. Tom says you ain't lost a day's pay in thirty-five years to his knowledge."

"Yeah, but if I was as ugly as you, Rip, I'd retire."

"Can't retire. Me and you've been out here too long to retire."

"Gotcha OK. Always said a pilot's no better off than a convict. Neither one
of you can quit. You still wear them cowboy boots?"

"You still spit tobacca, don'cha?"

The McElroy *and the* Jack Good *were coming abreast.*

Captain Ware pulls the whistle rope, one long blast and three short blasts.

From Jack Good *comes an even longer blast, followed by four staccato blasts.*

Captain Ware steps out the portside doorway, bows deeply to Preacher Captain, arms spread wide.

Across the way, Preacher Captain also bows deeply, his arms spread equally wide.

Returning to the controls console, Captain Ware picks up the radio-microphone.

"Listen, Preacher Captain, it's been good to talk to you. I'm gonna let
you go now 'fore you and Tom hurt my feelin's."

"You already hurt our feelin's," replies Preacher Captain.

"Here we are standin' a watch and lost. We know you know this river."

"Gotcha OK," says Captain Ware. "WJ9646 Pure Oil R. H. McElroy clear to Jack Good. *Out."*

"See you down the line somewhere, Cap," Preacher Captain answers.

"WJ8263 Jack Good *to* McElroy. *Clear."*

With my honeymoon raft movie in mind, I ask Captain Ware if he sees many rafts on the river.
"Mainly houseboats and cabin cruisers comin' up or down from Florida or the Gulf Coast," he
answers. "We met a 72-year-old jew'ler from Los Angeles last year who rowed down the river in
a rowboat. There was a Polish fella' from Chicago—kep' talkin' about a three-footed Lobo wolf
that almost ate him— up in Minnesota 'fore he even got started. Said the wolf ate a hunter
the week before who was all eaten up except for his feet. They were still in his boots. Back in 1907
a man walked down the river. Won a $5,000 bet he could walk the river from Cincinnati to
New Orleans in forty days. He wore big pontoon shoes. True. I've seen pictures. This spring we saw
two high school boys raftin'. I talked to them when we were goin' through a lock. Said they were
runnin' away to South America. Said they were gonna' dig for emeralds in Columbia. None of 'em
listen how dangerous this river is—" Captain Ware looked at me. "Goin' down the Mississippi's
somethin' people wanta' do. And they're gonna' do it. That's just the way it is in this country."

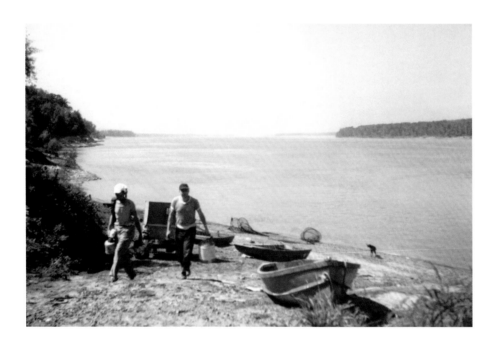

Figure 78: Below St. Louis, on the "Middle River," the stretch from St. Louis to Cairo, everything changes: There are
no more locks and dams. There's also a dream-like geometry to things. The shorelines are more distant. The air itself is
different. Below St. Louis you become aware that you are no longer in the North. On the northern river what you see
is what you get. On the southern river there are intimations of something beyond what the eye sees.

Below St. Louis, the geography changes; below Cairo, it changes utterly. It's a transcendent, timeless realm. There is an elemental awe about it. Everything human disappears in the riverscape. Emotions are affected, discomfited, made ambiguous. The horizon is empty, limitless. You are an irrelevant nothing in a watery wilderness. Through crazed boils and whirlpools the McElroy *and the tow move upon the brown mass of water.*

Figure 79: From Cairo, Illinois, to the Gulf of Mexico, there are no rock landforms to enclose the Mississippi. Created by millennia of nutrient-rich waters washing down from the north, the floodplains of the Lower Mississippi are as rich as the fabled Nile delta of Egypt.

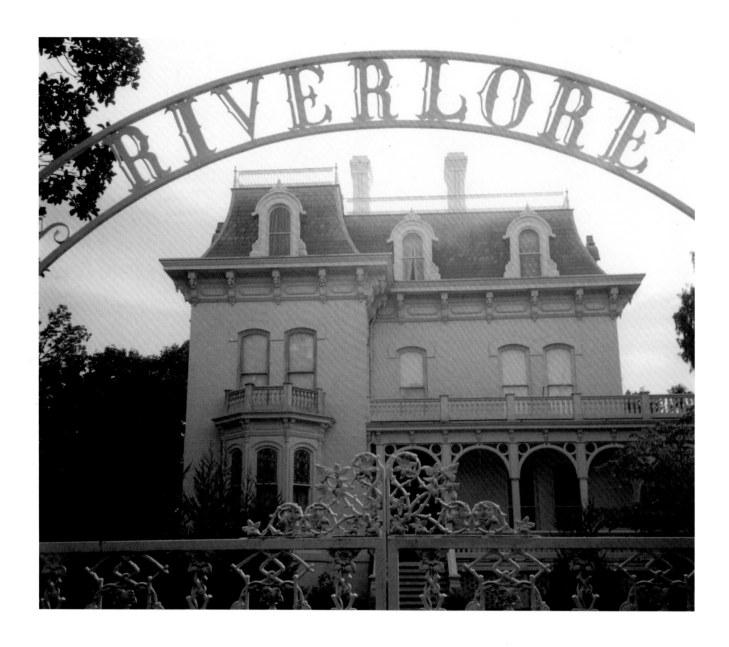

Figure 80: During its heyday, Cairo's commercial success created many wealthy men, including banker William Hollday, a former steamboat captain who constructed in 1865 a three-story mansion, *Riverlore*, on top of which he built a captain's walk so that he could survey the confluence of the two great rivers he once piloted, the Ohio and the Mississippi.

Figure 81: The Mississippi River Bridge at Cairo, Illinois. (2002 photo)

From the Washington Street Bridge in Minneapolis to the Mississippi's confluence with the Ohio River at Cairo, Illinois, the mileage is 852.7. The Corps designates Cairo as Mile 0 on its Upper Mississippi River chart, with each mile marker increasing numerically as one travels northward. On the Corps's Lower Mississippi River chart, Cairo is designated as "HP 953.8—Its distance in mileage Above Head of Passes, at the river's mouth 100 miles below New Orleans."

Figure 82: At Cairo two arching bridges, each a mile-and-a-half long, span the Mississippi and Ohio rivers. One bridge connects with Missouri to the west, and the other with Kentucky to the south. Lying between them is the ever-narrowing tip of Illinois, now a park ground.

Downriver a tow is moving upriver around the river's bend. Pulled up in the binoculars, it appears to be a large coal tow. Captain Ware reaches above his head and tugs the whistle rope. From the roof of the pilothouse a plaintive moan is heard, becoming louder and higher pitched the longer the captain holds the rope—a mournful, shivering cry reverberating out over the river.

Figure 83 : "Towboatin's a world unto itself, isn't it, Captain?"
"You got that'n right, Mr. Charles."

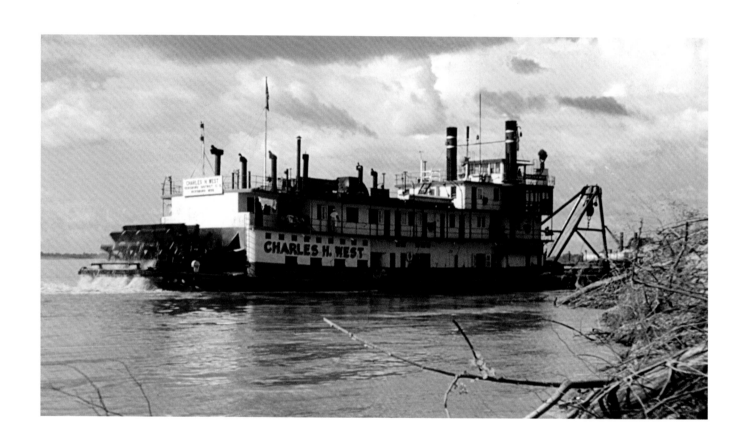

Figure 84: The U.S. Army Corps of Engineers' snagboat steamer the *Charles H. West*,
one of the last of the old stern-wheelers, was a pretty aged thing when the author saw it.

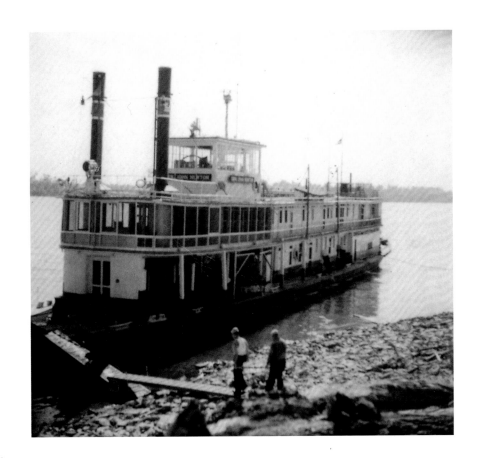

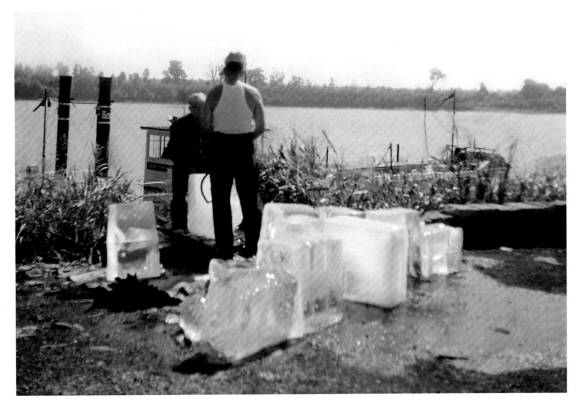

Figures 85 and 86: Crewmembers load provisions,
including blocks of ice, on the *Charles H. West*.

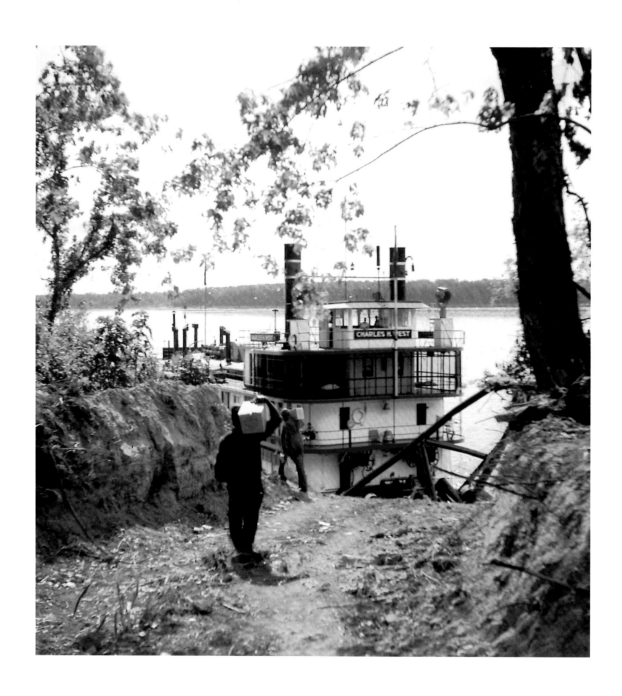

Figure 87: The *Charles H. West* riverside, picking up supplies and cargo, near Osceola, Arkansas.

"Well, it's a corporate river. The barge interests own it—and the polluters. That's just a fact."

—Captain Carole "Rip" Ware

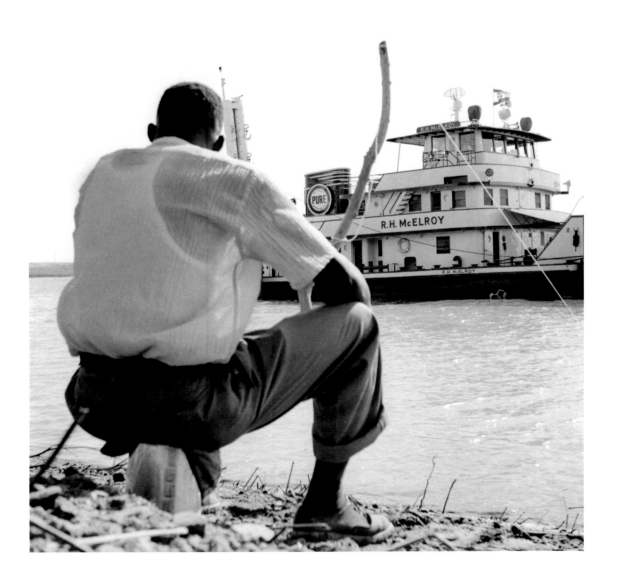

Figure 88: A fisherman watches as the Pure Oil towboat *R. H. McElroy* passes by.

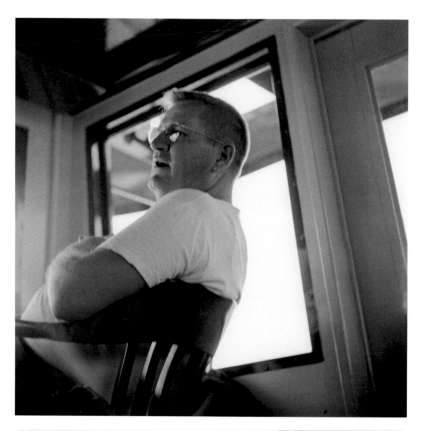

Figure 89: *R. H. McElroy* Captain Carole "Rip" Ware.
Figure 90: The Pilot's Chair.

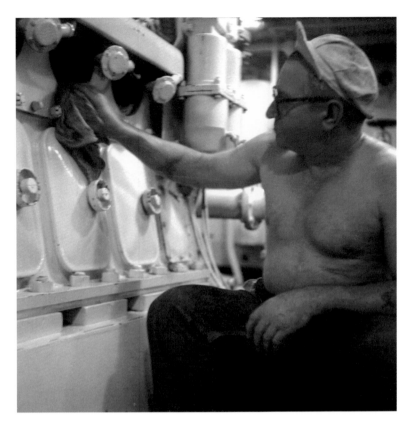

Figures 91 and 92 (above), 93 and 94 (following page): The crew of the *R. H. McElroy*.

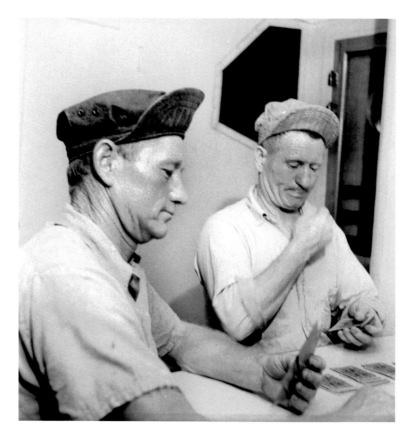

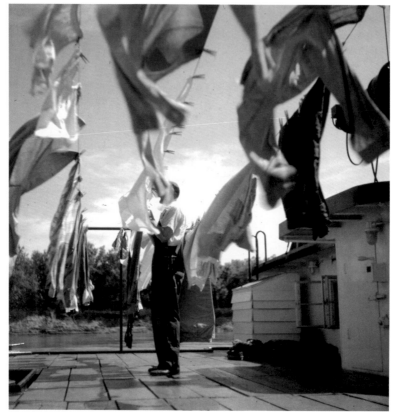

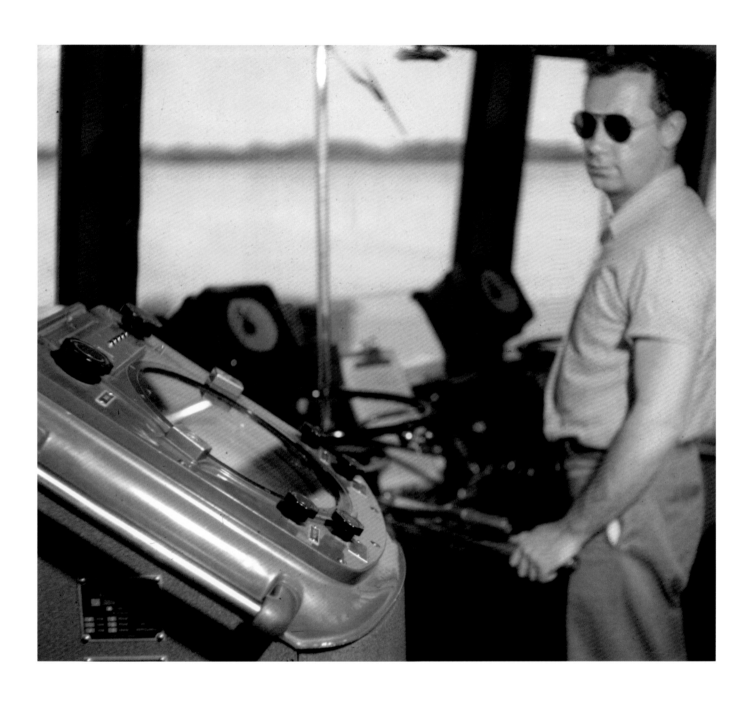

Figure 95: The *R. H. McElroy*'s Relief Captain John Hollings.

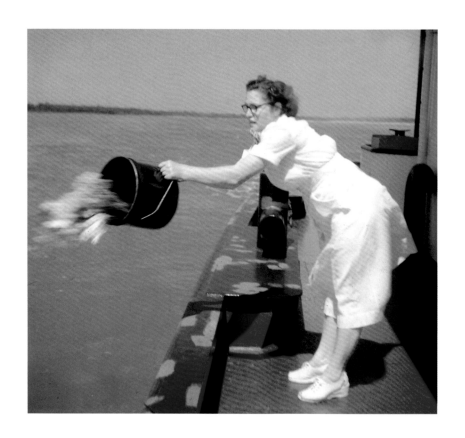

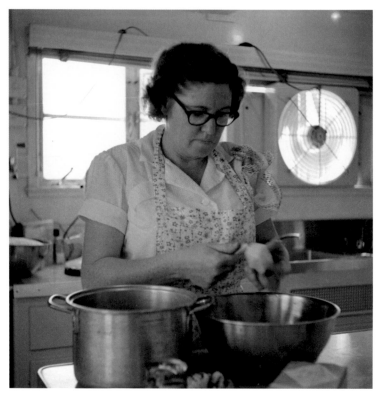

Figures 96 and 97: The *McElroy*'s cooks are sine qua non.

The strain of piloting through the night, the unremitting alertness at the McElroy's *controls, the gradual coming of the eastern light, and the physical world's quasi-mystical reappearance make breakfast (the very smell of it), crew members all agree, the most deeply satisfying of meals—orange juice, ham and eggs, red-eye gravy, pancakes, grits, maple syrup, bananas, butter-milk, coffee.*

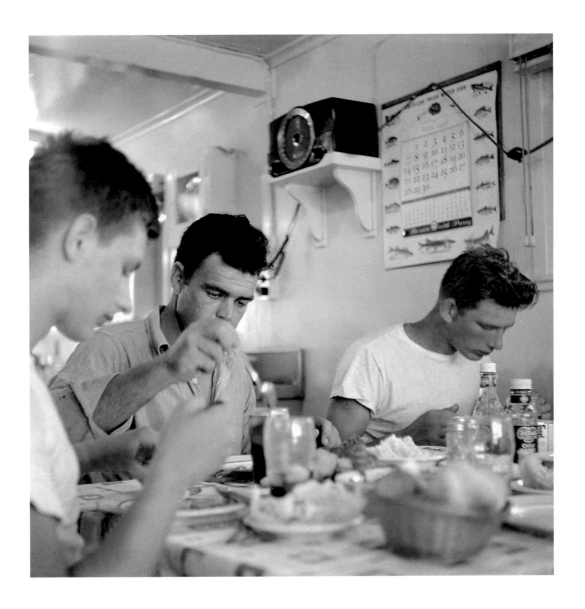

Figure 98: Country ham, barbequed pork, and hushpuppies; tomatoes, greens, and okra; white beans and corn bread; fried chicken, catfish, and dumplings; pecan pie, peach cobbler, and watermelon— "The orchestra," Captain Ware says, "is conducted in the kitchen."

"Pass the syrup."

"Sure, syrup for the old man."

"Look at Goddie there. He's a great feeder."

"I've always got a good appetite."

"You got a good appetite, too. You eat with both hands."

"Remember McCard, do you?"

"Sure I remember him. He'd spoil a wet dream."

"You knew he had twelve dogs at home? Saved all the bones from the galley to take home to his dogs. You couldn't go in his room the smell was so bad from all those bones under his bed."

"Master Charles," Captain Ware says to me in the pilothouse just before the midnight crew change, "I notice you've not quite got the hang of towboatin'—you're still learnin' how to eat on a towboat."

"Is that right?" I ask.

"You got to have a happy stomach when you go towboatin'," says the captain, stepping down from the pilot's chair as Relief Captain Hollings arrives. "Got to feed the inner hunger. Let the guts be full."

"Let the guts be full," I agree.

"The orchestra's conducted in the kitchen. On my table I don't want too much tablecloth showin'. The McElroy's grocery bill runs a thousand a month—more than any other in the Pure Oil fleet."

"Wow," I say, impressed.

"I keep gettin' notices from some vice-president bookkeeper, but I ignore him. You got to ignore that type of person. He's no idea what we do out here. Towboat crews're undeservedly held in poor esteem. He goes home to his plywood house in a new suburb with no trees and plastic shutters that're just for decoration, how would he know?"

"Of course not."

"Out here on the river workin' twelve hours a day 'n' bein' away from home weeks at a time, food's the main entertainment. Food and tellin' lies."

"Lies? Really?"

"Entertainment lies that make the day come alive. Not lies substitutin' for the truth like our Republican friends—hit the poor and reward the rich. Master John here's already got the sticks in hand so we can go down now and raid the Frigidaire. Git us somethin' good to eat. You ready, ain't you?"

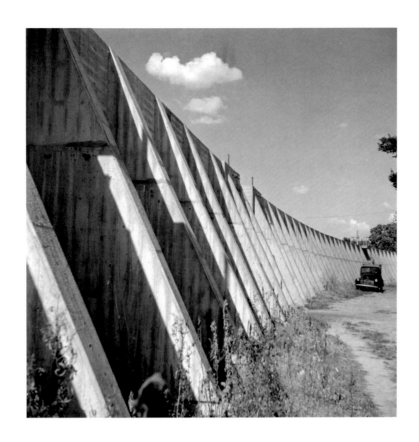

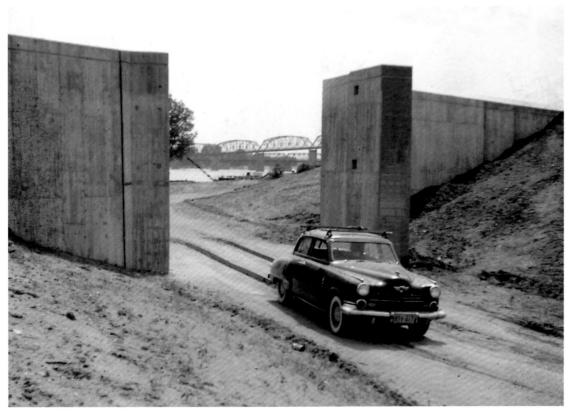

Figures 99 and 100: The floodwall outside Hickman, Kentucky, seat of
Fulton County, at the far western end of the state.

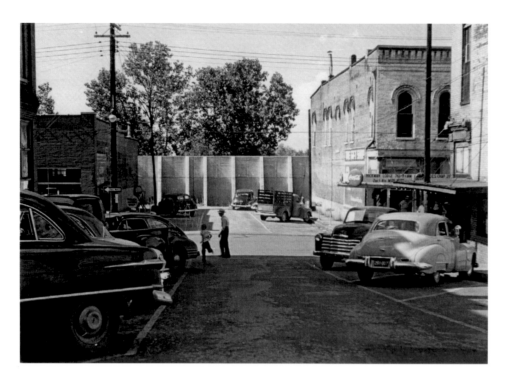

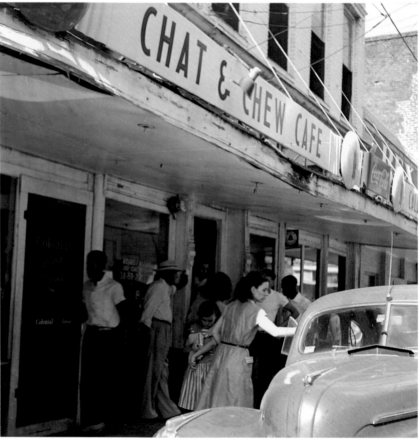

Figure 101 (top): Downtown Hickman, settled circa 1830, with its floodwall in the background. Figures 102 (bottom) and 103 (opposite): While other family members do the Saturday afternoon shopping, the important news of the day is discussed on a Hickman curbside or at the Chat and Chew Cafe.

"Preacher's wife's got a new baby."
"Her third?"
"Don't know. Wife says it's her fourth . . ."

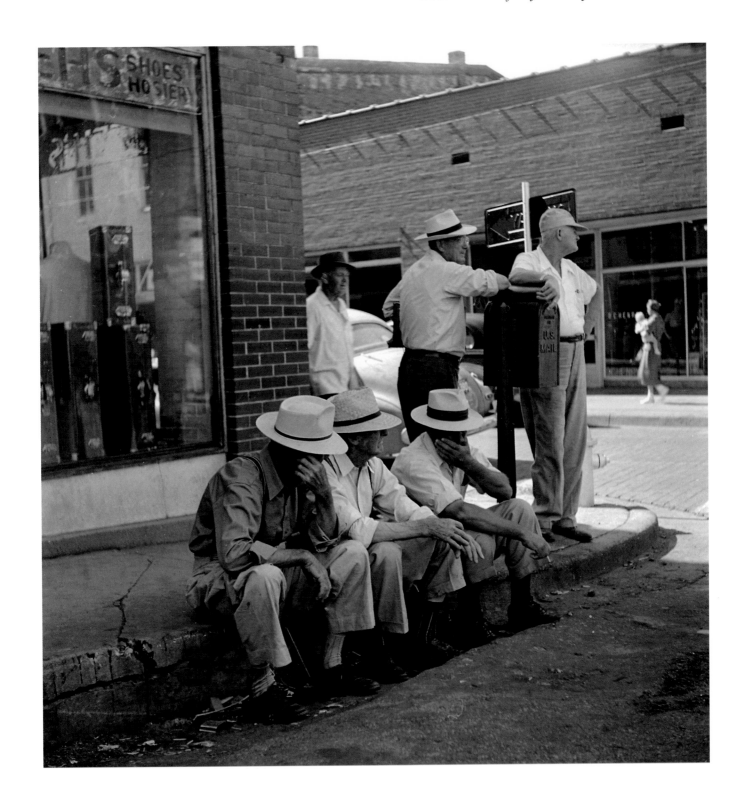

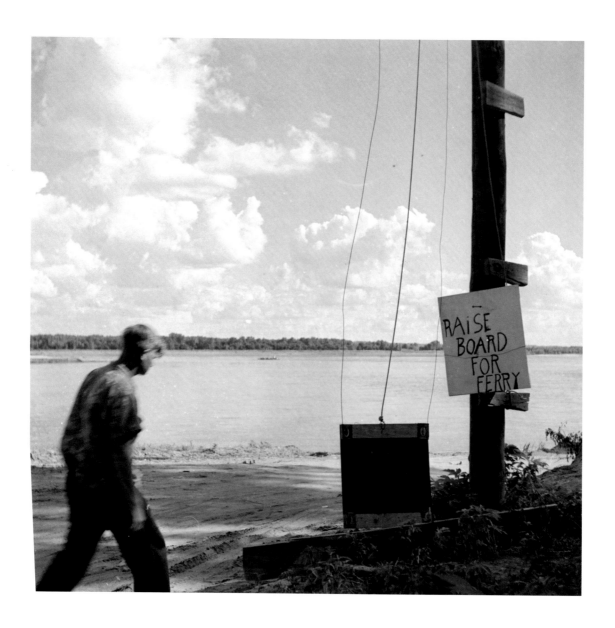

Figure 104: A ferry maintains a daily schedule between Hickman and Dorena, Missouri, across the Mississippi. In 1953 the boat was the *Lucy Lattus*. To signal you wish to cross the river, "RAISE BOARD FOR FERRY."

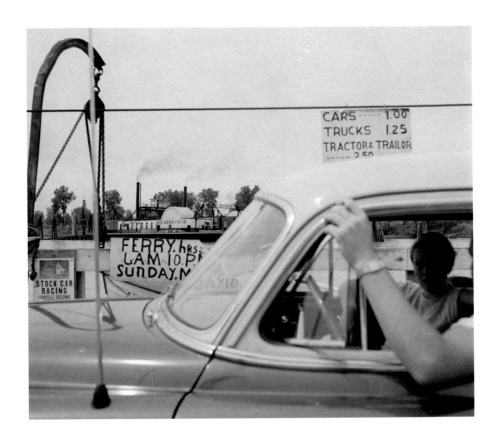

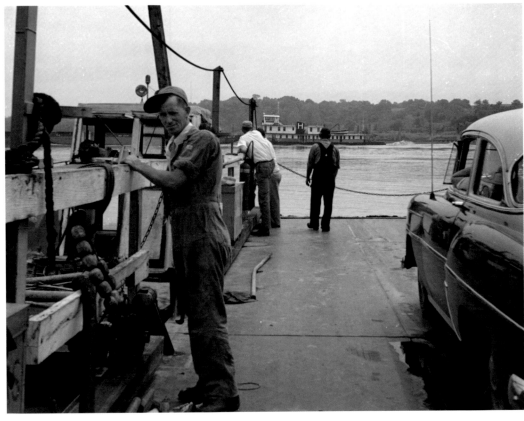

Figures 105 and 106: The toll ferry between Hickman and Dorena, Missouri, is one of the few remaining riverboat ferries still operating on the Mississippi River—or, for that matter, in the United States.

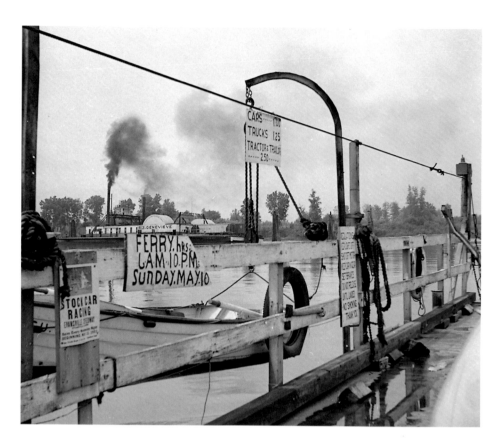

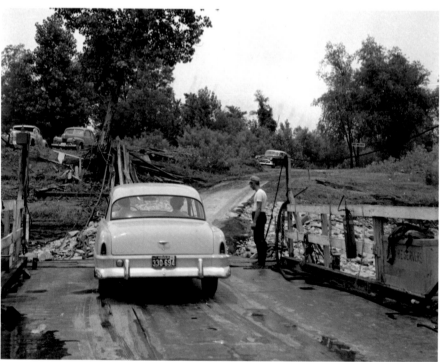

Figure 107: Crossing the Mississippi aboard the ferry *Lucy Lattus*.
Figure 108: Disembarking from the ferry.

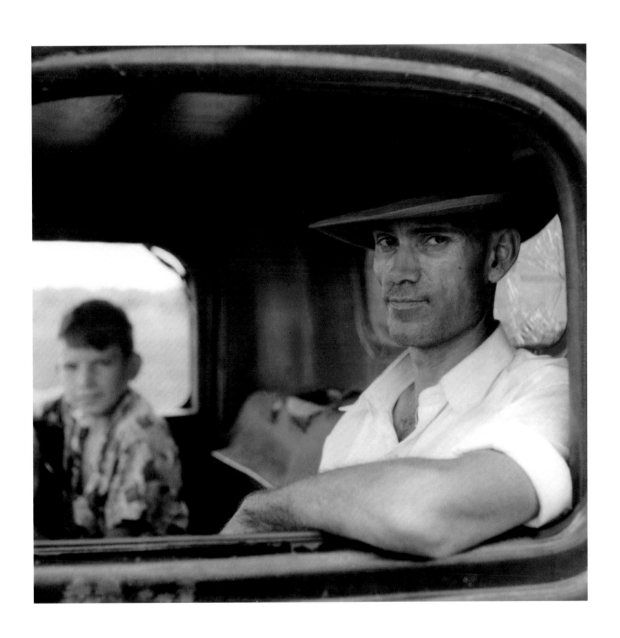

Figure 109: Passengers aboard the *Lucy Lattus*.

Far over on the starboard shore a white clapboard Methodist church, the principal structure of Dorena, Missouri, comes into view. I watch through the binoculars the Sunday afternoon parishioners having what appears to be a watermelon-lemonade social. The women are wearing cotton print dresses, the weather-scarred men freshly ironed shirts, the sleeves of their shirts turned up neatly to mid-forearm. Children are running around playing hide-and-go-seek.

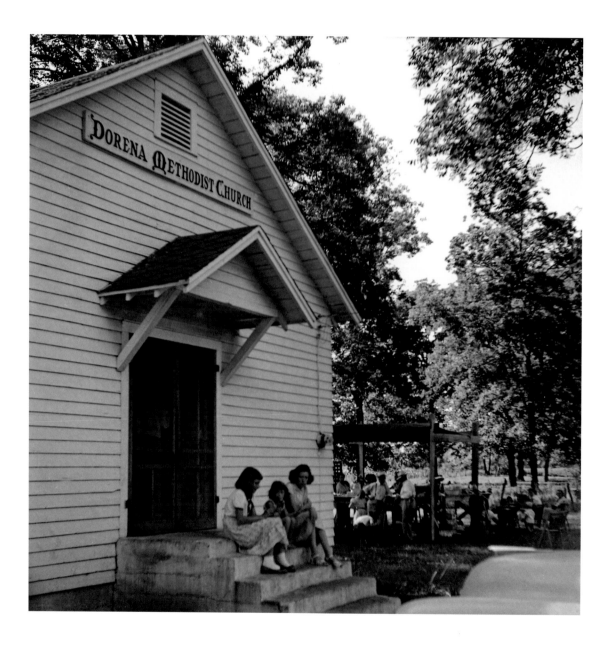

Figure 110: Folks gather for a Sunday afternoon watermelon social at the Dorena Methodist Church, where the author stopped during his auto trip—a lull he was unable to enjoy when he first saw the church while passing by on the *McElroy*.

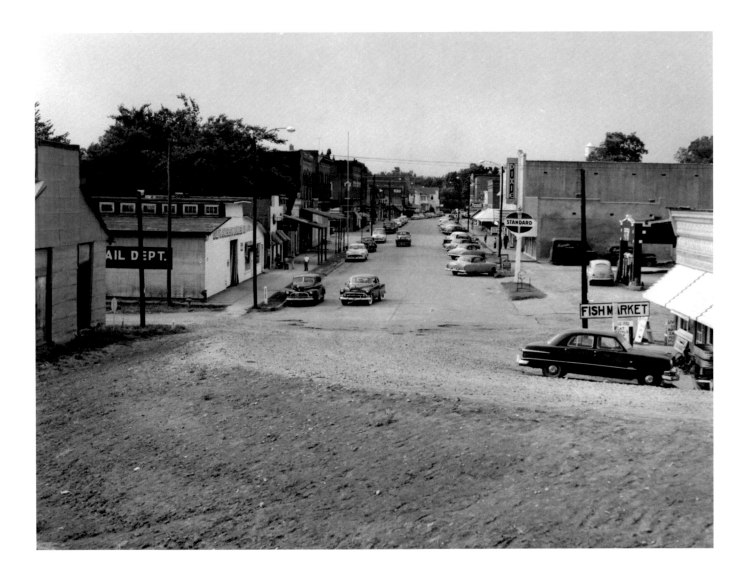

Figure 111: New Madrid, Missouri, at the top of Kentucky Bend's horseshoe curve (also called Bessie Bend), was one of the most important landings on the Lower River in the early nineteenth century.

On the eastern horizon banks of lemony-yellow clouds can now be seen. No longer a black void,

the river stretches away in every direction. Somewhere, I can hear a bob-white.

Something else, too—far off across the river: an intermittent dull, metallic sound.

I smile as a boyhood memory surfaces: It's the sound of hogs rooting grain out of a metal feeder.

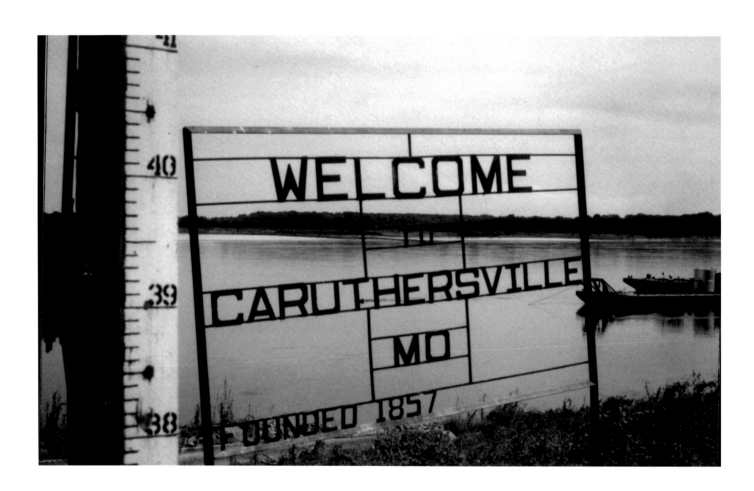

Figure 112: A flood gauge at Caruthersville, Missouri.

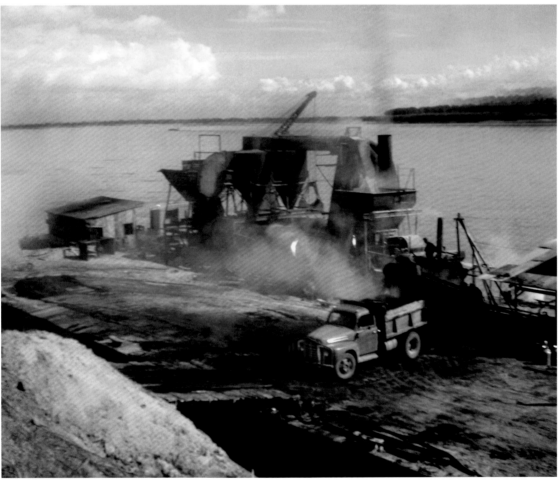

Figures 113 and 114: Industry along the Lower River.

Look on the Corps of Engineers river charts and you will see that the River Styx lies just beyond the levee at Mile 812. Fortunately, you will not find a ferry operating in the vicinity. Maybe a little pirating or a murder or two by some loner misfits that live off in the swamps, but there's no demon Charon, no smoke silhouetted against the night sky. Not usually.

Figure 115: Mile 812 on the Lower River.

Figure 116: Barfield Landing, Arkansas. Downstream, the side-wheeler *Sultan* blew up on April 16, 1865, killing 1,547 people, the worst tragedy in the river's history.

Captain Ware invites me to take the controls.

"Seriously?" I ask.

"Sure, seriously," he answers soberly. "How you gonna learn to towboat if you don't take the controls?"

I hitch up my pants and gingerly take my place between the rudder control arms, grasping them timidly, as though they might bite me; I stare at the bow of the tow, at the river and the river's horizon beyond. I feel suddenly small and overwhelmed.

I move the rudder control arms a little to the portside. Half an hour later (it seems) I can see the jackstaff move a degree or so to the starboard. I move the arms to the starboard.

Twenty minutes later (it seems) the tow edged to port.

It was a garden of possibilities. With the slightest movement of the rudder arms I could direct the tow this way or that. Amazing. Amazing that I could steer, control, such a mammoth enterprise. Frightening, too. Because from the time I moved the rudder arms to the time I could see the jackstaff at the bow of the tow (three football lengths away) begin to change course, a good thirty seconds had elapsed; and by that time, if I had not already made an opposite rudder movement to stop or limit the change or direction, we could end up crosswise in the river, couldn't we?! And if the current catches the tow broadside and if—Oh! Help, Captain Ware! Save me! Save us! (I'm humiliatedly aware that Captain Ware is talking to another pilot on the short-wave radio—"I got a young fella up here who says he's gonna make a movie of this ole river. I'm learnin' him how to be a pilot—right now he's jumpin' aroun' like a June bride in a feather bed.")

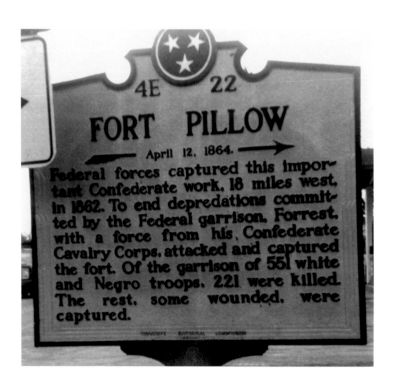

Figure 117: On the river bluffs fifty miles above Memphis are the remnants of Fort Pillow,
built by the Confederates at the beginning of the Civil War to protect the city.

And we made cotton king.

We rolled a million bales down the river for Liverpool and Leeds.

1860: we rolled four million bales down the river,

Rolled them off Alabama,

Rolled them off Mississippi,

Rolled them off Louisiana,

Rolled them down the river!

—Pare Lorentz, *The River* (1937)

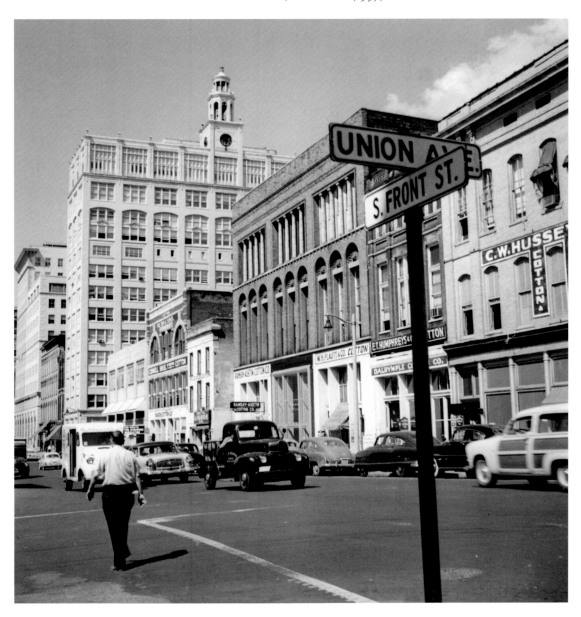

Figures 118: Front Street, Memphis, is the site of Cotton Row, a concentration
of cotton mercantile buildings that traces its origins back to the 1840s.

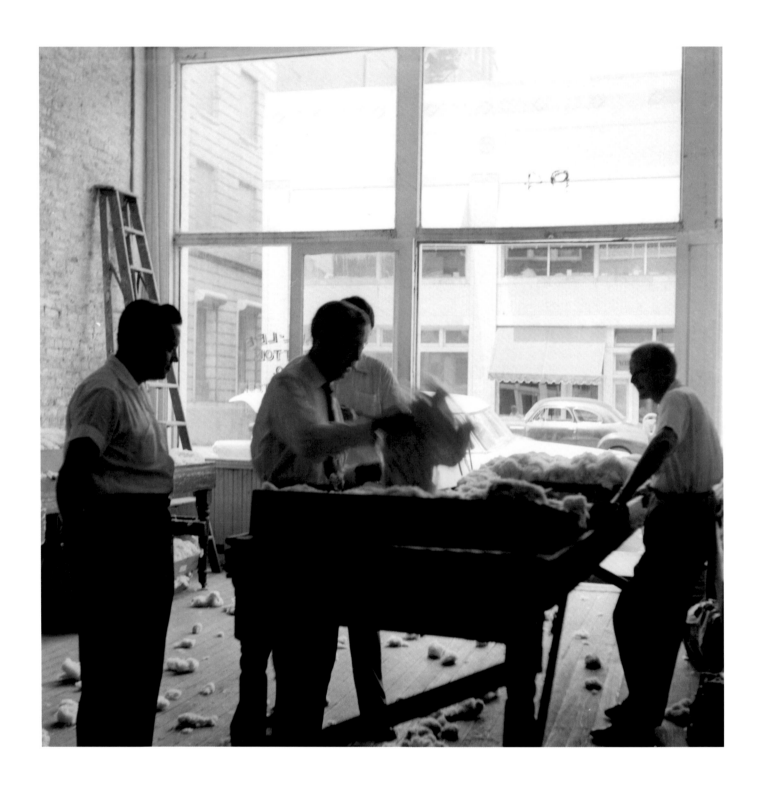

Figure 119: A trader inspects a new shipment of cotton.

Figure 120: Cotton Row, Memphis.

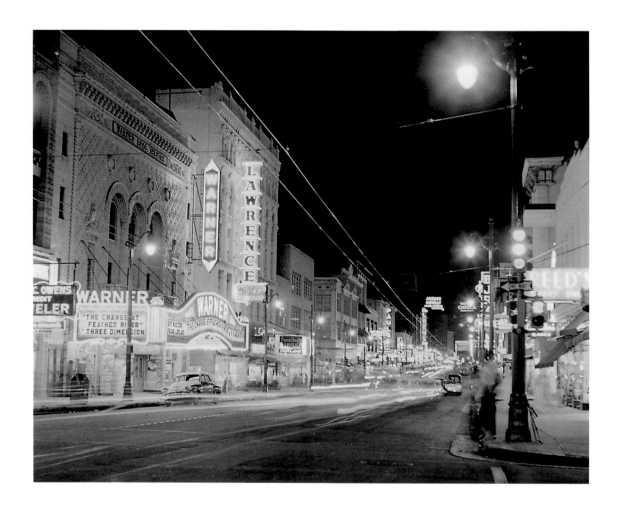

Figure 121: Downtown Memphis.

If Beale St. could talk, If Beale Street could talk
Married Men would have to take their beds and walk...

—W. C. Handy, "Beale Street Blues"

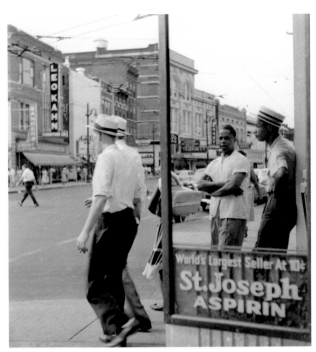

Figures 122 and 123: Beale Street emerged in the 1890s as a center of Memphis nightlife
(and vice) for African-Americans and the few (often elite) whites who ventured into it after dark.

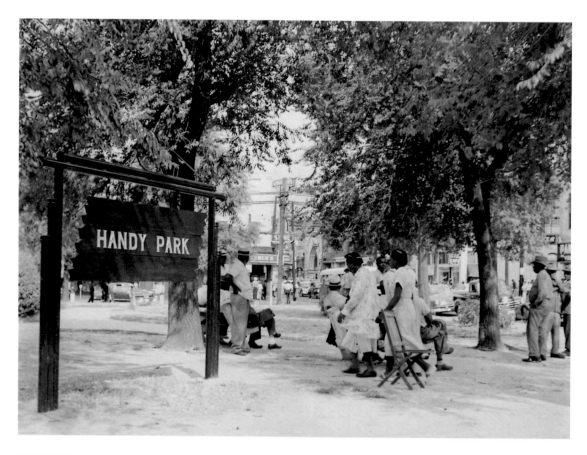

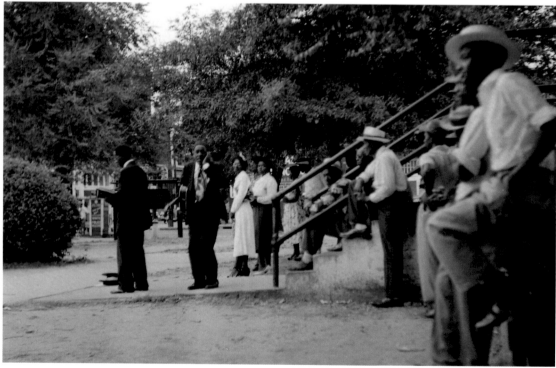

Figures 124, 125, and 126 (opposite): Handy Park, at the northwest corner of Beale and Hernando streets.

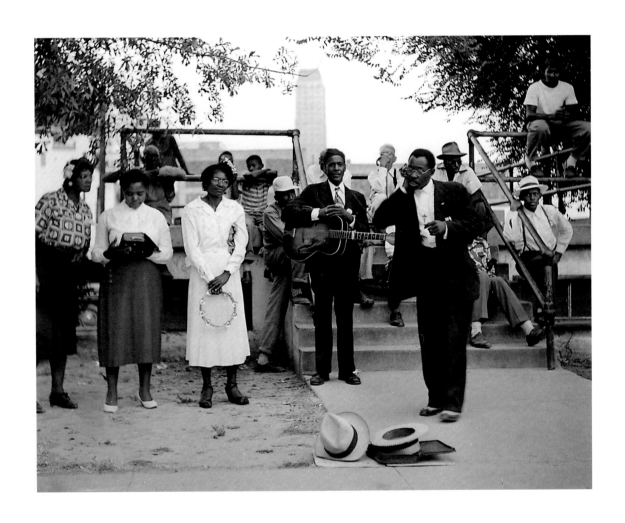

The air is warm, breezy; the color of the sky bleached away, the horizon jellied. I stand looking out at the empty sea of water, featureless in the colorless light. The far away starboard levee, brought up in the binoculars, is a hazy blur, but on the portside you can see groves of poplar trees tilting in the breeze like palm trees on the Gulf, their slender trunks, stripped of their lower leaves, stained gray, the color of death.

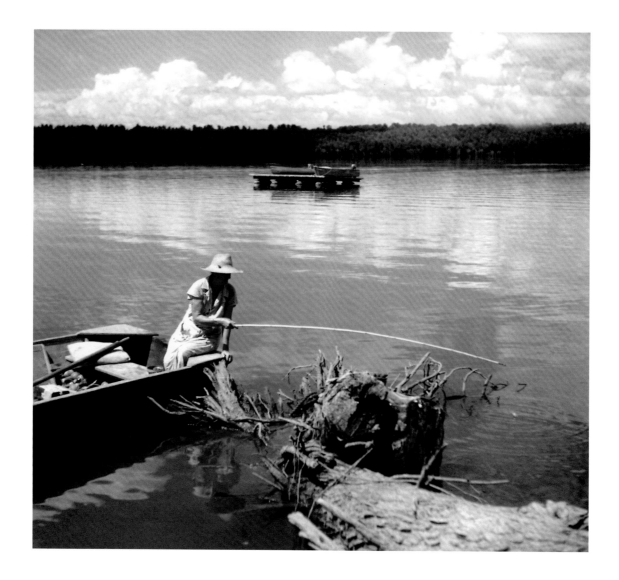

Figure 127: South of Memphis, on the Arkansas side of the river across Shoo Fly bar, is the Tunica Lake oxbow near which Mark Twain's younger brother Henry died from burns received from a steamboat explosion before the Civil War.

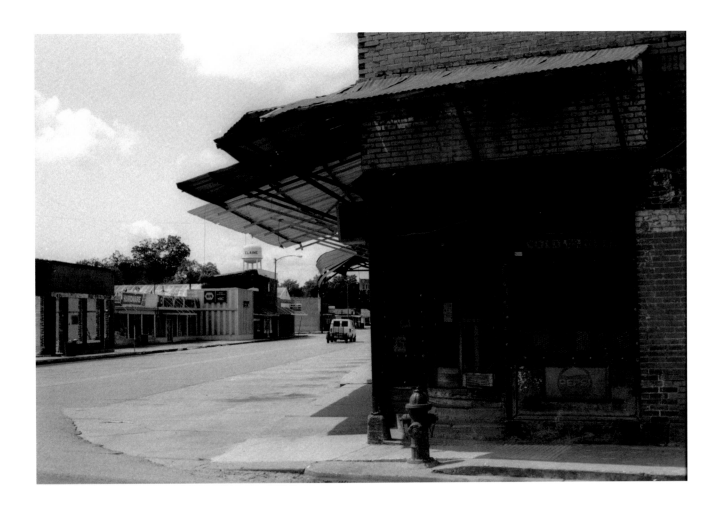

Figure 128: Among the original photographs lost since the author's 1953 river journeys were those of Elaine, Arkansas. In 2002 he returned and took this photo of its ghostly main street, a striking contrast to the fraught town he remembered.

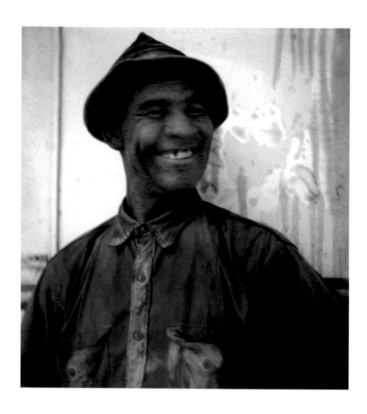

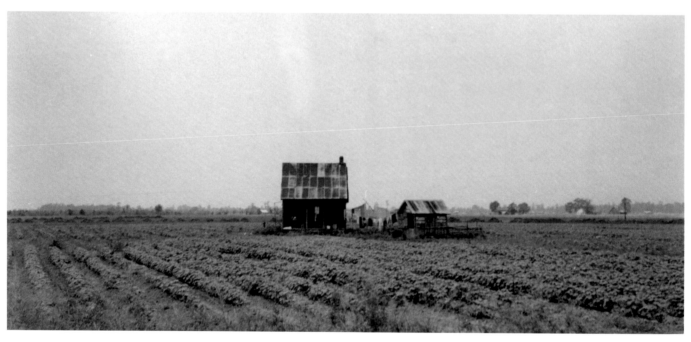

Figures. 129, 130, 131 (opposite), and 132 through 140 (on pages 118–122): Heading south from Memphis, one enters the region known as "The Delta" or, geographically speaking, the Yazoo Basin—that rich alluvial floodplain between the Yazoo River to the east and the Mississippi to the west.

Mid-summer the long rows of cotton in the black delta earth are green and sumptuous. Within the deep South, I've the sense of venturing, within my own country, into a geography that I do not fully apprehend.

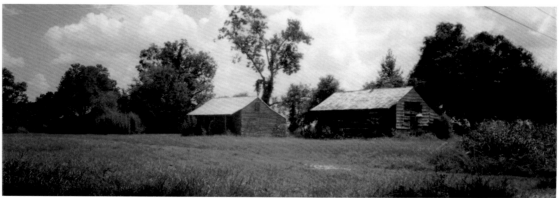

My country is the Mississippi delta, the river country. It lies flat, like a badly drawn half oval,
with Memphis at its northern and Vicksburg at its southern tip. Its western boundary
is the Mississippi River, which coils and returns on itself in great loops and crescents,
though from the map you would think it ran in a straight line north and south.

—William A. Percy, from *Lanterns on the Levee* (1941)

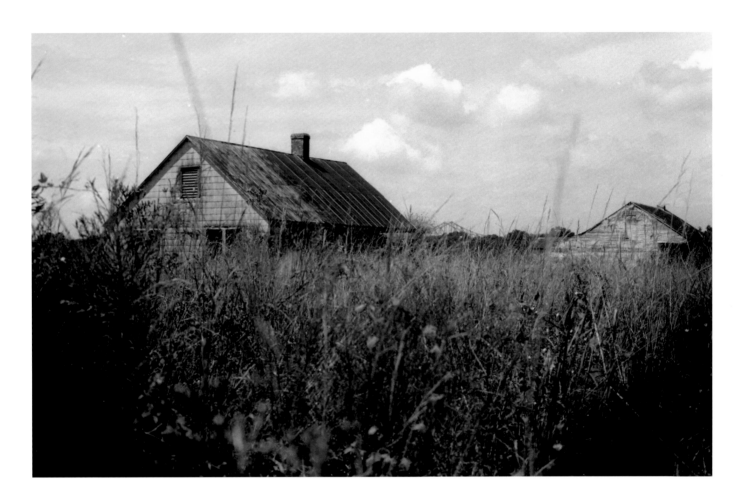

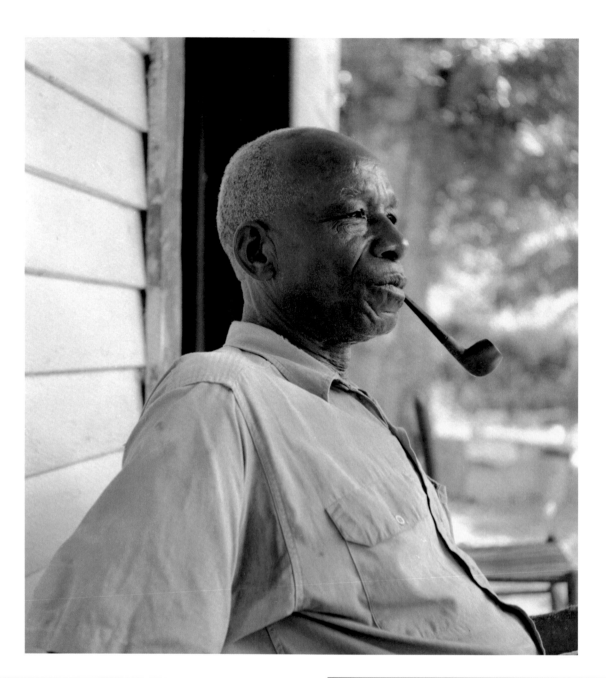

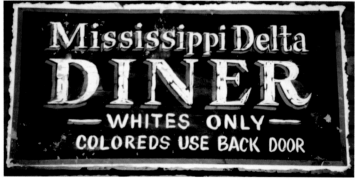

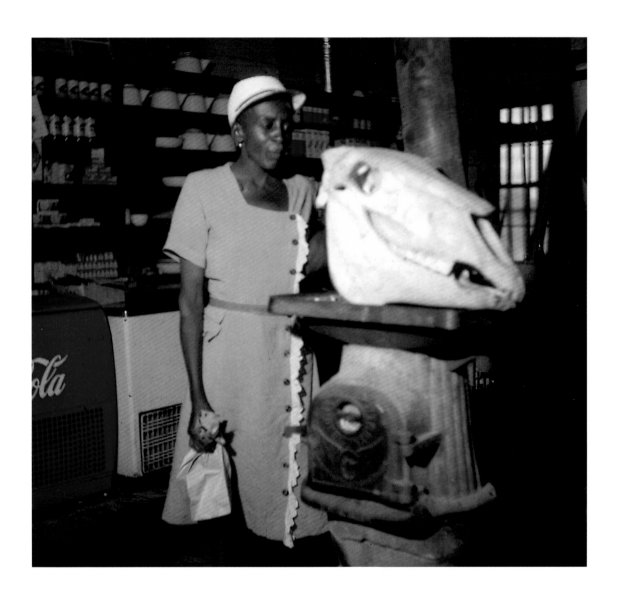

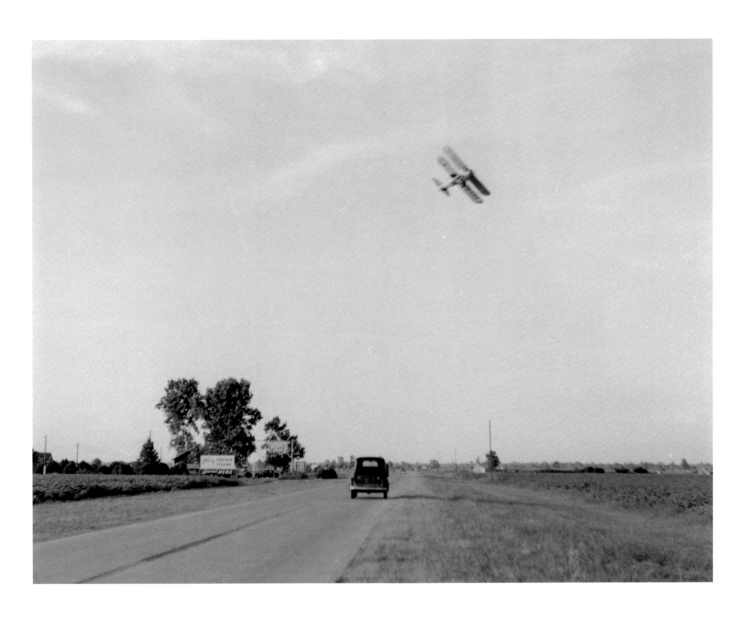

Figure 141: A bi-wing Stearman airplane suddenly appeared above the highway. Pulling sharply up,
it turned hard over on its left wing and dipped down out of sight beyond the tree line,
its insecticide spray pluming up in the distance.

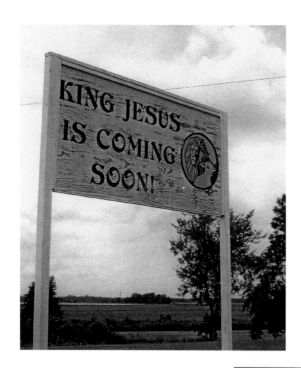

Figures 142 and 143: When you give a name to your church, you want more than just to name it, you want the name to inspire: Mt. Nebo; New Haven; Mt. Hope; Strangers Home; Bethlehem; Morning Star; Promised Land; Mt. Pisgah; Pilgrim's Rest; Hopewell; Prince of Peace; Mt. Calgary; Mt. Harmony; Corner Stone; Kings Chapel . . .

The people of the Delta fear God and the Mississippi River. On Sunday mornings the air of the little towns vibrates with the ringing of church bells as the faithful of many sects and both races gather for worship. And in the springtime when the waters of the river are high against the levees, the faithful go, after services, to look at the yellow flood and ponder the possibilities of disaster.

—David Cohn, from *Where I was Born and Raised* (1948)

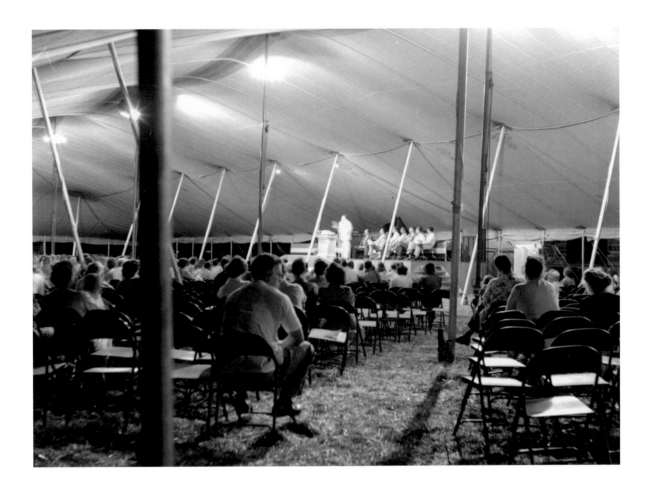

Figure 144: A tent revival meeting.

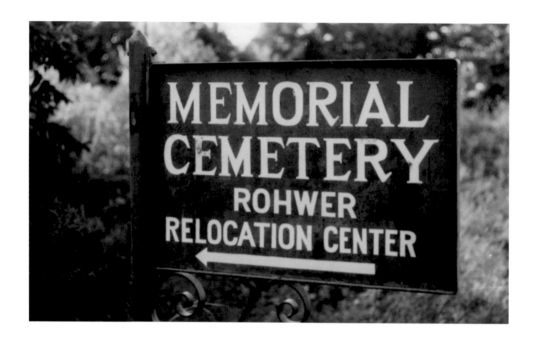

Figures. 146, 147 and 148 (opposite): In September 1942, a trainload of Japanese-American citizens—uprooted from their homes in California, their belongings taken away, their property confiscated—disembarked under armed guard at a "relocation camp" at Rohwer, Arkansas. A two-door outhouse, a dozen gravestones, and a small cement monument are all that remain of the camp.

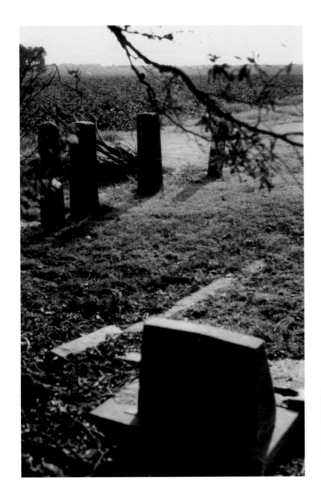

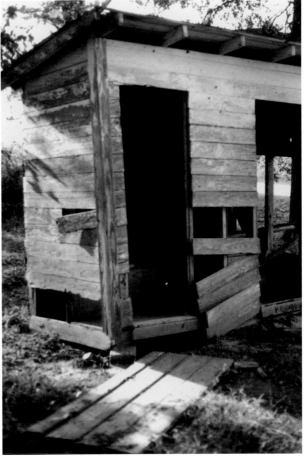

Figure 148: Greenville, Mississippi, was never the same place after the great flood of 1927. A Greenville gas station owner recalled for the author: "The river was sev'ty miles wide, some say a hun'erd. Cattle 'n people swep' clean away, marooned up top-a barns— Jesus, boy, you cain't even imagine."

Figure 149: Here at Young's Point, Louisiana, General Ulysses S. Grant made his headquarters in the winter of 1862–63. It was later the site of a crucial Union supply depot (one of three) during the Union campaign against Vicksburg, which lies just downriver.

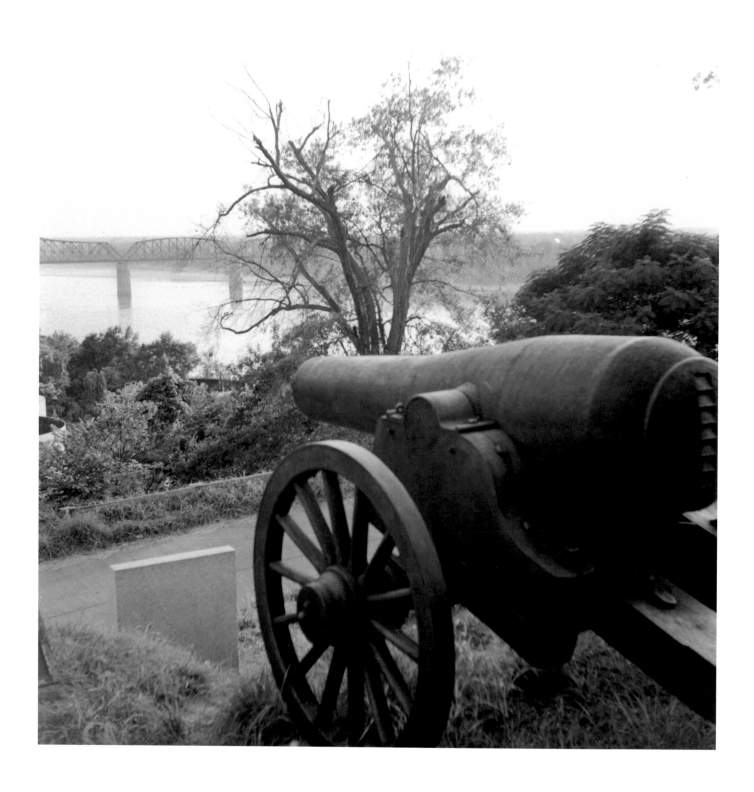

Figure 150: Situated on steep bluffs near the confluence of the Yazoo and Mississippi rivers, Vicksburg, once the site of a Spanish fort, was key to controlling the Lower Mississippi during the Civil War, after the Union had captured Cairo and New Orleans.

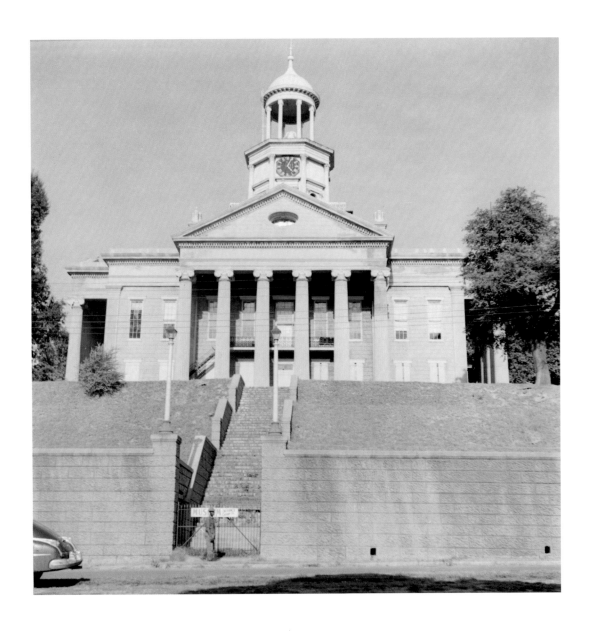

Figure 151: Vicksburg's courthouse, arguably the city's most historic building, was constructed by slaves in 1858, just three years before the Civil War. During the siege of the city, it housed Union prisoners and thus avoided severe shelling.

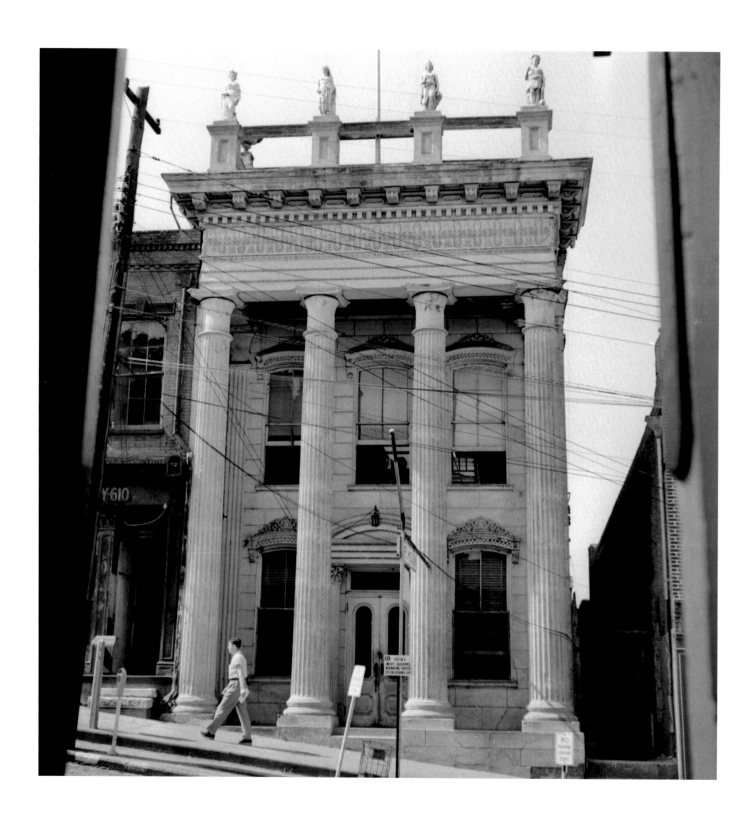

Figure 152: Just up from the river on Crawford Street (very steep) near Vicksburg's central business district, the derelect Vicksburg Cotton Exchange and former Mississippi Valley Bank (constructed in 1870, six years after the end of the Civil War) was a homeless shelter in 1953.

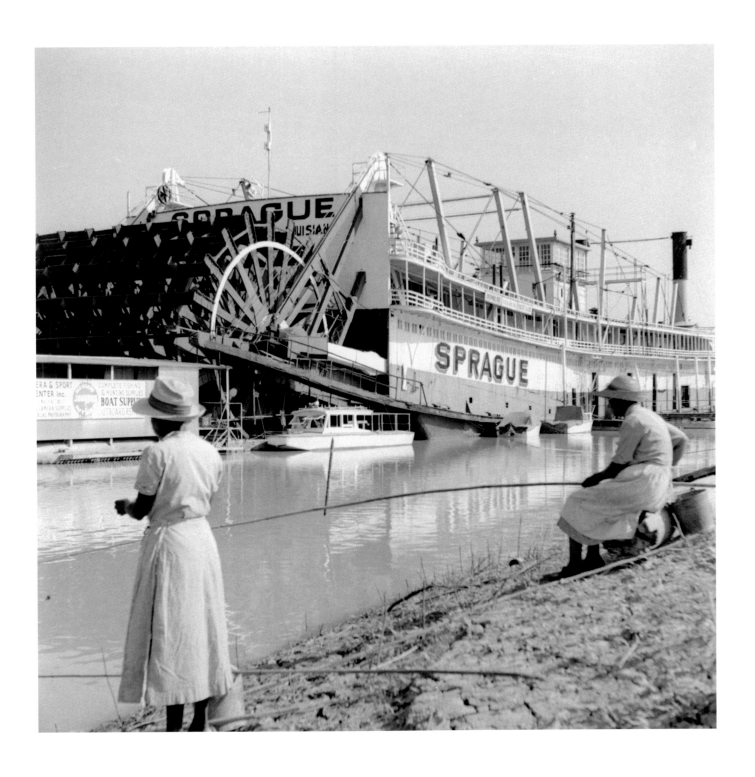

Figure 153: Longer than a football field, the *Sprague*, at 318 feet (including a thirty-eight-foot-high sternwheel), was the largest towboat steamer in the world.

"It's in the history books," says Captain Ware. "The packet Drennan Whyte *was carryin' $100,000 in English gold north of Natchez when she blew her boilers. Two salvage attempts were made and both failed. Twenty years later, several miles downstream, a farmer name of Ancil Fortune dug a well and struck metal—a rusty steamboat smokestack. Right away he knew what it was. He knew it was the* Whyte *because his father had been captain of the second salvage boat and had told him about it.* "Problem was," *Captain Ware continues,* "he didn't own the land he found it on. So he planted a grove of willows and waited five years for the willows to grow up. Then he began diggin'. For months he dug, gettin' the mud out of the* Whyte's *hold. Finally he found it, the cache of gold coins. He headed for his barn to get new sacks to put all the gold in. But then he tripped, broke his leg. That night a big rainstorm came up—washed away the willows, the* Whyte, *and the gold. By mornin' the river'd moved a mile or so east, more or less to the same place where it was thirty-one years before. They say ole Ancil Fortune pulled himself, splinted leg and all, out across the field to where he'd found his gold, but there was nothin' there, just a sea of mud where the river'd been. This here river, I guess you know, you don't judge it, it judges you."*

Sitting out at the tow's bow, the sound of the water softly shooshing beneath the barge's rakes, there is only now. Desire is absent. All around is the calmness of eternity. The sheltering sky, the moonlight on the lake—a terra incognita wherein history seems to have just begun—all is in repose, full of the verities, an Arcadian scene from a nineteenth-century Currier and Ives lithograph. Embraced by solitude, I think I am not where I know am, but in another world.

Figure 154: U.S. 61, much of it paralleling the Mississippi River from Minneapolis to New Orleans, became known as the Blues Highway. In the days before the interstate highway system, it was an essential route of black southerners heading north to Memphis, St. Louis, and Chicago.

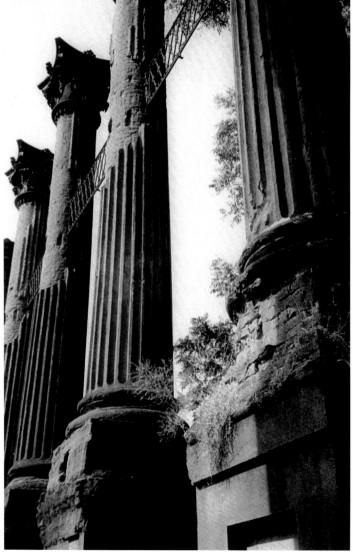

Figures 155 and 156: Twenty-two Corinthian columns, thirty feet high, known as Windsor Ruins, are all that remain of what was one of the great mansions of the antebellum South. It is located a few miles from the river, near Port Gibson, Mississippi.

Figures 157 and 158: A Union cannonball is embedded in the 1832 First Presbyterian Church at Rodney, one of the oldest surviving churches in Mississippi. The church is unusual because of its Federal architecture, an uncommon style for a religious building in Mississippi.

Evening descends. The world falls away, the river's horizon becomes incorporeal, metamorphosing now into gloom, into the underworld.

Figure 159: The second largest Mississippian ceremonial mound surviving in the United States, Emerald Mound is a flat-topped earthwork that rises thirty-five feet on eight acres of ground. (2002 photo.)

Figure 160: Natchez, Mississippi, has more antebellum mansions than any other place in the United States. Pictured here is Stanton Hall, built in 1857. Its grounds encompass an entire city block.

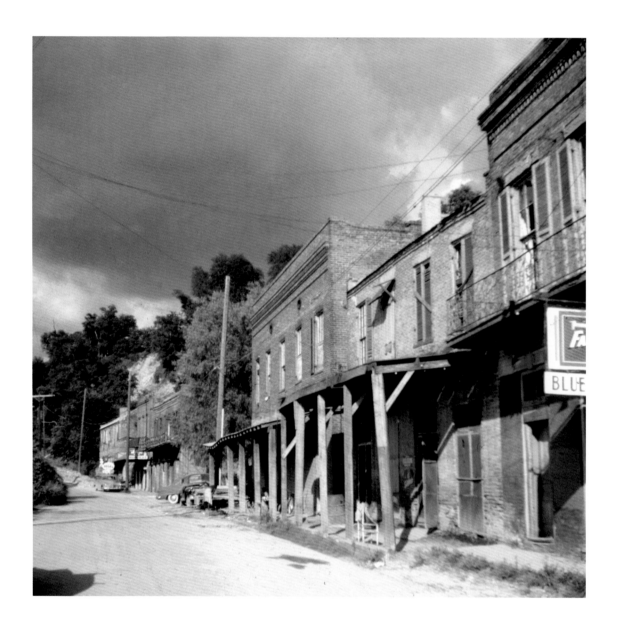

Figure 161: While Natchez's respectable citizens and high society held forth upon the bluff above the river, another kind of (infamous) life was lived in Natchez-Under-the-Hill, a riverfront street that paralleled a half-mile-long wharf.

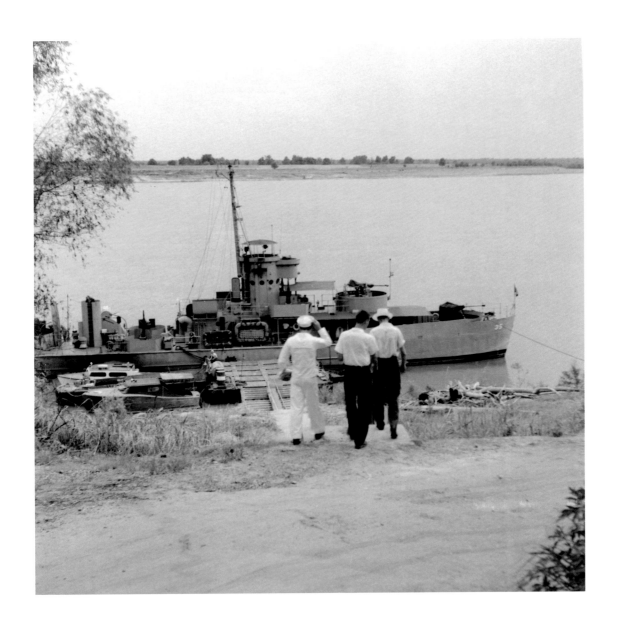

Figure 162: A U.S. Navy destroyer at dockside at Natchez-Under-the-Hill.

Narrowing and deepening, the river is now a hundred feet deep in the channel and 200 feet deep at its bends. Cargo ships and oil tankers are berthed on either side of the half-mile-wide river. The smell of petroleum pervades the air.

Figure 163: Prior to construction of the new state capital, the Louisiana legislature met in the Old State Capital, built in 1850 in a castellated Gothic Revival style. It now serves as a museum.

Figure 164: Beyond the crewmembers of the *R. H. McElroy*, across the river, looms the largest state building in the nation, the 450-foot, thirty-four-story Louisiana State capital at Baton Rouge.

Figure 165: With the second largest concentration of chemical factories in the U.S, the stretch of river from Baton Rouge to New Orleans is known as "Chemical Corridor" and "Cancer Alley."

"We think we got this river under control but we don't. No levee system's ever built that's gonna hold this river forever. What we're lookin' at out there is a cataclysm waitin' to happen."

"How's that?" I ask Captain Ware.

"The Army Corps of Engineers've shortened the river by 144 miles, taken out sixty-six bends, and they've overdone it. Baton Rouge and New Orleans is gonna be left with just a muddy oxbow. A quarter of the Mississippi River already discharges out through the Atchfalaya and some day, prob'ly sooner than later, it's gonna' capture ole Miss. That's right. Old Babylon didn't die because of too many languages; it died 'cause the Euphrates River changed course."

Figure 166: Children walk along a levee south of Baton Rouge.

White herons and herds of Angus and Charolais cattle graze atop the levee.

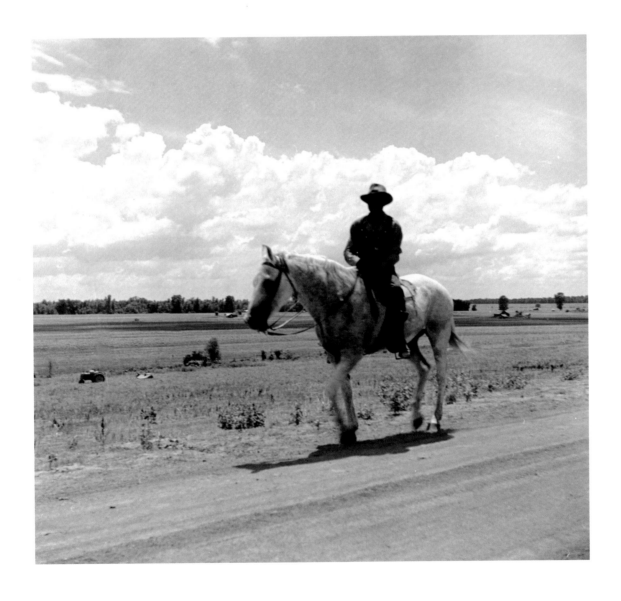

Figure 167: South of Baton Rouge, where the author photographed this horse and rider, is where you begin to see, beyond the levees, fields of sugarcane growing in the red earth, tall as trees.

Figure 168: Behind the levee lies a 1756 cemetery of the first Arcadians to settle in Louisiana (near Donaldsonville).

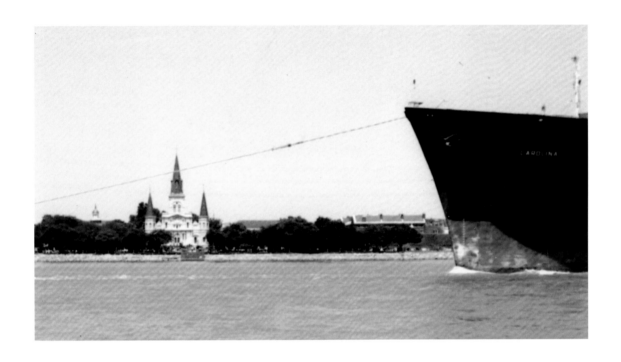

Figure 169: Approaching New Orleans from the river, the St. Louis Cathedral, on Jackson Square, is the focal point of the city's historic waterfront.

It rained during the night. I thought I'd have coffee and a beignet at the Café du Mond.
I parked the car behind the Saint Louis Cathedral. Blackbirds rested on the ledging
above the three-steepled cathedral entrance.

Inside, I sat on one of the wooden benches. The interior was very plain, its wall unadorned.
It was quiet. No doctrinal recipes were being performed. The Frontier Spanish architecture—
squat pillars, black-and-white tiled floor, vaulted ceiling, and iron candelabra hanging from
an encircling balcony—was comforting. I liked it. I did not think the interior was ugly the way
some people, even tourist brochures, said it was.

A pagan chinging of altar bells interrupted the quietude, the scene of divinity. Outside,
I breathed deeply again the early morning air. In the distance I could hear someone
playing a cornet. On Rue de Chartres, pigeons strutted through water puddles.

A gate-keeper was unlocking the iron gates of Jackson Square. I nodded to the gate-keeper,
but he remained expressionless as I passed on through the square, the mashed, wet leaves
and cooing pigeons. At the base of General Andrew Jackson's equestrian statue an inscription
was incised: "The Union Shall be Preserved." What's the significance of Jackson saying "shall"
instead of "will"? "Shall" has a significantly different meaning, after all, than "will." I could hear
the cornet more clearly now—from up on the levee beyond the Café. I thought I should read
Jackson's biography. Andrew Jackson—Stonewall Jackson. They weren't the same. Were they?
Why had I never gotten that straight?

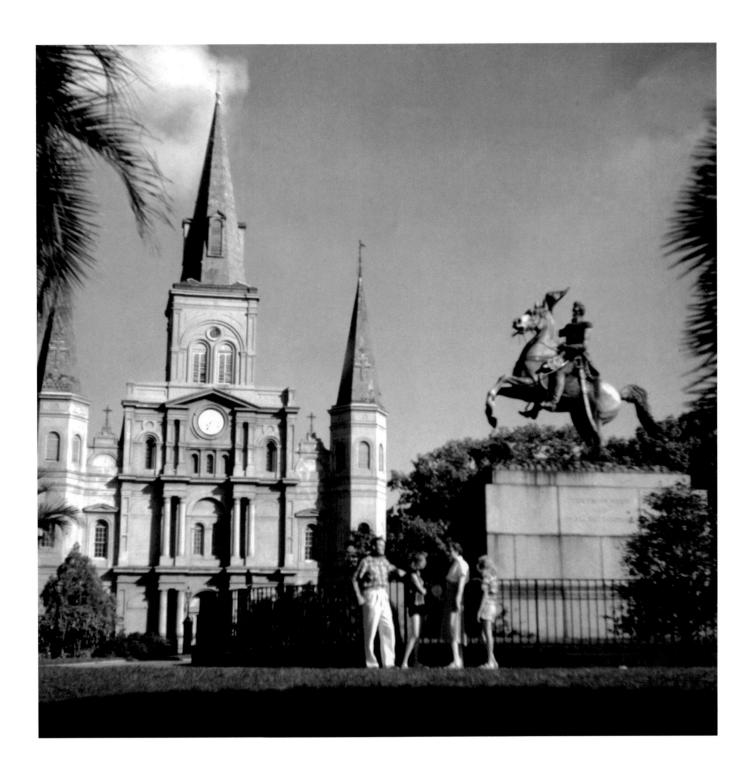

Figure 170: Jackson Square and St. Louis Cathedral in early morning, before the arrival of the caricaturists and portraitists who set up their easels along the iron fences around the square, and before the mimes, magicians, tumblers, jugglers, dancers, musicians, shoeshine boys, and camera-toting tourists gather in front of the landmark cathedral.

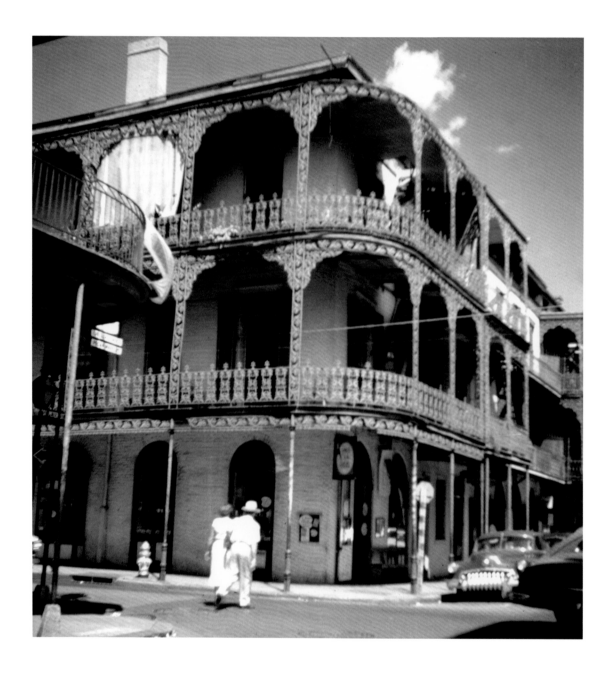

Figure 171: The French Quarter with its narrow streets and lacy wrought iron balconies—as revealed here in one of the two Pontalba buildings restored by the WPA during the 1930s—is a magnetic draw to tourists, bohemians, and revelers seeking a world of authentic charm and history, a world that is real, a world that is not Disneyland.

It's not at two o-clock in the morning when it's going full tilt, but in the early morning light when the air is fresh and sweet and the mud wrestlers and female impersonators and tourist-revelers are gone; when, that is, Bourbon Street's garish come-on signs have darkened, the Absinthe House become silent, the music and hustle has dissipated and the neon, most of it, has been turned off and just the street litter dominates the sidewalks and but two or three all-night bars with vacuous-eyed strawberry-haired girls stare desultorily out at you; when, that is, the honky-tonk capital of America is almost staid and you may now have, as though standing on the streets of Pompeii, a clear-eyed perspective of what it all may or may not mean.

Figure 172: Bourbon Street. (2002 photo)

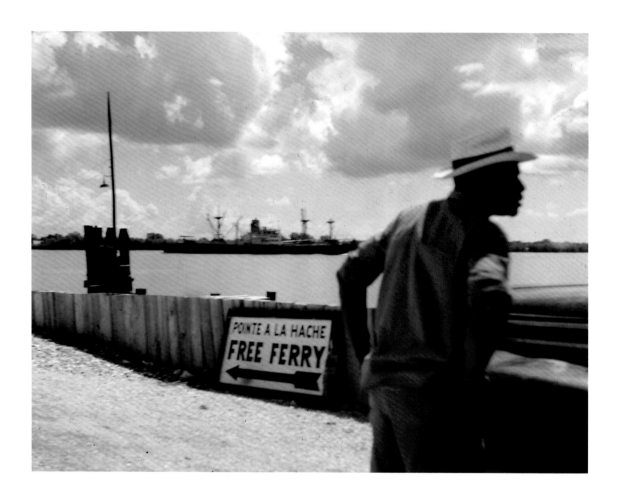

Figure 173: From New Orleans you can take the Pointe a la Hache ferry that passes
by Chalmette, where in 1815 the Battle of New Orleans was fought.

It was already dark when I headed south from New Orleans on Highway 23, past used car lots, darkened gas stations, closed fire-works stands, and mobile-home sales lots; past snow-white burial vaults decorated with plastic flowers; past the lights of Pointe a la Hache on the other side of the river and on through melancholy communities called Happy Jack, Port Sulfur, Empire, Burn, Triumph, and Boothville to Venice, the end of the river's roadway.

Can't go no furthur.

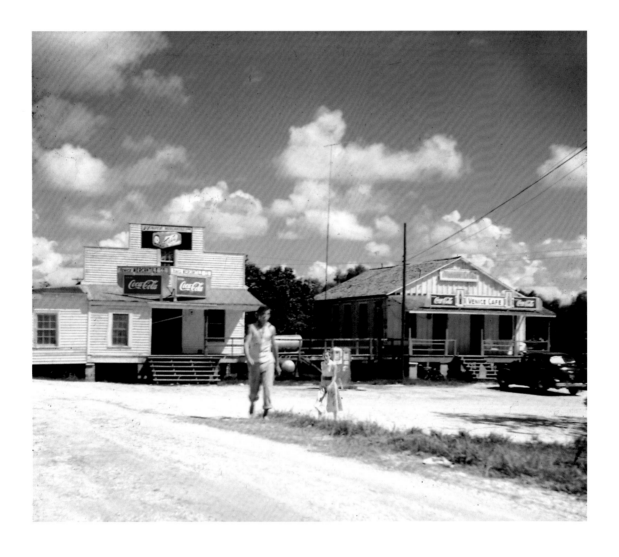

Figure 174: Seventy-three miles south of New Orleans, the highway paralleling the long arm of the Mississippi River that extends into the Gulf of Mexico comes to an end in Venice, Louisiana.

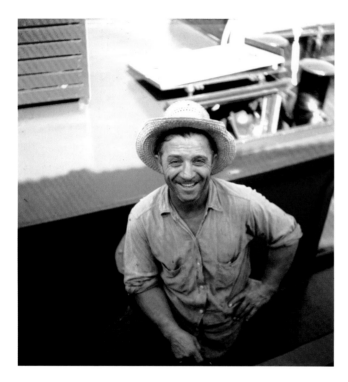

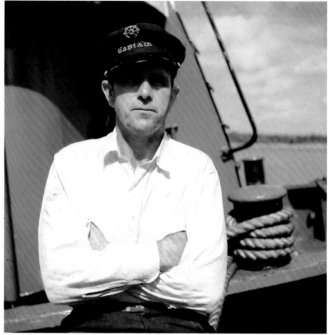

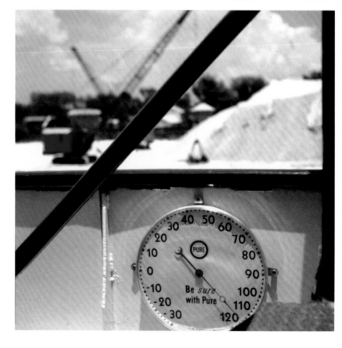

Figures 175, 176, and 177: The hot humid savor of Arcadia is all about now . . .

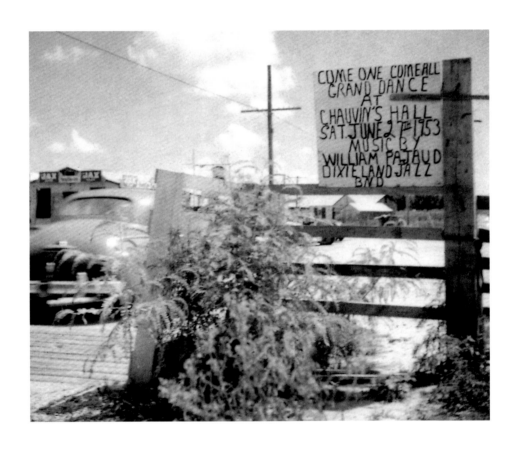

Figure 178: The grand dance at Chauvin's Hall has passed, but not to fret: There'll be another one soon enough.

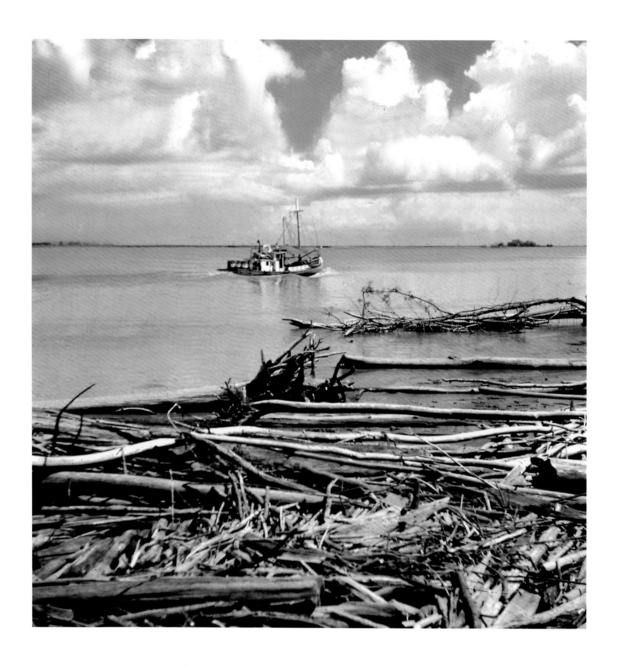

Figure 179: Head of Passes, the gateway to the Great River's three main mouths that empty into the Gulf of Mexico, lies twenty miles south of Venice—and 2,552 miles from its origin at Lake Itasca, Minnesota.

Coda

I'D FINISHED WHAT I'D SET OUT TO DO. I had photographed the river from its clear, blue beginning at Lake Itasca, Minnesota, all the way down to its silt-laden delta in the Gulf of Mexico. The musical "mais yeah" friendliness of the Cajun/Creole locals did not alter the fact that I was nearly broke and that I was tired.

Since the beginning of my trip at Lake Itasca, I'd slept on the front seat of my car, interrupted by my ten-day trip aboard the McElroy, every night for just over a month. For someone who is six-feet two-inches tall, it was never comfortable but it was my choice and I had no reason to complain, which I didn't, with one exception: It occurred on my return to New Orleans from Venice, while I was folded up on my Studebaker's front seat on a hot, humid, breathless New Orleans night, with dark chimeras and assorted bugbears flitting outside the car windows, and mosquitoes buzzing about my ears. It was an experience I decided against repeating.

When dawn finally arrived, I drove down Canal Street. A St. Charles streetcar circled back toward the Garden District. Watching it in an exhausted daze, I knew it would go lurching on up St. Charles Avenue under arching 300-year-old oaks, past Greek Revival homes with thick columns and broad porches and crepe myrtle and gardens of azaleas — a quintessential scene of grace and beauty representative of a unique era in American history. But, for me, my memory of New Orleans's Garden District, as with all my memories of the Great River, were ended. I could no longer entertain more, physically or monetarily.

I headed north to Chicago. Chicago seemed a likely place to write a shooting script for my movie and to raise production money for filming it the following summer.

Unsurprisingly, that is not what happened. I took a menial job delivering sight drafts for a bank, while doing research in the public library and writing my script. But also, as a kind of lark, I left my resume at Chicago's four TV stations. Two months later, CBS News called and I was hired as assistant manager of CBS Television's Midwest news bureau, a compelling, chal-

lenging position I would hold for the next several years—Ozzie and Harriet years that preceded Elvis, the Beatles, and the Pill; years in which the Brown v. Board of Education desegregation decision of 1954 would infuse screaming, taunting mobs; conformist years (so-called) in which my river trip would be revisited with the 1955 middle-of-the-night Money, Mississippi, lynching-murder of fourteen-year-old Emmett Till, and again later, in the early sixties, when I had my own documentary film company on location in Winnfield, Louisiana, Huey Long's home town, while filming a black family preparing to emigrate to Chicago, my crew and I were confronted by the Winnfield sheriff who, confiscating our equipment, escorted us to his office for an intimidating "talk." We, in turn, offered our own intimidation, by pointing out that if any harm came to the black family, to us (or our equipment), as agents of a national news organization, ABC News, the whole world would know about it. The South was still the South of Bilbo and Jim Crow, but television, in ways large and small, was beginning to change the way things played out.

All this is to give some account, or excuse, of how other interests, professional and personal, intruded—intrusions that would inevitably forestall but never entirely erase my "crazy" desire to make a movie of a newly married couple rafting their way down America's yellow brick road, the Mississippi River. It was a birthright.

The Cold War and its insidious sense of doom notwithstanding.

Conclusion

John O. Anfinson

A River of Stories, a Sense of Place

Few geographic names evoke a more powerful sense of place than the Mississippi River. Nearly everyone who writes about it seems compelled to call it "the Mighty Mississippi." Most do so without thinking about how the Mississippi came to be mighty or what makes it mighty. Charles Dee Sharp begins to explore these questions. He suspects that the river's physical prowess and Mark Twain are behind its universal stature. In the end, he says, he does not try to "understand any more why, individually and as a nation, we have such esteem for the Mississippi River."

The Mississippi is mighty at many levels, but the two Sharp identifies stand out. First, Americans and Europeans considered the Mississippi one of the world's greatest rivers by the early nineteenth century, although they had only a general understanding of its size, power, and abundance. That we can now quantify the river's physical assets with statistics only confirms what they believed. The Mississippi River drains the third largest watershed in the world and largest in North America, emptying all or part of thirty-one states and two Canadian provinces. Before levees hemmed it in, great floods on the Lower Mississippi occupied most of the 28,000-square-mile floodplain. The Mississippi River flyway draws about forty percent of North America's waterfowl and sixty percent of its bird species.[1]

Physically the Mississippi River demands respect. But the river's hold over the American imagination emanates even more from its history. The Mississippi is mighty because of the stories it has accumulated. The Mississippi gathers stories like it does tributaries, growing culturally stronger and deeper with each one. These stories include contributions to American literature, art, music, and the national narrative.

Nature writer Terry Tempest Williams asks, "What stories do we tell to evoke a sense of place?" She says that, for the Navajo Indians of the Southwest, "each landform, each significant site, seemed to have a name accompanied by a story. The stories they told animated the country,

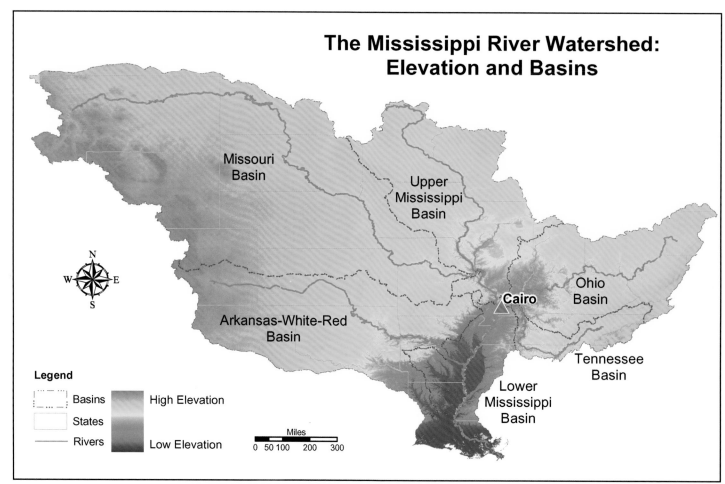

The Mississippi River Watershed: Elevation and Basins

Missouri Basin

Upper Mississippi Basin

Ohio Basin

Cairo

Arkansas-White-Red Basin

Tennessee Basin

Lower Mississippi Basin

Legend

Basins
States
Rivers

High Elevation
Low Elevation

Miles
0 50 100 200 300

made the landscape palpable and the people accountable to the health of the land, its creatures, and each other."[2] Palpable means "relating to things that occupy space and can be perceived by the senses." How can our senses perceive something that runs for 2,350 miles? Travel accounts, I believe, have been helping us do it for at least 200 years. The stories told and images created by the stream of individuals who have traveled on the Mississippi River have established the river as a place.

This history is what leads Charles Dee Sharp to call the Mississippi River America's "yellow brick road." This is why he and so many others find it "as central to American culture as Old Glory itself." Sharp is not sure where the river's power as a historical entity began, but he suspects with Mark Twain, as most people do. Twain played a role; he took an already renowned river to an even higher level. But it goes back much farther.

Author William Least Heat-Moon's personal library includes more than 2,000 travel books. Of those about rivers, most are all or partially about the Mississippi. This is especially true, he says, for river books written during the last half of the twentieth century. He believes that, "In our time a pattern of travel, seemingly on its way to becoming an archetype, has happened: taking a craft of whatever configuration down the Mississippi from somewhere not far below its headwaters in northern Minnesota on to New Orleans or even beyond to where the huge delta meets the Gulf of Mexico." These trips, he contends, have become so common that they are "on the way to developing into a ritual for a nation shy on communal rituals."[3] For Sharp and for many of those individuals whose accounts reside in Heat-Moon's library, traveling on the Mississippi was a sacred endeavor. Through their voyages they communed with a place that melded nature and history into one of its most powerful forms in the world.

The difference between ritual and cliche here is thin, however. Sharp and all those who have intentionally tried to find a different way to travel the Mississippi recognize this. Captain Ware told Sharp of a seventy-two-year-old jeweler from Los Angeles who rowed a boat downriver and of a man who stepped down the Lower River in pontoon shoes. People have skied, swam, and sailed it. They have motored down in fishing boats, speedboats, and houseboats, and they have paddled down in kayaks and canoes (seeing who can do it the fastest). And to do it more authentically, more like Twain's Huckleberry Finn and Jim, they have floated down on rafts. Sharp calls all these pilgrims "rafters." Some have misjudged the river and died. Despite the dangers, years of experience had led Captain Ware to conclude that "'Goin' down the Mississippi's [sic] somethin' people wanta do and they're gonna do it. That's just the way it is in this country.'" Sharp knew he needed a special angle to make his project worth funding. So, the honeymoon raft documentary became the new twist.

As Heat-Moon's library indicates, many of Sharp's "rafters" were not just compelled to take the trip; they were equally compelled to write about it. When did this mania begin and what can another travel account add? The obvious answer to when is with the publication of Mark Twain's books: *The Adventures of Tom Sawyer* (1876), *Life on the Mississippi River* (1883), and *The Adventures of Huckleberry Finn* (1885). The flight of Huck and Jim is the model. Sharp's association with Huck and Tom had been formed by his fourth-grade year.

But, as noted, travel trips on the Mississippi and writing about them had begun well before Twain. Written accounts by Father Louis Hennepin (1626–1701?), Father Jacques Marquette (1637–1675) and Louis Joliet (1645–1700), Zebulon Pike (1779–1813), and others first gave the Mississippi its aura of greatness. Published accounts of its physical size, power, and beauty entranced audiences in the East and Europe. These trips, however, differed fundamentally from Sharp's. These were business ventures and government exercises. They focused on finding an all-

water route to the Far East, laying claim to America, and discovering the inner continent's wealth.

Texts by individuals seeking adventure, escape, or meaning on the Mississippi River arise at least as early as the nineteenth century. For these early adventurers, Eric Watkins writes: "The Mississippi was no ordinary river encountered in the course of travels but one which captured the imagination of these travelers and was of peculiar importance and significance to them. It was a goal, a quest, something they had long wished to behold and which when they did see it did not disappoint them." The Mississippi River's reputation was so well-established that by 1820 Timothy Flint called it "far-famed," and in 1821 Zadok Cramer asserted that "this noble and celebrated stream, this Nile of North America, commands the wonder of the old world, while it attracts the admiration of the new."[4] Twain had not yet been born.

The greatest impetus to travel on the Mississippi River came from the beginning of steamboat transportation on the Lower Mississippi River in 1811–12 and on the Upper River above St. Louis in 1823. Steamboats allowed adventurers and tourists from the East and Europe to experience the already fabled river with relative comfort and speed. Italian adventurer Giacomo Beltrami boarded the *Virginia* for its first trip to Fort Snelling, at the confluence of the Minnesota River, in 1823. His account, published five years later, is filled with passages adding to the river's fame and enticing others to come and behold it.

Beltrami found the Mississippi River valley above St. Louis to be one huge forest, interrupted by tree-dotted meadows that ran up the slope of a bluff or away on a prairie. The trees, he says, were "disposed with so much art and symmetry, that, but for the death-like silence which pervades this vast solitude, it would be impossible not to think that they had been placed there by the hand of man."[5] On the river he found that "Wooded islands, disposed in beautiful order by the hand of nature, continually varied the picture: the course of the river which had become calm and smooth, reflected the dazzling rays of the sun like glass."[6]

After two years rambling through the upper Great Plains, George Catlin, an artist and adventurer from Philadelphia, headed down the Mississippi River from Fort Snelling in the fall of 1835. The scenery and wildlife and ease of travel on the Mississippi so impressed him that he encouraged Easterners to take a "Fashionable Tour" of the Upper River. Accompanied by a corporal from the fort, he wrote that they had "ducks, deer, and bass for our game and our food; our bed was generally on the grass at the foot of some towering bluff, where, in the melancholy stillness of night, we were lulled to sleep by the liquid notes of the whip-poor-will; and after its warbling ceased, roused by the mournful complaints of the starving wolf, . . ."[7] He urged his readers to hurry to the Mississippi River before its beauty disappeared under the rush of settlement.

Catlin did not start the fashionable tour of the Upper Mississippi. He simply encouraged it. As of 1835, he reported, steamboats arrived every week at Ft. Snelling from St. Louis, during the summer of 1835, the year Twain was born.[8]

Catlin left more than his published letters. He painted some of the earliest scenes of the Mississippi River's landscape and infant towns. As much, and perhaps more so, artists lured travelers to the river. During the 1840s and 1850s, artists painted eight to ten panoramas of the Mississippi. One of the most well known is that of Henry Lewis. Completed in 1849, it covered the river from St. Anthony Falls to New Orleans and spanned a roll of canvas twelve feet high by 1,300 feet long. Lewis toured the United States and Europe with his panorama. Although no one has created such a large-scale photographic panorama, you could cobble one together from all the picture books about the Mississippi. So, what is the value of another pictorial and written account of the Mississippi River?[9]

The value comes at two levels at least. First, each text (and Sharp's is no different) is a primary document (an original source) about the Mississippi River and America at the time of the trip. Second, most authors (and Sharp is no different) identify and discuss or photograph the river's famed natural features and historic sites. In doing so, they keep these places alive in the public's mind.

Most travel narratives are historic manuscripts, similar in value to those of early explorers and travelers. A manuscript about a Mississippi River trip has probably been penned every year since 1835, when Catlin beckoned Americans to the river. Historians and geographers can cull from these accounts what the river was like at the time. They can learn about the attitudes of the travelers and the public toward the river. While often acutely aware that they are following the path of Hennepin, Marquette and Joliet, Rene-Robert Cavelier, Sieur de la Salle (1643–1687), Pike, and others, most travelers seem oblivious that their own observations will join this literature. Still, travel narratives provide a continuous thread of documentation about the Mississippi River.

Sharp's trip aboard the *R.H. McElroy* underscores this aspect. In 1953 the odds favored that he would find his way onto a towboat pushing empty oil barges downriver, since oil shipping then dominated commerce on the Upper River. Today he would most likely catch a towboat pushing loaded grain barges downriver. Sharp's photographs captured an important transition in Mississippi River navigation: the shift from paddlewheels to propellers and steam engines to diesel engines. Two diesel engines, generating together 2,200 horsepower, drove the propellers of the three-year old *R. H. McElroy*. Yet the U.S. Army Corps of Engineers still employed the *Charles H. West*, a sternwheel snagboat, and the Corps had retired the *Sprague*, a steam-powered sternwheeler, only five years before. The slap of the wooden paddlewheel would soon disappear from the Mississippi River, except for the nostalgic excursion boats.

Travel writers on the Mississippi River often highlight the river's well-known sites. The Battle of the Bad Axe, the Mormon expulsion from Nauvoo, Mark Twain's boyhood at Hannibal, the Civil War battle for Vicksburg, the struggle to keep the Mississippi from going down the Atchafalaya River, and a score of other stories appear in one book after another. Through this repetition, the landscape of the Mississippi and the river's historic sites have become embedded in the American narrative. Repeating the old stories helps to protect historic sites from being bulldozed.

A sense of place happens in specific places. "Indeed," stresses geographer Edward Relph, "events and actions are significant only in the context of certain places, and are coloured and influenced by the character of those places even as they contribute to that character."[10] Sharp searched for places on the Mississippi River that explained to him what made the Mississippi so representative of the American experience, places colored by the river and places that explained his infatuation with the Mississippi and that of the nation. He hoped that his written and photographic account of such places would convince sponsors to back his documentary film project.

Sharp recognized that he could not ignore those places that represented the dark side of American history. This theme emerges from his work in stories and images about mass discrimination, intolerance, slaughter, and despoliation. The Battle of the Bad Axe site at Victory, Wisconsin, and the Trail of Tears site at Ware, Illinois, illustrate the consequences of American expansion for Native American tribes. The Nauvoo House in Nauvoo, Illinois, is a witness to the religious intolerance that forced thousands of American citizens from their homes and community. The sign for Elaine, Arkansas, where whites killed African-Americans, emphasizes the tragedy of racial hatred and discrimination. The images of the Memorial Cemetery sign for the Rohwer, Arkansas, Relocation Center, marks America's ethnic intolerance toward Japanese-Americans during World War II. And his remarks on the chemical corridor, beginning at Baton Rouge, Louisiana, emphasize America's lack of accountability for what we do to the river and each other.

Robert Archibald, in his book *A Place to Remember: Using History to Build Community*, insists that "there is a point to history, for history is a process of facilitating conversations in which we consider what we have done well, what we have done poorly, and how we can do better, conversations that are a prelude to action."[11] The above-mentioned sites, dark as they are, provide the opportunity to converse about what we as a nation have done poorly and to think about how we can do better. Metaphorically, the Mississippi River offers hope for a better future. Like rafters on the Mississippi, we can dream that, around the next bend, lies an opportunity for life to be better.[12]

Authentic places act as witnesses to the past. Such places prove that the "stories are not make-believe, but involve real people facing real-life situations and issues."[13] Traveling on

the *R. H. McElroy*, Sharp found it easier to lose himself on the Mississippi as a historical place. Traveling by car, he complains, required more imagination to "get away from the present and gain some feeling of being connected to history, to events that took place on the very spot where you are standing." Yet, only on land can one experience many of the places he mentions and photographs. Through these stories, the Mississippi's power as a place comes through. These stories are America's stories and the river's. They run from the north to south, cutting across time, race, religion, ethnicity, and the environment.

The sites of such tragic stories had special meaning in 1953, as the world abroad and at home seemed to be coming apart. The Cold War had intensified. The Korean War dragged on. At home, Senator Joseph McCarthy ruined the lives and careers of government workers and private citizens, accusing them of being or harboring communists. His witch-hunt festered into 1954. Even on the *R. H. McElroy*, Sharp could not escape the anxiety of the time. Upon entering the *McElroy's* pilot house, a notice warned him of what to do in case of an atomic attack. One bend in the river, however, brought some hope. On July 27, 1953, he read in a newspaper that the war in Korea had ended.

The importance of travel trips to the individuals taking them and to those who read their accounts and examine their photographs is greater than stories about individual places. Each trip confirms that the real Mississippi River exists. For most people the Mississippi has become more a place in the mind than in reality. The Mississippi became a public place in the mind of America through the works of Twain initially and then through the great volume of literature that emerged during the 1920s and 1930s, according to Eric Watkins. Americans escaped into this literature as the dammed, leveed, and polluted river lost its mystique and romance. This explains, in part, why the image most Americans have of the Mississippi is associated with steamboats and Twain. It explains why there is a vast literature of travel trips and books about the glory days of the steamboat era and few serious histories of the Mississippi River in the twentieth century. We do not want to think about what we have done to this invaluable resource.[14]

Being only a place in the mind temps us, even allows us, to overlook what happens to the real river. The danger is that the real Mississippi can go away; real places, historical and natural, along the river can disappear. Without a deep sense of place, we have nothing tangible to fight for, and the river and its natural and historic places can be taken apart piecemeal; more unwittingly, I think, than maliciously. Returning to the river nearly fifty years later, in 2002, Sharp saw how much had changed. Gambling boats and huge parking lots had taken over some riverfronts, and many historic buildings had disappeared. Travel trips continue to remind us that the Mississippi River is real and that there are places all along it that tell us who we are and where

we came from. Every travel account shows that you can experience it; you can still live an adventure.

People will continue their pilgrimages up and down the Mississippi River, and they will continue writing about, photographing, painting, and filming their trips. The ritual will go on. What will they tell future generations about the Mississippi River as a place, and what places along it will they focus on? What new places and stories will they add to the American narrative? What changes will they show us, for better or for worse? Whatever they tell us, they will continue to make the Mississippi River palpable as a place, and hopefully persuade people to be accountable to each other and to the river's environment. Archibald argues that "narratives firmly rooted in place bind people to each other through a shared past, pride in mutual accomplishment, is imbued with an understanding of their place as an inter-generational work in progress."[15] As a nation, the Mississippi River is our common place. We have a shared past with it. And it is certainly an inter-generational work in-progress.

The Mississippi: A Work in Progress

Charles Dee Sharp journeyed down a Mississippi River vastly different from the one paddled by Native Americans and steamboats. From the stones neatly placed at the outlet of Lake Itasca to the jetties that escort the river's water into the Gulf of Mexico, America had changed the river by 1953. We had altered the river's width and depth, where it flowed, how fast it ran, and how much water it carried. Reservoirs on the main stem and its tributaries now hold back the Mississippi's flow. Locks and dams make navigation by diesel towboats and their barge fleets possible from Minneapolis to St. Louis, and a system of dikes and dredging ensure navigation from St. Louis to the Gulf of Mexico. Upland reservoirs, flood diversion channels and a nearly continuous wall of levees prevent most flooding from Rock Island, Illinois, to the Head of Passes, below New Orleans. The U.S. Army Corps of Engineers has shortened the lower Mississippi River by more than 150 miles, cutting through its long, coiling meanders.

THE UPPER MISSISSIPPI: FROM THE HEADWATERS TO CAIRO, ILLINOIS[16]
Sharp began his 1953 towboat voyage at the Washington Avenue terminal, then the upper limit of navigation on the Mississippi River. The terminal lay one mile below St. Anthony Falls, the only major cataract on the Mississippi, and 8.5 miles above the mouth of the Minnesota River. Sharp and the tow *R. H. McElroy* completed their first of twenty-six lockages at Lock and Dam No. 1, about five miles below the Washington Avenue terminal. The Corps opened this lock and dam in 1917, extending the head of navigation from St. Paul to Minneapolis (Figures 5 and 6).

Historically, few boats had traveled above the Minnesota, where the Mississippi enters an 8.5-mile gorge. Nowhere else along its entire course does the Mississippi drop so deeply into such a tight canyon. During high water, a fast and turbulent rapids once boiled through the gorge, jumping and twisting over massive limestone boulders. During low water, you could have waded over to the other side. You might have been able to cross the river by hopping from one limestone boulder to the next, resting at one of the more than a dozen islands. Whether high or low, navigation through the gorge ranged from treacherous to impossible. So St. Paul had been the head of navigation, and Minneapolis, employing the river's steep slope, had become a lumber and flour milling center.

Minneapolis, however, yearned to be a port city. St. Paul had more than 1,000 steamboat dockings in 1857, while Minneapolis had only fifty-two. So from the 1850s on, Minneapolis pushed for locks and dams to overcome the gorge. Lock and Dam No. 1 made navigation safe to just below the falls. But the narrow walls of the gorge provided little space for a terminal.

Navigation boosters in Minneapolis recognized as early as the mid-nineteenth century that they would need two locks and dams to get traffic over the falls. Another Mississippi River—the prairie river—began above the falls. Here the land ran up to the Mississippi on either side, with low banks that rarely flooded. Here businesses could build up to the river's edge and spread far back from the river, and railroads had easy access. But Minneapolis would have to wait.

Minneapolis faced a greater problem than the falls in its quest for river commerce. In 1918, one year after the Corps opened Lock and Dam No. 1, shipping on the Mississippi River above St. Louis died. No steamboats carried cargoes between St. Paul and St. Louis. Most boats moved ten to twelve miles between ports and pushed barges loaded with materials to build navigation improvement structures, such as wing dams and closing dams. For Minneapolis to become the head of navigation, shipping had to return. The natural river could not entice it back, and decades of navigation improvements had failed to attract commerce.

River traffic died on the Upper Mississippi River for two reasons. First, railroads offered more direct, more efficient, and more reliable service. Second, the natural Mississippi was too fickle to compete with railroads. Too often the Upper River fell so low that heavily loaded barges or steamboats ran aground on sandbars.

Uncounted side channels, backwaters, snags, islands, sandbars, and wide shallows characterized the natural Upper Mississippi, delaying, stranding, and sometimes sinking steamboats. Spring floods spread into the river's wide floodplain and slowly receded during the summer and fall, until the river reached its low-water stage. This great annual cycle or pulse renewed backwater and main channel habitat. During low water, no continuous channel existed. The average

depth over the sandbars at low water between St. Paul and St. Louis measured only two feet. The Des Moines Rapids, which extended 11.25 miles upstream from present-day Keokuk, Iowa, and the Rock Island Rapids, which ran for 13.75 miles, near Rock Island, Illinois, posed two of the most dangerous obstacles.

Sandbars, however, presented the most frequent and difficult problem for navigation. As the 1820 expedition under Territorial Governor Lewis Cass headed down the Mississippi, one member reported that, from St. Anthony Falls to Prairie du Chien, they found "sand bars without number," and complained that they struck fifteen to twenty per day. They were traveling in birch bark canoes, which drew only a few inches of water.[17]

Three years after the Cass expedition, the *Virginia* became the first steamboat to paddle upstream from St. Louis to St. Paul, arriving on May 24, 1823. The *Virginia* announced a new era for the river above St. Louis. Under steam power, people and goods could be transported upstream far more quickly and in greater numbers and quantities than on keelboats, which relied on sails, oars, and poles.

Steamboat traffic above St. Louis grew quickly after 1823, but did not reach its heydays until the 1850s. By 1857 St. Paul and other Upper River cities had become bustling ports. St. Paul counted more than 1,000 steamboats arrivals that year, Davenport, Iowa, had almost 1,600, and St. Louis nearly 3,500. The river, however, had already begun losing traffic to railroads.

The first railroad reached the Mississippi River at Rock Island (Figure 32), in 1854, and it became the first railroad to span the river in 1856. The Economic Panic of 1857 and the Civil War (1861-1865) stopped more railroads from crossing the Mississippi, but following the war railroads quickly spread to the west and along the river. Recognizing the steamboat companies could not compete, railroads began charging monopolistic prices. Farmers and other shippers responded by lobbying Congress for navigation improvements.

Before 1866, Congress authorized no comprehensive program for navigational improvements on the Mississippi River. The Corps had removed some rock from the Des Moines and Rock Island rapids, had improved the St. Louis and Dubuque harbors, and—particularly below St. Louis—had pulled some trees from the river and had cut others from the river's banks. This work had been local and limited.[18]

In 1866 states along the upper river persuaded Congress to authorize the Corps to establish a four-foot channel above St. Louis, through dredging, snagging, clearing overhanging trees, and removing sunken vessels. The Corps set the benchmark depth against the low-water year of 1864. Ideally, the river would carry a four-foot depth if it fell as low as it did in 1864. Subsequent projects used this benchmark. Work under the four-foot channel, however, could not create a permanently deep and safe channel, especially given the limited and sporadic funding Congress provided.[19]

As the Midwest's population and agricultural production grew following the Civil War, and as railroads began monopolizing bulk commodity transportation in the Midwest, pressure mounted on Congress to invest in more intensive navigation improvements. In 1878, Congress responded by authorizing the 4.5-foot channel project. Although just one-half foot more, this project would fundamentally change the Upper Mississippi's physical and ecological character.[20]

To achieve the 4.5-foot channel, the Corps built wing dams and closing dams, protected shorelines, and dredged stubborn bars. Long, narrow piers of rock and brush, wing dams constricted the river's flow, like the nozzle of a garden hose, making the river flow faster. In flowing faster it could cut through sandbars and could scour and carry more sediment. As water flowed around the ends of the wing dams and into the space between or behind them, it slowed and the sediment dropped out. Over the years, sand and vegetation filled the space between the dams. In this way, the Engineers constricted the river, gradually moving its banks inward, changing its landscape and its ecology.[21]

Wing dams depended upon the volume of water in the river. Without enough water, they could not scour the channel. To deliver more water to the main channel, the Corps built closing dams. These dams ran from the shore to an island or from one island to another. While the river could flow over them when high, for most of the year the dams directed water to the main channel.

Despite the Corps's efforts, river traffic declined. By 1880 the heyday of steamboating had passed. Railroads had taken most of the grain and passenger traffic away, and by 1890 timber rafting remained the only significant commerce. Timber products dominated the Upper River's commerce from the 1870s to the first decade of the twentieth century. Timber shipping, however, fell with the white pine forests of western Wisconsin and northern Minnesota. At its peak, during the years 1893 and 1894, the lumber industry employed about 100 raft boats and 100 sawmills on the Mississippi River between Minneapolis and St. Louis. The number of sawmills dropped to eighty by 1900, thirty-six by 1903, and one by 1913. Raftboats followed a similar decline. Of more than 100 raftboats plying the Upper River in 1893, eighty-six remained on the river in 1900, twenty in 1906, and only four in 1912. In 1915, the last lumber raft sailed down the St. Croix River from Hudson, Wisconsin, into the Mississippi River and down to Fort Madison, Iowa.[22]

Timber's demise revealed a problem that had been developing for nearly fifty years. The Mississippi had become a one-commodity river. As that commodity disappeared, the Upper River's failure as a transportation route became clear. In 1902, railroad baron James J. Hill declared that shipping on the Upper Mississippi River had declined so much that the river was no longer worth improving for navigation.[23]

Boosters again mobilized. They feared that the government might abandon navigation improvements on the Upper River, which would allow railroads to dominate shipping further in

the Midwest. They contended that a deeper, six-foot channel would provide the reliability and economies of scale needed to restore river commerce and compete effectively against railroads. For the next five years, they pushed for a six-foot channel, and on March 2, 1907 Congress authorized it. This project called for more wing dams and closing dams and more dredging. Under the 4.5- and six-foot channel projects, the Corps ribbed the Mississippi with wing dams from St. Louis to St. Paul and closed most of its side channels. The Corps also relied on channel constriction, dredging, and snag removal for the Mississippi between St. Louis and Cairo.[24]

In the end, despite the thousands of wing dams and closing dams and more than sixty years of dredging and snagging, commerce failed to return to the Mississippi. Recognizing the lack of traffic, in 1922 the Interstate Commerce Commission (ICC) declared much of the Upper Mississippi River valley landlocked and ordered railroads operating above St. Louis to dramatically raise their rates.

Agricultural equipment manufacturers in Moline, Illinois, repeatedly supported efforts to make the Upper Mississippi navigable. In 1917 the John Deere Company of Moline (Figure 31) sent 360 tons of plows on four government barges to Minneapolis. With adequate terminal facilities, the company's transportation manager believed, the company would save at least forty percent on shipping costs.[25] And in 1925 the company again tried to revive navigation and convince the ICC that the Upper Mississippi was still a working river. On May 4, the company sent 108 tons of farm machinery manufactured at its plant in Moline to the Deere-Webber Company of Minneapolis. The executives of John Deere and the Moline Plow companies would play important roles in the movement for a new navigation project.[26]

During the six-foot channel constriction era (1907-1930), the Corps opened two locks and dams on the Mississippi River above St. Louis, and a private interest completed another. In 1913, the Keokuk and Hamilton Power Company finished its hydroelectric dam at Keokuk, Iowa, flooding over the Des Moines Rapids (Figure 45). This would become Lock and Dam No. 19. The Corps completed Lock and Dam No. 1 in 1917, and in 1930 the Engineers finished Lock and Dam No. 2 at Hastings, Minnesota. For a distance above each lock and dam, navigation became safe and reliable, making the failure of channel constriction obvious.

In response to the ICC's decision and other forces, navigation boosters initiated another movement to revive navigation, a movement that surpassed all previous movements. Between 1925 and 1930, they fought to restore commerce and to persuade Congress to authorize a new project for the river, one that would allow the river truly to compete with railroads. Rather than constricting the channel more, they argued for locks and dams. They now wanted a nine-foot channel to match the depth Congress had ordered for the lower river in 1896 and for the middle river between St. Louis and Cairo in 1927.[27]

Their long effort succeeded on July 3, 1930, when President Herbert Hoover of Iowa signed the River and Harbor bill, authorizing the Corps to build twenty-three locks and dam from just above Red Wing, Minnesota (Figure 9), to Alton, Illinois.[28] The Corps built the structures between 1930 and 1940. Three years after Sharp's trip, the Corps finished the Lower St. Anthony Falls Lock and Dam, and in 1963 it completed the Upper St. Anthony Lock and Dam, extending the head of navigation 3.5 miles upstream and fulfilling Minneapolis's long-held dream. With a lift of 49.2 feet, the lock at Upper St. Anthony is the highest on the Mississippi River. Reflecting steep grade from above the falls to the Minnesota River, the two locks and dams at the falls and Lock and Dam No. 1 combine for a drop of 111 feet in 6.5 miles. In 1973 the Corps opened Lock and Dam No. 27 above St. Louis to bring the total number of locks and dams on the Upper Mississippi River to twenty-nine.[29]

When the Corps completed locks and dams No. 3 through 26 in 1940, no one knew whether shippers would use them. The Corps had been improving the Upper Mississippi River for navigation since before the Civil War with no success. Every time navigation boosters predicted that shippers would come back, they had not.

Captain "Rip" Ware (Figure 89) and the *R. H. McElroy* (Figure 88), featured in Sharp's journey, represented the beginning of the dream realized. They participated in the return of commerce to the Upper River. Ware arrived in Minneapolis with a tow of oil barges and left with six empties. During the downstream trip, the *R. H. McElroy* met coal tows coming up the river (Figure 27). Oil and coal dominated the Upper Mississippi River's commerce in the 1940s and 1950s. The completion of the locks and dams and World War II spurred this traffic.

German submarine attacks on shipping off the Atlantic and Gulf coasts during the first seven months of 1942 drove transportation to the Mississippi River. With no more than a dozen submarines, the Germans attacked 285 ships off the U.S. coast, sinking 248 and damaging thirty-two. The Germans recognized that they could cripple the U.S. Navy's Atlantic fleet and disrupt American civilian life by cutting off oil shipments to the East Coast, and they successfully did so, for a while.

The German submarine campaign caused an acute shortage of fuel oil and gasoline for the East Coast. To supply the East, the United States turned to railroads and inland waterways. While railroads hauled the majority of the petroleum, waterways made a vital contribution. The Lower Mississippi River and its eastward-branching tributaries directly benefitted from shortages along the Atlantic seaboard. The Upper Mississippi River also profited, because railroad car shortages forced oil and other commodities into barges.

Oil and oil products (fuel oil, kerosene, and gasoline) quickly became the most important commodities moving on the Upper Mississippi River. Comprising from thirty-five to forty per-

cent of the Upper River's traffic at the war's outset, petroleum products grew to nearly sixty percent by its end. In 1943, approximately ninety percent of the Twin Cities' fuel oil arrived in barges. Most of it came from the Wood River Refineries across from St. Louis, and the remainder from refineries in southern Louisiana. In addition, about twenty-five to thirty percent of the Twin Cities' gasoline arrived in river barges. The shipping of oil and oil products would more than double on the Upper River following Sharp's trip, overshadowing all other commodities. Not until the 1960s would oil shipping level off.[30]

Coal movement also increased dramatically on the Upper Mississippi during the war. By 1943, barges delivered about 600,000 tons of coal to the Twin Cities. Most went to power companies.[31]

Agricultural products counted among the most valuable products shipped downstream before and during the war, but the quantity of grain moved in barges at the time of Sharp's trip remained small.[32] Grain returned slowly to the river but would eventually dominate. Wheat, corn, and soybeans accounted for less than ten percent of the total commerce shipped on the Upper River until 1958, when these crops reached fourteen percent. Leading the resurgence of river commerce, grain comprised thirty percent of the total tonnage shipped by 1964, remaining at this level until 1972 when grain exports began booming. Between 1986 and 1995, grain shipping averaged 42.9 million tons or about fifty-two percent of the total annual tonnage. Today, corn and soybeans are the two principal crops moved on the Upper River.[33]

Although no other commodities approach the quantity of grain shipped on the river today, barges carry significant amounts of other commodities. Coal and petroleum products are the next most important. Between 1986 and 1995, barges carried an average of 9.8 million tons of coal or about twelve percent of the total. Petroleum products trailed just behind at an average of 9.2 million tons (eleven percent of the total) for the same period.[34]

THE LOWER MISSISSIPPI: FROM CAIRO TO THE GULF OF MEXICO

Given its physical character, the Lower Mississippi River would prove more difficult for the Corps to control. Engineers would have to line the river on both sides with levees from Cairo to below New Orleans, if it hoped to protect and occupy the Lower River's vast and fertile floodplain. To aid navigation and flood control, the Corps would shorten the Lower River by more than 150 miles, by cutting through some of the worst meanders. And the Corps would have to prevent the Mississippi River from taking a new course to the Gulf of Mexico through the Atchafalaya River.

Mark Twain, in *Life on the Mississippi*, writes that "One who knows the Mississippi will promptly aver—not aloud but to himself—that ten thousand River Commissions, with the mines of the world at their back, cannot tame that lawless stream, cannot curb it or confine it, cannot say to it, 'Go here,' or 'Go there,' and make it obey; cannot save a shore which it has sentenced; cannot bar its path with an obstruction which it will not tear down, dance over, and laugh at."[35] Twain was referring to the Mississippi River Commission (MRC), which Congress established in 1879 to develop plans to improve navigation, control flooding, and generally promote commerce.

Echoing Twain and many others, Captain Ware warned Sharp that the Lower Mississippi River's levee system could not contain the river indefinitely. He also predicted that the Atchafalaya River would capture the Mississippi's flow above Baton Rouge and send it down the new outlet. Yet, by 1953, the Lower Mississippi River's levee system had become a fortress from which the river is unlikely to escape, even as the Atchafalaya's fate was unclear in 1953.

From the time Jean Baptiste LeMoyne, Sieur de Beinville, founded New Orleans in 1717, residents of the Mississippi River's floodplain have tried to overcome the river's geologic origins. Between 1717 and 1727, Beinville oversaw the building of the Mississippi's first levees. Settlers in New Orleans created a mound one mile long, eighteen feet wide, and about three feet high. By 1735, levees extended to the north about thirty miles on both sides of New Orleans. By 1802, the levees had reached Baton Rouge (Figure 166), some 135 river miles upstream. And by 1849 levees ran up the river's west bank nearly to the Arkansas River, 489 river miles above New Orleans (Figure 168).[36]

Prior to the Civil War, some farmers along the floodplain between Rock Island, Illinois, and New Orleans joined to form levee districts, pooling their money to approach a segment of levee as one structure. Still, they simply did not have the capital or technical expertise to build a seamless and durable levee system. Up to 1866, the river could recapture its floodplain at will.

The federal government began its first concerted efforts to understand and control flooding on the Mississippi in 1879, when it created the MRC. Initially, the organization's flood prevention mandate extended only to planning efforts. Following the devastating flood of 1882, Congress expanded the MRC's mission to include building levees from Cairo to the Gulf, but only if they helped navigation. Up to the Civil War, Congress and the Presidents had generally opposed federal funding for navigation improvements and flood control. Following the war, Congress reversed its stand on navigation improvements, but continued to oppose flood control projects.[37]

To bypass this constraint, proponents of a federally funded levee system contended that narrowing the Mississippi at high water would deepen the navigation channel, like wing dams did

at low water above Cairo. Based on this argument, Congress and the MRC adopted a "levees only" policy for the Lower Mississippi River. Although some engineers suggested a multiple prong approach to floods (including upland reservoirs, diversions, and cut-offs), Congress refused to take an openly pro-flood control stand.[38]

By 1927 the MRC had brought nearly all of its 1,833 miles of levees up to the recommended height. The federal government and local interests had spent more than $228 million on the system. To protect the levees from the Mississippi's meandering tendencies, the MRC had also poured $57 million into armoring the river's banks. The levee system appeared complete and capable of handling any size flood, but by denying the river its floodplain, the Mississippi could only go up during high water.[39]

In 1927 the Lower Mississippi River's greatest flood proved the "levees only" theory wrong at a tremendous expense. The Lower Mississippi reclaimed much of its floodplain, submerging some 25,000-27,000 square miles. In places the river spread to sixty miles wide, damaging more than 162,000 homes. Not counting those who died from disease and other secondary causes, the flood killed more than 250 people. American Red Cross workers helped some 325,000 people in refugee camps. To save New Orleans, the government dynamited the Poydras levee, flooding St. Bernard and Plaquemines parishes. At its peak, the Mississippi carried more than 3,000,000 cubic feet per second (cfs). The Flood of 1993 only passed 1,000,000 cfs by St. Louis at its crest. The 1927 Flood caused more than one billion dollars in damage.[40]

Congress abandoned the levees only policy in the 1928 Flood Control Act for a multifaceted approach. While the Corps would repair and raise the levees, it would build floodways and spillways to carry excess floodwaters away from the Mississippi River. It also would end the MRC's long stand against cut-offs. Today, the diversion projects can funnel up to two-thirds of the water from a major flood away from Baton Rouge and New Orleans, sending some down the Atchafalaya and some into Lake Pontchartrain. Despite Captain Ware's belief that the levee system could not contain the Mississippi, today the river's chances of escaping are slim.[41]

ATCHAFALAYA

While the Corps and the MRC had secured the new levee system by 1953, the Atchafalaya River's fate, and with it that of the Mississippi below Baton Rouge, remained in doubt. As Sharp and Ware cruised downriver, a team of geologists reported that, unless the Corps did something, the Atchafalaya would begin siphoning away forty percent of the Mississippi River's flow sometime between 1965 and 1975. Once this happened, the Atchafalaya would become the Mississippi's primary outlet. The Mississippi from Baton Rouge to the Gulf of Mexico would become unnavigable, unless the Corps dramatically intensified dredging. Salt water from the

Gulf would push up the Mississippi, threatening urban water supplies and the river's ecosystem. Urban wastes and pollution from the chemical corridor would have nowhere to go.[42]

The Atchafalaya problem began during the fifteenth century, when a loop in the Mississippi River bowed out to the west, until it ran into the Red and Atchafalaya rivers. The meander became known as Turnbull's Bend. The Red then flowed into the Mississippi at the top of the bend's western curve and the Atchafalaya, a distributary, flowed out at the bottom. Fortunately, a large, long mass of trees and debris, called a raft, blocked the Atchafalaya, preventing the Mississippi from shifting course into it.

In 1831 Henry M. Shreve dredged through the eastern neck of Turnbull's Bend. Shreve's cut led the Mississippi away from the other two rivers. The old channel became an oxbow and began filling in. The oxbow's top and bottom portions became known as the Upper and Lower Old Rivers. Severed from the Mississippi, the Atchafalaya diminished, to the chagrin of shippers who relied on it.[43] In the 1880s, the Corps began trying to open the Atchafalaya for navigation. Between about 1880 and 1950, Corps work increased the Atchafalaya's share of the Mississippi's flow from seven to twenty-five percent.[44]

The Mississippi River had begun its ancient process of finding the steepest and shortest route to the Gulf. From the Old River to the Gulf, the Mississippi traveled more than 300 miles, but from Old River to the Gulf down the Atchafalaya measured only 140 miles. The Atchafalaya's bed sloped twice as much. Generally, the slower water moves the less sediment it can carry. As the Mississippi lost water to the Atchafalaya, the Mississippi's bed would start rising, encouraging even more water to follow the usurping stream.[45]

Recognizing the danger that Captain Ware alluded to and that geologists warned of, Congress authorized the Old River Control Structure in 1954. The structure would serve three purposes. First, it would hold the Mississippi River's flow into the Atchafalaya at about twenty-five percent. Second, it would act as a diversion channel during a major flood. The project could take 600,000 (cfs) from the Mississippi and 300,000 cfs from the Red, sending it away from Baton Rouge and New Orleans. Third, the project would include a navigation lock for commerce between the Mississippi and the Atchafalaya. Begun in 1955, the Corps completed the project four years later. The Atchafalaya project now keeps the Mississippi from forming its eighth lobe.[46]

MEANDERS

The meander at Turnbull's Bend characterized most of the Lower Mississippi. The soft alluvial deposits making up the Lower River's floodplain, combined with the river's shallow slope, created the dynamic that has defined the Lower Mississippi's landscape and ecosystem for well over 10,000 years. Wandering about the nearly flat valley, trying to find the steepest and easiest path

to the Gulf, the river topples banks and dissolves islands. Whenever its current slows—beyond its already slow pace—the Mississippi drops its sediment and builds sandbars, islands, and banks. Sharp's account of the *Drennan Whyte* illustrates this process well.

The *Drennan Whyte* sank with its cargo of gold worth $100,000. Shortly after, the channel shifted and buried the wreck in sediment. Ancil Fortune, a farmer, found the wreck twenty years later while digging a well. Since he did not own the land, he planted willows to screen the site and waited five years. Then he began digging. Before he could get the gold, the river changed course by a mile and reclaimed the wreck and the gold. This story has an air of folklore, but it captures the real character of the Lower Mississippi River. The river's wandering course has threatened more than sunken and buried treasure. Memphis has endured both the river's ability to give and to take away.

When first settled, boats landed below the high bank above which Memphis lies. But in the mid-1830s, the river began depositing sediment in front of the harbor. Two years later, a 1,000-foot sandbar lay anchored before Memphis. Brush and trees sprouted from it, and the Corps built a navy yard on it. During the next twenty years, more buildings followed on the seemingly permanent land.[47]

Then, in the 1860s, the Mississippi began cutting away the island, and within ten years the river's current attacked the exposed bank below Memphis, eating away an average of 100 feet per year. The floods of 1882 and 1883 ended the assault by realigning the channel again. This time the river began working on Hopefield Point, across from Memphis. The Mississippi shifted enough that the point aimed the current directly at the city. The Corps could not keep the city's harbor clear or stop the point's erosion. Instead of claiming the city's bank, the river redeposited Hopefield Point in front of Memphis, creating Mud Island, which is now the home to one of the largest museums dedicated to the Mississippi River and a popular spot for tourists.[48]

CUT-OFFS

As of 1953, Ware informed Sharp that the Corps had cut through sixty-six meanders, shortening the Mississippi River by 144 miles. Ware's estimate of the number of cut-offs is high, but he is close on the total miles. While cut-offs saved the *McElroy* and other tows time and money, the Corps and the MRC have not always supported cut-offs.

Shreve's cut-off at Turnbull's Bend might have spurred a wholesale program of cut-offs, but Congress refused to fund them and too many people recognized the dangers. Flood-control interests wanted to cut through the loops, because they knew that shortening the path to the Gulf would hurry the passage of flood waters and reduce damage. Yet, they recognized that speeding up the river's current would cut it more forcefully at the first bend downstream. Without substantial bank protection, the river would find a new course at someone else's expense.

From a steamboat pilot's perspective, cutting through the meanders to shorten the river seemed common sense. Why take a thirty-mile detour, when a little dredging could reduce the distance to a few miles? Steamboat navigation had begun on the Lower Mississippi in 1811-1812, when Nicholas J. Roosevelt (great-granduncle to President Theodore Roosevelt) piloted the *New Orleans* down the Ohio River from Pittsburgh, Pennsylvania, to the Mississippi River at Cairo and on to its namesake city. The *New Orleans* left Pittsburgh on September 27, 1811, and, despite the most powerful earth quake recorded in North America, it reached New Orleans on January 10, 1812. By 1834 New Orleans counted some 2,300 steamboat landings.[49]

The Corps warned that navigation could suffer from cut-offs. Making the slope of the river steeper through a short reach worked well to pass high water. At low water, however, the river would fall lower than it otherwise would have, threatening to ground steamboats and make city harbors inaccessible. This would force the Corps to dredge more, which it could not afford. For a number of reasons, the MRC refused to excavate cut-offs from 1884 until 1933.

Partially because of the 1927 Flood and partially because new equipment and methods suggested better results, the MRC reversed its stance in 1933. That year the Corps excavated five cut-offs below Memphis and nine more in next nine years. Together the new cut-offs shortened the river by 152 miles. In 1942, however, the MRC again discontinued the cut-off program. The MRC has approved some cut-offs since but generally does not pursue them.[50]

CONCLUSION

By 1953 the Corps of Engineers had transformed the Mississippi River from its headwaters to the Gulf of Mexico. In addition to all the work between Minneapolis and New Orleans, the Corps had constructed six dams in the headwaters region, in north-central Minnesota, between 1884 and 1912. The Corps planned to store water from the spring snowmelt and release it during the late summer and fall to aid navigation downstream. To overcome the eight-to-twelve-foot clay bars at the river's mouths, James Eads built his famous jetties at the end of the South Pass between 1875 and 1879, allowing New Orleans to grow into one of America's largest port cities.[51]

Today the Mississippi River embodies what generations of Americans have wanted it to be. While America is still deeply invested in what it has done, more recent generations are trying to undo and mitigate the environmental damage caused by efforts to manipulate the Mississippi. Hundreds of biologists warn that the locks and dams above St. Louis are killing the river. More than ninety percent of the Lower Mississippi's floodplain is gone. The already massive dead zone in the Gulf doubled in size between 1993 and 2001 and now covers an area as large as New Jersey. Nitrogen-loaded fertilizer, running off Midwestern and Great Plains farm fields, spurs the dead zone's growth. The algae attracts "tiny crustaceans called copepods and other organisms that graze on plankton," says David Malakoff. When "Dead algae and the grazer's fecal pellets

sink to the bottom," he explains, "they are devoured by oxygen-consuming bacteria." The bacteria consume so much oxygen that no fish, shrimp, lobster, or other aquatic life can survive.[52] And the Gulf is eating away twenty-five to thirty-five square miles of Louisiana's coastal marshes each year. The rate is fastest along the Mississippi River delta. Exotic species have invaded the river and have taken over large portions of the river's ecosystem from the delta to the Twin Cities.

What does losing the Mississippi River's natural and historic places mean to our understanding of, and relationship to, the river? Without thinking about the answers, we are losing them. Every time we eliminate a natural area or historic site, we lessen the real and spiritual power of the Mississippi River. We cannot freeze the river in time. There are places where development is possible and even desired, but as communities and a nation we need to think much more about where and how we do it. As Sharp says, "the Mississippi River will always be there." But in response, we might ask, In what condition?

Notes

1. For additional information about the Mississippi's geology, see the *Appendix* on pages 183–185.

2. Terri Tempest Williams, *Red: Passion and Patience in the Desert* (New York: Vintage Books, October 2003; copyright 2001), p. 4.

3. As quoted in Clarence Jonk, *River Journey* (St. Paul, Minnesota: Minnesota Historical Society Press, Borealis Books, 2003; first published 1964 by Stein and Day, New York), p. x.

4. Eric Watkins, *The Mississippi River as Image, Myth, and Metaphor in American Literature* (Minneapolis: University of Minnesota, Ph.D. Thesis, 1971), pp. 8, 10, 11.

5. J. C. Beltrami, *A Pilgrimage in America, Leading to the Discovery of the Sources of the Mississippi and Bloody Rivers; with a Description of the Whole Course of the Former, and of the Ohio* (Chicago: Quadrangle Books, Inc., 1962; first edition published in London, England, 1828), p. 132.

6. Beltrami, *Pilgrimage*, p. 151.

7. George Catlin, *Letters and Notes on the Manners, Customs, and Conditions of North American Indians* (New York: Dover Publications, 1973; London, 1844), vol. 2, p. 142.

8. Catlin, *Letters*, vol. 2, pp. 130, 132.

9. Catlin, *Letters*, vol. 2, see pp. 129–59 for his account of the Upper Mississippi River. Lewis, pp. 2, 5.

10. Edward Relph, *Place and Placelessness* (London: Pion Limited, 1976), p. 42.

11. Robert R. Archibald, *A Place to Remember: Using History to Build Community* (Walnut Creek, California: AltaMira Press, 1999), p. 25.

12. This is an often used metaphor. See Roger Rosenblatt, in "Life on the Mississippi," *Time*, Special Issue (July 10, 2000), p. 92.

13. From *Explore Your National Parks: Historic Places, Teacher's Guide*, B-1. National Park Service.

14. Watkins, *Image, Myth, and Metaphor*, pp. 3, 117–18.

15. Archibald, *A Place to Remember*, p. 46

16. Technically, the Upper River Mississippi River flows from Lake Itasca to Cairo; the Middle from Cairo to St. Louis; and the Lower from St. Louis to the Gulf of Mexico. Most people, however, refer to only two sections: The Upper River, from the headwaters to Cairo, and the Lower River, from Cairo to the Gulf. See the *Appendix* for further clarification.

17. *Schoolcraft's Narrative Journal of Travels*, edited by Mentor L. Williams (East Lansing: Michigan State University Press, 1992; copyright 1953, 1992, Michigan State University Press), pp. 216–17, 494.

18. Frederick J. Dobney, *River Engineers of the Middle Mississippi: A History of the St. Louis District, U.S. Army Corps of Engineers* (Washington, D.C.: U.S. Government Printing Office, 1978), chapter 2. Dobney shows that the Corps of Engineers carried out much more snagging and clearing on the Middle Mississippi between 1824 and 1860, but it did so in fits and starts, due to inconsistent funding from Congress. Louis C. Hunter, *Steamboats on Western Rivers: An Economic and Technological History* (Cambridge: Harvard University Press, 1949; reprint New York: Octagon Books, 1969), chapter 2.

19. *Laws of the United States Relating to the Improvement of Rivers and Harbors*, vol. 1 (Washington, D.C.: Government Printing Office, 1913), chapter 138, p. 156; Ronald Tweet, *A History of the Rock Island District, U.S. Army, Corps of Engineers, 1866-1983* (Washington: U.S. Government Printing Office, 1984), p. 67; and Dobney, *River Engineers*, p. 44.

20. U.S. Congress, Senate, *Report of the Select Committee on Transportation Routes to the Seaboard*, 43d Congress, 1st session, 1874, S. Rep. 307, pp. 1, 7–8, 188, 198-99, 211, 213, 243.

21. The Corps began working on the Des Moines and Rock Island Rapids before the Civil War, surveying them and removing rock. Roald Tweet, "A History of Navigation Improvements on the Rock Island Rapids: The Background of Locks and Dam 15," U.S. Army, Corps of Engineers, Rock Island District (Rock Island, Illinois, 1980), pp. 1–15.

22. Grain traffic through the Des Moines Rapids Canal and at St. Louis during the late-nineteenth century illustrates the decline of the freight trade on the Upper River. In 1879 and 1880, more than 2,000,000 bushels of grain passed through the canal, but the canal keeper only registered 400,000 bushels at the end of the decade and less than 56,000 bushels after 1895. See Frank H. Dixon, *A Traffic History of the Mississippi River System* (Washington, 1909), p. 51; and U.S. Army, Corps of Engineers, *Annual Reports of the Chief of Engineers* (Washington, D.C., 1892-1909).

23. *Proceedings of the Upper Mississippi River Improvement Convention, 1902* (Quincy, Illinois: Volk, Jones & McMein Co., Printers, n.d.), pp. 5–6.

24. John O. Anfinson, *River We Have Wrought: A History of the Upper Mississippi River* (Minneapolis: University of Minnesota Press, 2003), chapters 5–6; Dobney, *River Engineers*, pp. 52, 67–68.

25. *Annual Report, 1918*, pp. 1169–70.

26. "Making History," *The Realtor* 9:44 (May 5, 1925), p. 2; "Minneapolis An Inland Port," *The Realtor* 10:43 (May 4, 1926), p. 2; Mildred Hartsough, *From Canoe to Steel Barge* (Minneapolis: University of Minnesota Press, 1934), pp. 238–39; and Anfinson, *River We Have Wrought,* chapters 9–10.

27. Anfinson, *River We Have Wrought*, chapters 8–11; Floyd M. Clay, *A Century on the Mississippi: A History of the Memphis District, U.S. Army Corps of Engineers, 1876–1976* (Memphis District, U.S. Army Corps of Engineers, 1976), p. 45; Dobney, *River Engineers*, p. 75.

28. Alton and St. Louis on the Mississippi were the two ultimate termini for the National Road (now U.S. 40), the nation's first federally funded interstate highway that began in Cumberland, Maryland, in 1808 and concluded in Vandala, the Illinois state capital, in 1850. From Vandalia the road split into two segments to the Mississippi.

29. Anfinson, *River We Have Wrought*, pp. 269–74.

30. Captain S. W. Roskill, *The War at Sea, 1939-1945* (London: Her Majesty's Stationary Office, 1956), vol. 2, p. 96; Homer H. Hickman, *Torpedo Junction: U-Boat War off America's East Coast, 1942* (Annapolis, Maryland: Naval Institute Press, 1989), p. 1; John O. Anfinson, "War in the Heartland: The St. Paul District," in *Builders and Fighters: U.S. Army Engineers in World War II*, Barry W. Fowle, ed. (Office of History, United States Army Corps of Engineers: Fort Belvoir, Virginia, 1992), pp. 252-57; "The River Never Dies," *Waterways Journal* (March 4, 1944), p. 1; "Neglected Shipping Routes Safe From Submarines," *Upper Mississippi River Bulletin* (*UMRB*) 11:5 (May 1942), p. 2; George H. Weiss, "River Traffic Barge Scarcity Faces Shippers," *UMRB* 11:2 (February 1942), p. 3; Richard Oberfeld, "War Comes to the Mississippi," *UMRB* 12:5 (May 1943), p. 4; "Busy Waterways," *Business Week* (July 22, 1944), pp. 40, 42 [In the same article, *Business Week* called petroleum products "A savior for the waterways, when consumer cargoes virtually vanished as a result of wartime production restrictions . . ." (p. 40)]; "History Proves Value of River Improvement, Navigation, Says Strong," *UMRB* 12:12 (December 1943), pp. 3, 4; and Raymond H. Merritt, *Creativity, Conflict & Controversy: A History of the St. Paul District, U.S. Army Corps of Engineers* (Washington: U.S. Government Printing Office, 1979), p. 159.

31. "History Proves Value of River Improvement, Navigation, Says Strong," *UMRB* 12:12 (December 1943), p. 3.

32. Joseph R. Rose, *Wartime Transportation* (New York: Thomas Y. Crowell Company, 1953), p. 127.

33. Richard Hoops, *A River of Grain: the Evolution of Commercial Navigation on the Upper Mississippi River*, College of Agricultural and Life Sciences Research Report, R3584 (Madison: University of Wisconsin-Madison, n.d.), p. 112.

34. Hoops, *River of Grain*, p. 112; and *The 1997 Inland Waterway Review*, Draft, pp. 3–16 to 3–17.

35. Mark Twain, *Life on the Mississippi* (New York: Bantam Books, 1990; original edition published by Harper and Brothers, 1896), pp. 138-39.

36. Albert E. Cowdrey, *Land's End: A History of the New Orleans District, U.S. Army Corps of Engineers, and Its Lifelong Battle with the Lower Mississippi and Other Rivers Wending Their Way to the Sea* (1977), p. 1; and Clay, *Century*, p. 4.

37. Dobney, *River Engineers*, pp. 78–79; and River and Harbor Act of 1913, *Laws*, p. 1597.

38. Cowdrey, *Land's End*, pp. 29, 23–33, 34.

39. Clay, *Century*, p. 82.

40. Clay, *Century*, chapter 4; Cowdrey, *Land's End*, p. 34; and John Barry, *Rising Tide: The Great Mississippi River Flood of 1927 and How It Changed America* (New York: Touchstone, 1998), p. 16.

41. Clay, *Century*, chapter 5; Cowdrey, *Land's End*, pp. 43–44; Martin Reuss, *Designing the Bayous: The Control of Water in the Atchafalaya Basin, 1800-1995* (Alexandria, Virginia: Office of History, U.S. Army Corps of Engineers, 1998), pp. 127–28; and USGS, "Mississippi River," p. 9.

42. Cowdrey, *Land's End*, pp. 51–52; Reuss, *Designing the Bayous*, p. 218.

43. In 1828, Shreve was appointed by Secretary of War James Barbour as Superintendent of Western Rivers. In 1829, Shreve completed the first steam snagboat, the *Heliopolis*, and began removing snags from the river. By 1830 Shreve had excised the most threatening snags between St. Louis and New Orleans. Reuss, *Designing the Bayous*, pp. 26–29; Dobney, *River Engineers*, pp. 21–23; and Hunter, *Steamboats on Western Rivers*, chapter 2.

44. Reuss, *Designing the Bayous*, p. 210

45. Reuss, *Designing the Bayous*, p. 211.

46. Reuss, *Designing the Bayous*, pp. 239–42; and Cowdrey, *Land's End*, pp. 51–52.

47. Clay, *Century*, pp. 23–24.

48. Clay, *Century*, p. 33.

49. Stephen E. Ambrose and Douglas G. Brinkley, *The Mississippi and the Making of a Nation, from the Louisiana Purchase to Today* (Washington, D.C.: National Geographic, 2002, pp. 84–85, 86; and Clay, *Century*, pp. 5–6, 10.

50. Clay, *Century*, pp. 128, 132-33; Anuradha Mathur and Dilip da Cunha, *Mississippi Floods: Designing a Shifting Landscape* (New Haven: Yale University Press, 2001), p. 38.

51. Ambrose and Brinkely, *The Mississippi*, pp. 21-22; Todd Shallat, *Structures in the Stream: Water, Science, and the Rise of the U.S. Army Corps of Engineers* (Austin: University of Texas, 1994), pp. 193–99; Barry, *Rising Tide,* chapters 5 and 6; and Anfinson, *River We Have Wrought*, pp. 81–81, 89.

52. David Malakoff, "Coastal Ecology: Death by Suffocation in the Gulf of Mexico," http://pangea.stanford.edu/courses/GES56Q/Malakoff-Death%20by%20Suffocation.doc.

Appendix:
The River's Geology

John O. Anfinson

So much of what once defined, and in important ways still defines, the Mississippi's physical and ecological character lies in its geologic origins. And so much of the rationale for doing what we have to the Mississippi comes from our efforts to overcome the river's natural qualities.

GLACIAL RIVERS

Cairo, Illinois, rests at the confluence of the Mississippi and Ohio rivers and separates the Upper from the Lower Mississippi River. The contrast at Cairo is striking. Sharp and Captain "Rip" Ware, like so many travelers, comment on the change. Below the Ohio's mouth, Sharp writes, the Mississippi "changes utterly. It's a transcendent, timeless realm. There is an elemental awe about it. Everything human disappears in the riverscape." To Ware the Upper River was beautiful and the Lower "wide . . . vast, desolate. . . . beyond the grasp of your imagination." One hundred and seven years earlier, in July 1846, Charles Lanman, a painter and travel writer, commented that, "Excepting a few rocky bluffs found some distance below St. Louis, and in the vicinity of Natchez, both shores of the river are low, level, and covered with dense forests of cotton-wood and cypress, where the panther and the wolf roam in perfect freedom, and the eagle swoops upon its prey undisturbed by the presence of man."[1]

These observations about the Lower River are understandable. Below Cairo the landscape flattens. Few bluffs frame the river valley to give it human dimension. The floodplain varies from thirty to ninety miles wide and covers 28,000 square miles. For many of the 954 miles to the Gulf, the only things you can see from the river are the levees, the floodplain forest, and the river itself.[2]

Cairo is the dividing point for geologic reasons. Four times during the Pleistocene era, which began about 2,000,000 years ago, glaciers advanced and retreated over North America. In doing so they defined the Mississippi River's basic shape. The Upper Mississippi and the

Lower Mississippi emerged through two different processes. The Upper Mississippi has cut down into the landscape; the Lower Mississippi lays on top of it.

The Mississippi above Cairo formed as the last glacial advance ended. As the glaciers melted, some 10,000 to 15,000 years ago, they created mammoth lakes. The Great Lakes stood hundreds of feet higher than they do today. Lake Agassiz, the largest glacial lake in North America, lay in south-central Canada and in the Red River valley between Minnesota and North Dakota. The glaciers blocked these lakes from draining to the north or out the St. Lawrence River to the Atlantic Ocean. So, Lake Erie poured down the Ohio, Lake Michigan down the Illinois, Lake Superior out the St. Croix, and Lake Agassiz into the Red and Minnesota river valleys and then into the Mississippi River between Minneapolis and St. Paul.

Each of the glacial lakes acted as a settling basin, where the sediment flowing into them dropped out. Water poured clear and clean from the glacial lakes. Rivers, however, bear as much sediment as they can carry. To compensate, the glacial rivers picked up sediments, by carving broad and deep valleys. When the glaciers disappeared, the glacial lakes fell and the land rebounded, ending the southern flows out of the Great Lakes and Lake Agassiz. Without their headwaters, the Ohio, Illinois, St. Croix, Minnesota, and Upper Mississippi rivers dwindled. Unable to carry as much sediment, their valleys began to fill in.

The Glacial River Warren cut a wide, deep valley for the Minnesota River and for the Mississippi below its confluence with the Minnesota. Above the Minnesota's mouth, a much smaller glacial Mississippi River flowed out of north-central Minnesota, leaving a narrow and shallow valley. The Mississippi River, therefore, begins its life as a large floodplain river at the mouth of the Minnesota River, six miles above downtown St. Paul. This is the Mississippi most people associate with Mark Twain and steamboats. From the confluence, the Upper Mississippi now winds its way between bluffs one-half to more than six miles apart and 100 to more than 325 feet high.[3]

The Upper Mississippi River differed markedly from the Lower River. Most importantly, below St. Paul the Upper River's main channel did not meander in great loops; it migrated slowly from side to side in long bows or arcs. Weaving inside one forested island and outside another and back inside the next, the river created a braided channel. The Upper Mississippi rarely threatened to carry a town or farm into the river. The Upper Mississippi's floodplain, while large, does not match the Lower River's.

At the beginning of the Pleistocene era, an arm of the Gulf of Mexico, called the Mississippi Embayment, met the Mississippi River near Cairo. The river and the Gulf battled each other during four periods of glacial advances and retreats. Each time the glaciers moved forward, they captured great amounts of the earth's moisture, and the oceans fell by as much

as 450 feet. During these periods, the Mississippi cut into the receding sea bed and deposited sediment over it, extending its delta downward. When the glaciers melted, the Gulf pushed the Mississippi's delta back and submerged it. At the end of the last glacial period, the great loads of sediment carried by the glacial rivers St. Croix, Warren, Illinois, and Ohio helped to fill the Lower Mississippi Valley and extended the delta out to near its present form.

Geologists figure that the Mississippi has occupied seven "delta lobes" during the last 5,000 years. Swaying over a 200-mile, east-to-west span, the river's goal has been to find the shortest and steepest route to the Gulf. As each lobe aged, the river's slope flattened, its pace slowed, it dropped more sediment, and its bed rose up. The river then sought a new, shorter, and steeper path to the Gulf.[4]

At the Head of Passes, the Mississippi splits into multiple distributaries that carry its water to the Gulf. For about 600 miles below Cairo, the alluvial sediment is made of course materials that allow the river to meander. Through this reach the Lower River is shallower. In its natural condition, the river became so shallow here that keelboats and steamboats frequently grounded on sandbars. In the last reaches of the Lower River, clay and silt are the primary materials. Meandering is more difficult, so the river cuts a deeper channel. Just above New Orleans, the Mississippi is less than one-half mile wide but about 200 feet deep. Yet, at the mouths of the Mississippi, before navigation improvements, the silt and clay once formed bars with only eight to twelve feet over them.[5]

Notes

1. Charles Lanman, *A Summer in the wilderness; embracing a canoe voyage up the Mississippi and around Lake Superior* (Library of Congress, American Memory Website; created/published: New York: D. Appleton & Company: Philadelphia, G. S. Appleton, 1847), p. 20.

2. Calvin Fremling and Barry Drazkowski, *Ecological, Institutional, and Economic History of the Upper Mississippi River*, Resource Studies Center, St. Mary's University of Minnesota, Winona, pp. 6–7; Cowdrey, *Land's End*, p. xiii; and Anuradha Mathur and Dilip da Cunha, *Mississippi Floods: Designing a Shifting Landscape* (New Haven: Yale University Press, 2001), p. 33.

3. Robert H. Meade, "Setting: Geology, Hydrology, Sediments, and Engineering of the Mississippi River," U.S. Geological Survey Circular 1133, http://water.usgs.gov/pubs/circ/circ1133/geosetting.html, p. 1.

4. Meade, "Setting," p. 2.

5. United State Geological Survey (USGS), "Mississippi River," p. 7; and Cowdrey, *Land's End*, p. 17.

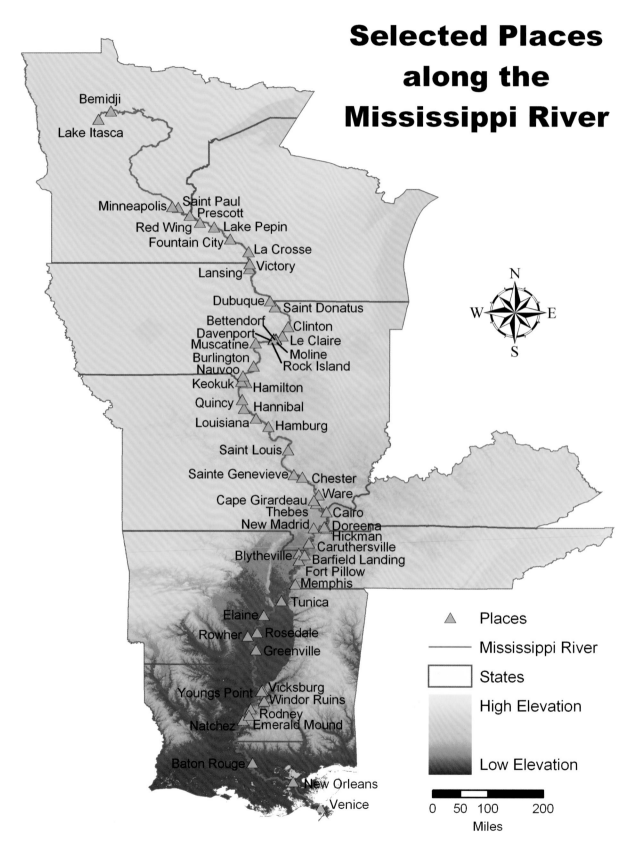

Selected Places along the Mississippi River

Bemidji
Lake Itasca

Minneapolis Saint Paul
Prescott
Red Wing Lake Pepin
Fountain City
La Crosse
Victory
Lansing

Dubuque Saint Donatus
Bettendorf Clinton
Davenport Le Claire
Muscatine Moline
Burlington Rock Island
Nauvoo
Keokuk Hamilton
Quincy Hannibal
Louisiana Hamburg

Saint Louis

Sainte Genevieve Chester
Ware
Cape Girardeau Cairo
Thebes Doreena
New Madrid Hickman
Caruthersville
Blytheville Barfield Landing
Fort Pillow
Memphis

Tunica
Elaine
Rowher Rosedale
Greenville

Youngs Point Vicksburg
Windor Ruins
Rodney
Natchez Emerald Mound

Baton Rouge

New Orleans
Venice

N
W E
S

▲ Places

— Mississippi River

☐ States

High Elevation

Low Elevation

0 50 100 200
Miles

Copyright © 2005 Kai Degner for the Center for American Places

186

Notes on the Photographs

FRONTISPIECE*

Rosedale, Mississippi, incorporated in 1882 by wealthy plantation owners, lies a few miles north of the confluence of the Mississippi and Arkansas rivers and about thirty-one miles north of historic Greenville, Mississippi.

Of this photograph taken outside Rosedale, Sharp writes: "Up and down the river I found insular communities of people who seemed more uncaring than poor. After the spring runoff, or a flood, when the river has receded and the sandbars dried out, they return with their scraggly children, chickens and pigs, rekindling wispy columns of smoke above their exhausted trailers and houseboats. Good times or bad, they face toward the river, not the land."

FIGURE 1

In 1832, more than 300 years after the first Europeans began exploring the Mississippi, Henry Rowe Schoolcraft was the first "white man" to locate its headwaters. He did so with the indispensable guidance through the northern forests of the Chippewa Chief Ozaawindib ("Yellow Head"). "What had been long sought," wrote Schoolcraft, "at last appeared suddenly. On turning out of a thicket, into a small weedy opening, the leering sight of a transparent body of water burst upon our view. It was Lake Itasca."

During the 1930s, the channel of the Mississippi as it emerges from Lake Itasca was re-routed by the Civilian Conservation Corps to make it easier for visitors to view. A surrounding swamp was drained, a new channel dug, and a human-made rapids installed.

FIGURES 2 AND 3

Bemidji is one of northern Minnesota's larger towns at the intersection of U.S. Routes 2 and 71 and Minnesota Highways 7, 12, and 15. It serves as a resort, lumber, and trade center for a large area, and as home to Bemidji State University (1919).

** These notes were compiled for most, but not all, of the photographs in this book. They were researched and co-written by Randall B. Jones, project director.*

FIGURES 4 AND 5

Minneapolis (combining *minne*, a Sioux word for water, and *polis*, the Greek word for city) is the largest city in Minnesota and is situated by the Falls of St. Anthony, the head of navigation on the Mississippi. The falls, named by Father Louis Hennepin in 1680, provided water-power for a mill that in 1823 ground coarse flour for the soldiers nearby at Fort Snelling. The fort, built between 1819 and 1824 on a bluff above the confluence of the Mississippi and Minnesota rivers, was 700 miles upstream from supplies and reinforcements, when bison reportedly still visited the river. As a power source, the falls played a crucial role in the rise of Minneapolis's flour and lumber milling economy. At one time, as many as twenty-seven sawmills were situated on the falls, when the seemingly inexhaustible forests of the north jammed the river. Eventually, flour milling superseded lumbering in economic importance, as the forests dwindled and wheat production grew. In fact, from 1880 to 1930 Minneapolis led the nation in flour production.

FIGURE 6

Lock and Dam No. 1 was completed in 1917, not only to support navigation between the Twin Cities, but also to generate hydroelectric power.

A visitor in 1848, Henry Lewis, described St. Paul as "a small Indian trading post" consisting of "only some forty or fifty families." Within just four decades, it was a major city of more than 70,000 residents.

FIGURES 7 AND 8

With the growth of lumbering and settlers traveling upriver into the Minnesota Territory, Prescott was established at the mouth of the St. Croix River, later assigned as a shared border between the states of Wisconsin and Minnesota. During long winter months upriver from Prescott, crews felled and stacked logs, and then with the spring thaw floated them downstream. At Prescott, the logs were gathered at a boom where they were sorted, scaled, and grouped into large rafts to be floated further downriver, and the men who manned those rafts made the necessary preparations for their trips. George Merrick, whose father opened a warehouse in Prescott in 1853, recalled: "Stores of pork, beans, flour, molasses and whiskey were laid in. The hundreds of rough men who handled the great steering oars on these rafts spent their money in the saloons which lined the river front and adjacent streets . . . often ending their 'sprees' with a free fight between rival crews." Mark Twain described these raft men as "fiddling, song-singing, whiskey-drinking, breakdown-dancing rapscallions."

In that era the northern timberlands seemed endless, depressing many travelers for whom it took days and weeks to navigate. Yet by the turn of the twentieth century, the forests were

significantly depleted, even as the largest log raft on the Mississippi was assembled at Lynxville, Wisconsin, in 1896. It was 270 feet wide and 1,550 feet long. The last rafting of lumber on the Mississippi River came in 1915. By 1953, the river's major commercial traffic was in barges of oil and coal, coming up-river from the south.

FIGURE 9

The name itself charms: Red Wing was a Dakota Sioux chief, and members of his band settled a village below Barn Bluff (shown in the background of the photo), which Henry David Thoreau climbed in 1861 and which today is listed on the National Register of Historic Places.

The Mississippi between Red Wing and Hastings served as a natural boundary between the Chippewa (on the river's east bank) and the Sioux (on its west bank), although land on either side was often fiercely contested between the two tribes before the arrival of Europeans.

FIGURES 10 AND 11

Lake Pepin's shorelines are the same ones along which Indians once paddled their canoes. It is easy to imagine their campfires, their plumed ceremonial headgear, their women and children moving about their tents in the sheltering forest; to imagine the seventeenth-century French voyagers, sustained by corn meal, fresh game, and tobacco, trading metal hatchets, along with measles, small pox, and other Old World diseases to the Indians for beaver pelts, and the black-gowned, hair-shirted priests eager to save the aborigines' infidel souls.

Despite its ofttimes serene aspect, "as reposeful as dreamland," wrote Mark Twain, Lake Pepin has had a fierce reputation for bedeviling river commerce and pilots, especially during the era of steamers. In the late autumn or early winter the lake tends to freeze up before other stretches on the Upper River, and then it remains iced up into late spring, impeding or blocking passage to river traffic. The exposed, windswept lake can be especially treacherous to navigate with the onset of a sudden prairie squall or thunderstorm.

The lake region gained a reputation with early white explorers and travelers as a place abounding with rattlesnakes. By 1931, a few conservationists and biologists were warning that declining oxygen levels due to run-off pollution, sewage, and silting would lead to a massive fish die-off in Lake Pepin. During the ensuing decades conservation efforts improved the health of the lake and river, and river recreation is now recognized as a vital economic activity to the region.

The fate of the Mississippi will probably always be contested between boosters of navigation and conservationists. President Clinton, in 1998, recognized the Upper Mississippi as a national heritage river.

FIGURES 12, 13, AND 14

Fountain City, named for the abundance of springs in the surrounding hills, is located near Eagle Bluff, which at 550 feet is the highest point on the Mississippi. The town's origins trace back to 1839 when a settler, Thomas Holmes, built a cabin and began selling cordwood to passing steamboats, which required tons of it to fire their boilers. Known initially as "Holmes Landing," the town was platted and renamed in 1854. About six miles downstream, on the opposite shore, is Winona, Minnesota.

About these photos the author notes: "The era is obvious: General Dwight D. Eisenhower is America's new president; in the Soviet Union, Stalin is suddenly dead of a cerebral hemorrhage, triggering a scramble for power in the Politburo; and Americans, exploring the new medium of television, are watching *Dragnet, Playhouse 90, Ozzie and Harriet,* and the amazing Liberace, while in movie theaters *Shane, Stalag 17, On the Waterfront,* and *From Here to Eternity* are drawing large crowds. Aerosol cans have made their first appearance, as well as credit cards issued by Diner's Club and American Express."

FIGURES 15, 16, 17, AND 18

La Crosse was founded in 1841, and by 1852 it had its first sawmill. With lumbering and steamboat construction underwriting its economy, La Crosse grew rapidly. By 1890, it boasted more than 30,000 residents and at least thirteen mills. City entrepreneurs in the 1890s invested more money in steamboats than investors in any other city on the Upper River. A railroad swing bridge was built at La Crosse in 1875, but as historian Mark Neuzil notes: "Perhaps because of the dominance of the steamboat industry, La Crosse's bridges were known as some of the least troublesome on the river" to steamboat pilots.

La Crosse's downtown featured electric lighting as early as 1881. Willard Glazier, a nineteenth-century travel writer, visited the city that year and reported, "the streets at night are . . . well illuminated."

FIGURES 19 AND 20

The Black Hawk War was a consequence of the national Indian Removal program approved by Congress and President Andrew Jackson in which roughly 70,000 Indians east of the Mississippi were relocated westward. Under Chief Black Hawk—who had defied the U.S. by repeatedly leading his people back across the Mississippi to their home village at Rock Island, Illinois, thereby incurring the short and vicious war that bears his name—starving Sac and Fox Indians tried unsuccessfully to surrender three times before being slaughtered—men, women, and children—by both white soldiers and Sioux who had been hired by the U.S. Army.

When Black Hawk's surrender was formally recognized, he said, "The white men are bad schoolmasters; they carry false books, and deal in false actions; they smile in the face of the poor Indian to cheat him; they shake them by the hand to gain confidence, to make them drunk, to deceive them, and ruin our wives. We told them to leave us alone, and keep away from us; they followed on, and beset our paths, and they coiled themselves among us, like the snake. They poisoned us by their touch. We were not safe. We lived in danger. We were becoming like them, hypocrites and liars, adulterous lazy drones, all talkers and no workers . . ."

With no ruins to sigh over, a simple marker is the lone indication that a peoples' holocaust took place here. Few know that the anonymous island, one of twenty islands in this stretch of the Mississippi River, has a name: Battle Island.

Abraham Lincoln cut his military teeth in the Black Hawk War, but he did not participate in the Battle Island massacre or any other fighting during the war.

FIGURE 22

Lansing was laid out in 1851 and became a center for grain and lumber milling, and a busy port-of-call. During the 1890s, as elsewhere on the river, pearl-button manufacturing became an important industry in Lansing. The buttons were fashioned from mussels and clams that commercial fisherman harvested from the Mississippi. Lansing lies about half-way between Lock & Dam No. 8 and No. 9, alongside the Upper Mississippi River National Wildlife and Fish Refuge.

At the time this photograph was made, the author writes: "Elsewhere in the world Edmund Hillary and Tenzing Norgay succeed in climbing Mt. Everest; twenty-seven year-old Elizabeth II is crowned Queen of England; Soviet and East German forces suppress rioting in East Berlin; convicted spies Julius and Ethel Rosenberg are executed in Sing Sing prison for passing military secrets to the Soviets; and thousands of American troops are dying in Korea. In the heartland, mindful of all that, life goes on the same."

FIGURE 23

In the 1780s a French fur trapper, Julien Dubuque, settled here, giving his name to the town that would arise during the first half of the nineteenth century, as the area's lead mines drew as many as 10,000 miners by 1829 to nearby Galena, Illinois, today a big-time heritage tourist town. The metal was an important commodity in Dubuque, making it one of the earliest and largest towns settled in Iowa. By the nineteenth-century's close, however, lumber milling and boat building were Dubuque's main industries.

The flags of England, Spain, France (twice), and the United States have flown over the Dubuque region, not to mention the prior ownership claims of the Indian nations of Mesquakie, Sioux, Fox, and Sac.

FIGURES 24, 25, AND 26

Peter Gehlen and other settlers from Luxembourg brought with them to Iowa's rolling hills their faith and traditional ways of building their homes, barns, and smoke houses, using local limestone. Today the entire village, proclaiming itself the "Luxembourg of America," is on the National Register of Historic Places and a shining example of a historic cultural landscape.

Behind the Catholic church of the village, Calvary Hill features a Way of the Cross pilgrimage, and boasts that it is the oldest outdoor Calvary in the United States.

FIGURE 27

The economy of Clinton, Iowa, thrived after the Civil War. The town was the home to "one of the largest sawmills on the Mississippi River," writes historian Mark Neuzil, making it, by the early 1890s, the third ranking producer of lumber on the river, right behind Minneapolis and Winona. Steamboat captains nicknamed Clinton "Sawdust Town."

Today, Clinton, which is below Lock & Dam No. 13 on U.S. 30 (the historic Lincoln Highway), is home to Mount St. Clare College (1895) and Clinton Community College (1946). In recent decades Clinton's population has declined from 32,828 in 1980 to 27,772 in 2000.

FIGURE 28

From old-time rivermen you can still hear of a great tree that once spread its canopy above Le Claire's riverfront, a giant elm under which high-spirited men often foregathered during the latter nineteenth century, sleeping and cooking their meals there while awaiting employment to come floating downriver from the north. The men were rafters, unafraid men who made their dangerous living steering five- to ten-acre log rafts through the fourteen-mile stretch of Rock Island's notorious white-water rapids, which imperiled river traffic before the locks and dams were built. The resplendent tree lived until 1956 when a monument was erected on Le Claire's riverfront memorializing these tough-as-nails rivermen of old, who spoke affectionately of the great elm as their "Green Tree Hotel."

FIGURES 29 AND 30

In 1953 the Boston Braves (*Hank Aaron and Warren Spahn!*) moved to Milwaukee

(*Milwaukee?*) and the Yankees (*Mickey Mantle! Yogi Berra! and Whitey Ford!*) beat the Brooklyn Dodgers to win a fifth World Series in a row.

Situated on land that was originally bought by the U.S. government from the Sac and Fox nations during the Black Hawk Purchase of 1832, Bettendorf was settled in the 1840s mostly by German immigrants, who called it Lillienthal. In 1858 the name was changed to Gilbert, and then, again, to its current name in 1903 to honor the Bettendorf brothers William and Joseph, who, after being deeded a $15,000 farm purchased by donations raised among the town's 440 citizens, relocated their Davenport iron wagon factory to Gilbert.

That same business model of financial incentive explains why the Braves moved from Boston to Milwaukee and why the Dodgers would soon go west to Los Angeles.

FIGURE 31

John Deere was an innovative and adept blacksmith from Rutland, Vermont, who arrived on the Illinois scene in 1836. Realizing the need for a better plow than the inefficient cast-iron ones settlers were using, on which the heavy Midwestern soils clotted, Deere and a partner designed, with the steel from a discarded saw blade, a mold board that scoured itself as it sliced through the tough grass soil. The plow didn't clog and kept polishing itself brighter with each turned furrow. In 1846 Deere relocated from Grand Detour, Illinois, to establish a factory in Moline, where he could take advantage of the waterpower and shipping transport the Mississippi provided. His factory began producing plows in 1848 using Pittsburgh steel. Deere's other innovation was in mass production: Within ten years of his original prototype, his factory produced about 1,000 plows annually. In so doing, Deere opened the prairie states to modern agriculture.

In 1917, in an effort to reinvigorate the river's moribund commercial shipping industry, the John Deere Company sent "360 tons of plows on four government barges from Moline to Minneapolis," writes John O. Anfinson. Despite the savings in shipping costs, the venture was short-lived, and "boosters failed to reinvigorate river traffic."

FIGURE 32

The Chicago and Rock Island line ("a-mighty-fine-line") became the first railroad to span the Mississippi River in 1856 with a bridge connecting Rock Island, Illinois, to Davenport, Iowa. Rock Island had long been viewed as a natural place to span the river. As early as 1829 DeWitt Clinton, of Erie Canal fame, envisioned that the Erie Railroad would extend through southern New York and northern Ohio, Indiana, and Illinois, ultimately terminating at Rock Island, a place founded before Chicago.

The Rock Island Bridge had many other famous firsts: Fifteen days after it was opened the steamboat, *Effie Afton*, struck it. The bridge destroyed the boat, and the boat burned part of the bridge. Steamboat interests sued the railroads, and Springfield, Illinois, lawyer Abraham Lincoln successfully defended them, by arguing that railroads had the same rights to the transport of commerce as steamboats. Nonetheless, in 1857, fifty-five steamboats crashed into the bridge's piers.

George Merrick gives a human face to one crack-up in 1861: The wreck of the legendary river-running *Gray Eagle*, built by Captain D. Smith Harris. Harris spent $60,000 on the steamer, intending that she "be the fastest boat on the upper river, and she was easily that," Merrick writes. Harris once raced another boat to St. Paul, running 290 miles in eighteen hours, averaging a little more than sixteen miles per hour, in order to deliver the news of the first transatlantic telegraph cable communication: A greeting between President James Buchanan and Queen Victoria. (St. Paul, Minnesota, had no telegraph line yet.) Captain Harris was justifiably proud of the *Gray Eagle*, which he once also ran at sixteen m.p.h. for a distance of 300 miles. "A few years later," recalls Merrick, "she struck the Rock Island Bridge and sank in less than five minutes, a total loss [including seven lives]. It was pitiful to see the old Captain leaving the wreck, a broken-hearted man, weeping over the loss of his darling, and returning to his Galena home, never again to command a steamboat."

The feud between boats and rails was tenacious as each vied for commerce. As John O. Anfinson writes, "Railroads reaching the river's east bank in the 1850s both hurt and promoted river traffic. . . . After arriving at railhead, many immigrants and goods transferred to steamboats for destinations up or downstream. Railroads, however, began segmenting the river trade. Boats that once traveled the whole upper river made shorter trips between railheads."

The city of Rock Island derives its name from a three-mile-long island near the river's east bank. The downstream end lies across from the city of Rock Island, while upstream it fronts Moline. Since its acquisition by the U.S. government, it has been home to Fort Armstrong, built in 1816, where Dred Scott lived as a slave from 1834–36; during the Civil War as an arsenal (hence its current name: Arsenal Island) and a Confederate prison (where more than 1,000 POWs perished); and, later, a headquarters for the U.S. Army Corps of Engineers. The island also denoted the Rock Island Rapids, with its sharp rock outcroppings, that extended upstream from the southern end of the island for a distance of nearly fourteen miles. A young Lt. Robert E. Lee surveyed problems at the Rock Island and Des Moines (Keokuk) rapids in 1837. Between 1867–86 the Corps chiseled and blasted a minimum-depth four-foot channel through the rapid's bedrock.

A few miles downstream from Rock Island is the mouth of the Rock River, the site of Black Hawk village, where the great Sac chief Black Hawk was born in 1767. After his death

in Iowa in 1838, "his skull was featured in a traveling tent show," writes historian Paula Mitchell Marks.

FIGURES 33, 34, AND 35

Davenport, across the river from Rock Island, gets its name from an Englishman, Col. George Davenport, a sergeant in the U.S. army who fought in the War of 1812, arrived on the frontier, traded with the Indians, and subsequently garnered wealth and influence. He tried to ease tensions between the Sac Nation and settlers prior to the outbreak of the Black Hawk War, reportedly traveling to Washington, D.C., to speak with President Andrew Jackson on behalf of the Indians. Nonetheless, when the war erupted he became a quartermaster in the Illinois militia. Circa 1833 Davenport built a mansion on the north end of Rock (today's Arsenal) Island. When a town was laid out in 1836 across the river from Rock Island, it was named in honor of George Davenport. In 1845, the criminal gang "Banditti of the Prairie" murdered Davenport in his home on July 4 while his family was attending holiday celebrations in Rock Island. The gang beat Davenport to death after finding less than $400 in a safe that was rumored to have as much as $20,000.

Steamboats and, later, railroads were central to Davenport's development. In 1857 alone there were 1,587 steamboat dockings, even as three years before, in 1854, the first cornerstone for a railroad bridge across the Mississippi was laid, the same year the first train reached the Mississippi River at Rock Island, thereby establishing an important river railhead to Chicago.

In 1920, Louis Armstrong arrived at Davenport aboard a steamboat that ran roundtrip seasonally between New Orleans and St. Paul and advertised a jazz band of "colored" musicians under the legendary disciplinarian bandleader Fate Marable. Young Armstrong was the band's featured cornet player. That's when a white seventeen-year-old farm boy, Iowan Leon "Bix" Beiderbecke, had his life changed, as did many persons up and down the river who heard Armstrong play, as he revolutionized jazz and American music. In 1953, Armstrong appeared in *The Glenn Miller Story*, performing "Basin Street Blues." Meanwhile, Miles Davis, another jazz trumpeter born in a Mississippi River town—Alton, Illinois—was well on his way to revolutionizing jazz for the next generation.

FIGURES 36 AND 37

A hundred years before Sharp's visit, a recently settled resident of Muscatine sent a letter to his father informing him about the locale: "Iowa as yet is quite new, she has a few smart towns on the river (among which this is one of the smartest), which derive their business directly and indirectly from the agricultural resources of the surrounding country. . . . The reason why [the site of Muscatine] was chosen is that the river here makes a large elbow, and this town is

built on the outer point of the elbow, thus securing a larger extent of the country. . . ." Commenting on the town's prosperity, he added that "there are more emigrant wagons than the ferry boat can take across the river in the day time; sometimes there are fifteen or twenty wagons waiting on the eastern shore to come across . . ."

The Mississippi's pearl-button industry actually began in Muscatine in 1891 when a new immigrant, John F. Boepple, who had worked as a button maker in Germany, established the first factory for that purpose on the river. His success was quickly duplicated elsewhere.

"During the late 1890s," writes John O. Anfinson, "button manufacturing replaced the faltering lumbering industry as the principal business in some Iowa and Illinois river towns." In 1929, manufacturers produced 20.2 million gross buttons. By 1953, however, over-harvesting of mussels and clams and the environmental consequences resulting from the creation of the nine-foot channel for navigation on the Upper River wiped out many species and nearly exhausted others. Nonetheless, the advent of plastic buttons had all but ended the region's pearl-button industry.

FIGURE 38

In 1837 Burlington became Iowa's first capital. The city was a hub for immigrants heading west and, later, for railroad interests. Mark Neuzil writes: "Bridges at places like Burlington, Rock Island, and Quincy often were built by Chicago-based railroads. This meant that grain and other products shipped from Iowa, Nebraska and points west often continued into [Chicago] . . . rather than being transferred to barges bound for St. Louis or New Orleans. Merchants in St. Louis, in particular, felt the loss of river trade as the railroads expanded west."

In the autumn of 1838, more than 800 Potawatomi Indians encamped at Quincy, before crossing the Mississippi on a steam ferry, on their way to Kansas after being forcibly removed by the federal government from their homeland in the Indiana Territory of present-day southern Michigan and northern Indiana. The ten-week ordeal became known as "The Trail of Death."

FIGURE 39

Snake Alley consists of five half-curves and two quarter-curves, covers a distance of 275 feet, and descends fifty-nine feet from Burlington's residential area to the city's downtown business district. It was modeled on the steep-slope vineyard paths in France and Germany. A bike race down Snake Alley is held each Memorial Day weekend.

The Mormons obtained from the Illinois legislature a charter for Nauvoo that they manipulated in such a way "to produce a quasi-independent municipal government that seemed to rival the sovereignty of the state itself," in the words of historian Robert Bruce Flanders, allowing them control of the courts and a militia of 5,000 men.

Mormon converts from all over America swelled Nauvoo's population to an estimated 15,000 to 25,000 persons. Trouble arose in 1844, however, after a mob of Mormons smashed the Nauvoo printing press of an ex-communicated Mormon who had published a newspaper denouncing Joseph Smith. Incensed by the incident, non-Mormons residing in the area surrounding Nauvoo, where tensions between the two groups had been simmering, threatened armed violence against Smith and his followers. The governor of Illinois, hoping to avert bloodshed, arranged for the arrest of Smith and his brother, both of whom were charged with treason, as well as his associates; he then had them jailed in Carthage, twenty-five miles from Nauvoo. A company of Carthage militia was posted to guard the prisoners, yet Smith and his brother were murdered after a renegade militia stormed the prison. Soon after, Brigham Young led the persecuted Mormons from Nauvoo, taking them west to establish their new Zion in the desert of Utah's Salt Lake Valley.

After its abandonment in 1846, one visitor to Nauvoo wrote: "Where resided no less than twenty-five thousand people, there are not to be seen more than about five-hundred; and these, in mind, body and purse, seem to be perfectly wretched. In a walk of about ten minutes, I counted several hundred chimneys, which were all at least that number of families had left behind them, as memorials of their folly, and the wickedness of their persecutors. When this city was in its glory, every dwelling was surrounded with a garden, so that the corporation limits were uncommonly extensive; but now all the fences are in ruin, and the lately crowded streets actually rank with vegetation. Of the houses left standing, not more than one out of every ten is occupied, excepting by the spider and the toad . . ."

In recent years, Mormons have begun to reclaim Nauvoo. In 2002 they rebuilt their former temple, which more than half a million people had visited by the summer of 2004, and restored a few dozen historic buildings to showcase life in Nauvoo during the early 1840s. According to an article in the *New York Times* (July 29, 2004), "Economic, political and social tensions have grown as Mormons have poured into Nauvoo." As Yogi Berra once said, "It's *déjà vu* all over again."

Even as Sharp doesn't recall *where* he shot this photo, he does know *why*: As he writes: "The scene was so personally meaningful: that monster engine moving tortoise-like and belching

black smoke—just as it did when it arrived at our Indiana farm at threshing time when I was a boy; its massive lugged wheels leaving cement-like indentations in the ground and its fire-box chuffing out flurries of sparks and cinders from its tall smokestack, and the man operating the engine, seeing me waving, returned my wave by pulling the whistle-rope from which, as from the bowels of the earth, a hoarse cry grew, and grew louder, thunderous and reverberant, a sound I knew, knew to the depths of my being, could otherwise be heard only when entering the portals of heaven."

Figures 43, 44, and 45

Keokuk, platted in 1837, was once a deep forest outpost two miles below the Des Moines River at the base of the lower rapids of the Mississippi. It was known as the Des Moines Rapids (or, alternately, the Keokuk Rapids), the worst on the Upper River, nearly twelve miles long with a fall of some twenty-five feet. With no clear channel through the rapids, which flowed over the river's bedrock, it was an especially dangerous stretch at low water, and no boat with a draft of more than two feet would attempt passage through it at such times. Between 1867–1877 the U. S. Army Corps of Engineers constructed a canal around the rapids at a cost of around $4,000,000.

Within a little more than a decade after its founding, Keokuk was a thriving town of approximately 7,000. Some of Mark Twain's earliest travel pieces were first published in Keokuk's newspapers.

In return for his compliance, the U.S., in 1837, recognized Keokuk as leader of the Sac Nation. After repeatedly giving land to the U.S., Keokuk successively moved further west until he died on a Kansas reservation for the Sac tribes, wealthy but unesteemed among his people.

Figures 46 and 47

Hamilton, Illinois, thirty-three miles north of Quincy, is best known for its stock farms. Its population declined from 3,509 in 1980 to 3,029 in 2000.

Figures 48, 49, and 50

Quincy, Illinois, settled about 1822, today is a commercial, industrial, and distribution center in an agricultural and livestock-raising area. Quincy College (1860) and John Wood Community College (1974) are located here.

Mark Twain wrote in *Life on the Mississippi* of Quincy's "broad, clean streets, trim, neat dwellings and lawns, fine mansions, [and] stately blocks of commercial buildings."

FIGURES 51 AND 52

Hannibal, Missouri, known throughout the world as the home of Samuel Langhorne Clemens, who derived his pen name, Mark Twain, during his piloting days on the Lower Mississippi River just prior to the Civil War. "Mark twain" was a sounding call of steamboat men measuring the river's depth and meant water of two fathoms (twelve feet).

The town, laid out in 1819, gets its name from Hannibal Creek, so named by a Spanish general-surveyor passing through in 1800. In addition to steamboating and trade in lumber, hemp, tobacco, pork, and other commodities, Hannibal enjoyed considerable economic advantage by 1860 as the eastern terminus of the Hannibal and St. Joseph Railroad, making it a transfer point for western and eastern rail lines and river traffic north and south. (Clemens's father was an early investor in railroads.) During the Civil War, Hannibal's citizens mostly favored the Confederacy, but the Union occupied the town.

FIGURES 53, 54, AND 55

Mark Twain was born in Florida, Missouri, in 1835, and arrived in Hannibal with his family when he was a pre-schooler. Despite Hannibal's later prosperity, Twain recalls an inauspicious beginning: "In my own time the town had no specialty, and no commercial grandeur; the daily packet usually landed a passenger and brought a catfish, and took away another passenger and a hatful of freight."

In 1953, forty-three years after Twain's death, steadily growing and avid interest in his life and fiction fueled one of the town's most auspicious enterprises—tourism.

FIGURE 56

The historic marker to the left in this photo reads: "It was in the second story of this building that he set type and first wrote for the newspaper. It was under one of the windows that he found the article on Joan of Arc which caused him to write her life."

FIGURE 57

European-American settlement in the area began around 1808, with many tobacco-growing Kentucky homesteaders; by 1860 the town of Louisiana supported fourteen cigar factories.

FIGURE 59

Though a prominent engineer, James Buchanon Eads had no bridge building experience when called upon to design a railroad/vehicular bridge across the Mississippi River at St. Louis. His 1,550-foot double-deck structure, supported by three arches of steel webbing, rest-

ing on massive limestone piers sunk on caissons through 100 feet of river bottom (sand) to bedrock, was the revolutionary solution. One of the most impressive engineering feats of the nineteenth century, it required the labor of roughly 2,000 men and seven years to complete. Three hundred thousand people attended its dedication on July 4, 1874 as the first bridge across this part of the Mississippi, thereby assuring St. Louis's role as a major Midwest rail hub.

Saint Louis is located about ten miles below the confluence of the Mississippi and Missouri rivers. It was founded in 1764 by the French fur-trader and pioneer Pierre Laclede of New Orleans as trading post, and it soon became a crossroads for westward expansion. Ever since the nineteenth-century steamboat era and the arrival of the railroad in the 1850s, St. Louis has been a vital transportation and manufacturing center. In 1904 the city hosted the World's Fair, known as the Louisiana Purchase Exposition and Olympic Games.

FIGURES 60 AND 61

At the beginning of the twentieth century railroads had severely undercut the commercial need for Mississippi steamboats to transport cargo or people on business or personal travel, so steamboat owners turned increasingly to offering excursion trips for pleasure and sightseeing. By the late 1930s, day trips on newly built or converted older steamboats had become a popular recreation for properous Americans indulging in nostalgic river travel. The steamboats were powered by gasoline or diesel fuel, not coal or wood, and in some cases the paddlewheels were simply superfluous. Nonetheless, excursion cruises helped the steamboat to survive through the twentieth century (and into the twenty-first). The *Admiral* encapsulates that history.

Originally a side-wheeler steamboat named the *Albatross*, the *Admiral* was built in Dubuque, Iowa, in 1907, with a steel hull designed for transporting as many as sixteen loaded railroad cars and other cargo. In 1937, she was refit at a St. Louis shipyard and converted into an excursion boat, with a steel, art deco-derived, futuristic superstructure that enclosed her side-wheel. With truncated smokestacks and a passenger capacity of 4,400, she also was the first tourist boat on the river with air conditioning. "The result was a boat designed completely for function, with the lore of the steamboat all but forgotten," writes riverboat historian William C. Davis. The *Admiral* continued running tourist excursions out of St. Louis until 1979, although in 1974 she was stripped of her steam engine, boilers, and paddlewheels, and overhauled with a diesel engine and propellers. In 1979 the *Admiral* was retired from service and tied to the dock near Gateway Arch (designed by Eero Saarinen, proposed in 1948 and completed in 1968), where it housed a restaurant.

Figures 62 and 63

Showboats are an American folk institution. For more than a century they helped relieve cultural starvation on river frontiers of the Midwest and South, penetrating regions where theater and had not gone. The first showboat, essentially a large room built atop a barge, appeared in 1831 on the Ohio River, floating from landing to landing, playing such dramas as Shakespeare's *Julius Caesar*. According to William C. Davis, the impresario-owner of that first showboat sold the boat for wood after he reached New Orleans and staged its last performance. He then returned to Ohio to build another and start again. In addition to staging Shakespearean dramas, with serious actors (Junius Brutus Booth and Edwin Forrest, among them), showboats also presented magicians, animal acts, and, after the Civil War, vaudeville and melodramas. Stephen Foster's songs added sentimental charm to their programs. They carried humor, music, and emotion throughout the Ohio-Mississippi River system. Thousands of people saw for the first time an imaginary world on stage, laughing and crying to simplified battles of good and evil.

The showboat *Goldenrod* stopped traveling the rivers in 1943. When the author boarded her a decade later eager to hiss the villain and cheer the hero, she was permanently anchored on St. Louis's levee.

In *Old Times on the Upper Mississippi: Recollections of a Steamboat Pilot from 1854 to 1863* (1905), George Byron Merrick recalls: "The cabin orchestra was the cheapest and most enduring, as well as the most popular drawing card [on steamboats]. A band of six or eight colored men who could play the violin, banjo, and guitar, and in addition sing well, was always a good investment. These men were paid to do the work of waiters, barbers, and baggagemen, and in addition were given the privilege of passing the hat occasionally, and keeping all they caught. They made good wages by this combination, and it also pleased the passengers, who had no suspicion that the entire orchestra was hired with the understanding that they were to play as ordered by the captain or chief clerk, and that is was strictly business engagement. They also played for dances in the cabin, and at landings sat on the guards and played to attract custom. It soon became advertised abroad which boats carried the best orchestras, and such lost nothing in the way of patronage."

Figure 64

The neo-Romanesque railroad station opened in 1904 in time for the St. Louis World's Fair. "Combining terminals of all the railroads converging on St. Louis, with thirty-two tracks," writes geographer and rail historian James E. Vance, Jr., "it was the largest station ever constructed."

In 1953 America's passenger rail service, faced with increasing competition from autos and highways, was already in rapid decline from its post-World War II peak in 1946.

FIGURE 65

These Dred Scott trials were the first steps of a legal journey of ten years that ended in the U.S. Supreme Court in 1857, when that court's august body of mostly pro-slavery judges, led by Chief Justice Roger Taney, ruled that Scott could not claim to be a "citizen," although he had twice resided in "free" territory. Afterwards, a previous master's son purchased Scott's freedom, and he lived fifteen months a freeman, working as a porter at a St. Louis hotel before dying of consumption.

FIGURE 66

The plaque on the wall behind Captain Leyhe reads:

> THIS MEMORIAL PRESENTED BY / THE CHAMBER OF COMMERCE OF CAPE GIRARDEAU, MISSOURI, ON THE OCCASION OF THE DEDICATION OF / THE NEW STEAMER CAPE GIRARDEAU / IN GRATEFUL RECOGNITION OF A FRIENDLY / RELATIONSHIP AND LOYAL SERVICE OF OVER THIRTY YEARS. / APRIL 23, 1924.

FIGURES 70 AND 71

According to Sharp, "Somewhere along Missouri State Road 79, near Winfield (I believe, but cannot be certain), cars and trucks were parked in an open field about a large tent. Curious, I stopped to investigate. Long before I stepped inside the tent, I could hear the down-home chant of an auctioneer as cattle were herded one by one before a bleacher-filled audience of sellers and buyers, the latter in suits and ties, fanning away the July heat with their panama hats."

FIGURE 72

The Bequette-Ribault House's exterior walls, surrounding a central chimney, are made of upright, hewn cedar logs set vertically into the earth, a building-style termed *poteaux en terre*. The interstices between the logs were originally filled with *bousillage*, a mix of straw and clay, and then the outside was whitewashed. Heavy timbers on the interior form the truss that supports the house's hipped roof. Built by Jean-Baptiste Bequette, the house remained in his family until 1837, when title to the property was given to "Clarise, a free woman of color," who lived there with a French widower, John Ribault. When Sharp photographed it, the house was

still in the Ribault family, who sold it in 1969. Located a few blocks from Ste. Genevieve's historic village center, the house is one of the few surviving *poteaux-en-terre* structures standing in North America.

Because it retains more unspoiled French Colonial buildings in a village setting than any other place in the United States today, Ste. Genevieve is an important cultural landscape, earning it designation as a National Historic Landmark District. When the author visited, an original eighteenth-century limestone bank and jail housed a museum in which could be seen a safe that Missourians Jesse James and the Dalton brothers busted open, along with birds mounted by one-time town businessman and ornithologist-artist John James Audubon.

Today, plans are under way to construct near the Mississippi River in northern St. Genevieve County a cement plant that would be the biggest in the nation and among the largest in the world, even as environmentalists raise concerns about destruction of wetlands and significant ozone pollution from the plant's emissions of nitrogen oxide.

FIGURE 73

The original toll for using this bridge required a two-horse wagon to pay twenty cents, with a charge of five cents for each additional animal. Although the bridge enterprise never really prospered, the bridge did eventually become an integral part of the state highway system until 1930. It's now preserved as an historic attraction. Inside, the bridge still contains its original oak timber.

FIGURE 74

Thousands of Cherokee died on this southern Illinois plain from starvation, exposure, and disease. In the spring, when the Great River's ice melted, the survivors continued their forced migration west to lands unknown to them in the Oklahoma Territory. Their "trail of tears" was authorized by the United States Congress and President Andrew Jackson, who made fortunes for himself, relatives, and squatters usurping through biased laws the lands and homes of the self-governing Cherokee, consequently pauperizing them through denials of legal rights to person or property. The Cherokee, who had a written language, schools, and a constitutional form of government, were so "advanced" that many white people thought them to be one of the lost Tribes of Israel. Thomas Jefferson had counseled them to assimilate; cotton kings wanted their land.

John Burnett, a survivor of the Cherokee's march, recalled: "The ice was not solid enough to cross on, but it clogged the river so that ferryboats could not move . . . On the morning of November 17th we encountered a terrific sleet and snow storm . . . and that day the suffer-

ings were awful . . . a trail of death . . . had to sleep in the wagons and on the ground without fire. I have known as many as 22 to die in one night of pneumonia."

In traveling America's historical landscapes, reverence is not always what one feels; sometimes there is disillusionment.

FIGURES 75 AND 76

Cape Girardeau originated in 1733 as a trading post. A French soldier, Jean D. Girardot, established it to deal with the more than twenty Indian tribes in the area. Later, under Spanish possession, it was a military post. Lewis and Clark, on their way to their winter encampment near St. Louis in preparation for their great western journey, were cordially received here. Prior to the Civil War, the town claims to have been the busiest port between St. Louis and Memphis, and during the war Ulysses S. Grant briefly had his headquarters here. When Sharp visited, its riverfront architecture bore muted evidence of better days. Southeast Missouri State University (1873) is located here.

FIGURE 77

Abraham Lincoln practiced law here during his circuit-riding days, and Dred Scott was held briefly in the courthouse's dungeon-like jail before standing trial in St. Louis, in an attempt to establish a right to his own person.

FIGURES 79, 80, AND 81

As early as 1818 speculators envisioned a magnificent city befitting the confluence of America's two great rivers, the Ohio and the Mississippi, and the name they gave to it was Cairo (pronounced Kayro unlike the Egyptian city on the Nile). But the venture floundered over the years because the town was sited "on ground so flat and low and marshy, that at certain seasons of the year it is inundated to the house-tops, [and] lies a breeding-place of fever, ague, and death," as Charles Dickens wrote after visiting Cairo in 1842. At the outbreak of the Civil War, with both armies well aware of the geographic importance of Cairo, Union troops rushed into it, only a few hours before Confederates could do so. The Union erected Fort Defiance and Grant was soon in command. The war turned Cairo, site of a major Union naval yard and staging area, into a boomtown, and it continued as such for many post-war years from commerce in river and rail freight traffic. Cairo's prosperity, however, faded during the early twentieth century, and by 1953 it had the appearance and feel of a sleepy southern town on the decline.

FIGURE 82

The joining of the brown waters of the Mississippi and the bluish waters of the Ohio River at Mile O is impressive, even awesome: the breadth and force of it; the intuiting that these waters have come down from New York and West Virginia in the east, Montana and Idaho in the west, Minnesota and two provinces of Canada in the north; that here can be seen an amazement of nature—the ongoing discharge from nearly half the North American continent. It is a national wonder.

Towboats and their tows, along with smaller craft of every description, stir about; hundreds of barges are hawsered to the shorelines to be dispersed east on the Ohio, north and south on the Mississippi, and some westward on the Missouri at St. Louis. Yet the vastness of the confluence makes for seeming sluggishness, even indolence.

FIGURES 84, 85, 86, AND 87

Snagboats were a necessary and early innovation for keeping the Mississippi and its tributaries navigable. Henry M. Shreve invented the first one, the *Heliopolis*, in 1829. Thereafter, a few snagboats always plied the river removing sunken logs and other obstructions. After the Civil War, the Corps of Engineers sought to establish a fleet of them. People often called them "Uncle Sam's tooth-pullers" because of the way they operated: "They carried an iron hook and heavy tackle mounted to a derrick that towered between the [double] hulls. A single snagboat would straddle the offending log, hook onto it, and yank it out, like a dentist extracting a tooth," writes historian Michael Gillespie. Newspapers in towns along the river occasionally noted the whereabouts of snagboats and often reported the removal of notorious snags. The boats are essential to keeping the river safe for navigation, which is why the Corps, in 1953, still relied on an old stern-wheel workhorse such as the *Charles H. West*.

FIGURE 88

Like snagboats, the towboat was another innovation of the Mississippi. As Michael Gillespie writes:

"By combining the economy of rafts and flatboats with the powered advantage of the steamboat, the concept of towing barges made its debut [in the 1850s]. . . . From a practical standpoint, a barge could not be towed, or pulled, on the moving currents of the Western Rivers—the barge would tend to swing from side to side, or else ram the back of the towing vessel. . . . it worked out better to push the barges ahead, *provided* they were tightly bound to one another and to the powered vessel.

"While some of the original barges were nothing more than old steamboat hulls, true barges featured square bows and sterns. . . . Towboat bows were squared as well, and fitted with stout bumper posts, or "knees," to insure that the towboat did not run up under the stern of the barge."

FIGURE 89

Among the romantic archetypes of American history—the cowboy, frontiersman, Indian, pilgrim, and prospector, among others—is the riverboat pilot. The skills required of pilots on the Mississippi during Captain Ware's day were not nearly as daunting as those needed in the nineteenth century, when a pilot had to memorize, both from their upstream and downstream features, hundreds of snags, sandbars, reefs, shoals, and sundry other obstacles on their respective stretches of river. As early as 1852, the complexity of the job made piloting one of the first professions to receive federal scrutiny with passage of the Steamboat Inspection Act. Even so, today's Mississippi River still requires formidable piloting skills, not least of which is the ability to command powerful vessels such as the *McElroy*, with its 2,200-horsepower diesel engines. Some towboats today, fifty years later, are twice as powerful.

FIGURES 99 THROUGH 110

Hickman, Kentucky, is at the confluence of the Mississippi and two small tributaries: the Obion and Bayou du Chien. Big Oak Tree State Park is but a few miles to the northwest of Dorena, Missouri.

FIGURE 111

On December 6, 1811, when upwards of 150 boats laden with goods were tied up at New Madrid's landing, the first of three equally powerful earthquakes struck between that day and February 7, 1812. With its epicenter at New Madrid, the first quake caused plumes of sand and water spouts to shoot up thirty feet out of the river, and one stretch of the Mississippi to flow backwards for three days. People felt its tremors as far away as Virginia, where Thomas Jefferson was awoken from his sleep, and it caused church bells to ring in Washington, D.C. Boats were found along the riverbanks as far as forty miles upstream from where they had been moored. John James Audubon, who happened to be in the area at the time, wrote in his journal: "The earth waved like a field of corn before a breeze." Today, seismologists estimate the quakes were of a magnitude of more than eight on the Richter scale; they also warn that the area along the New Madrid Fault, the most active fault in the U.S. east of the Rocky Mountains, is susceptible to a major earthquake. In the spring of 2004 the area experienced seven quakes within one month. Memphis and St. Louis are especially vulnerable, since few buildings in these major urban centers are designed to withstand a major quake.

Figure 112

Caruthersville, Missouri, is the first town of some size to emerge on the Mississippi since Cairo, sixty miles to the north at the confluence of the Mississippi and Ohio rivers. The town's agricultural base was cotton and wheat in 1980, when its population was 7,389; in 2000 it had 6,760 residents.

Figure 116

Downstream beyond Barfield Landing, beyond Loosahatchie Bar and Robinson Crusoe Island, lies an oxbow that was once the main river channel. That's where, at 2 a.m. on April 27, 1865, the side-wheeler *Sultana*, overloaded with passengers, including 1,886 Union soldiers and former prisoners from Andersonville and other Southern POW camps, exploded its boilers. One thousand five hundred and forty-seven people aboard died through burning or drowning, including more than 1,100 soldiers. The steamer was licensed to carry no more than 376 people, but the captain disregarded safety for the revenue he could earn by taking on all the troops at a government-paid fee of $5 per head. It was the worst tragedy in the history of the river.

Figure 117

As the historical marker indicates, Union soldiers captured Fort Pillow in 1862 and garrisoned it with soldiers who were former slaves. In April 1864, Confederate General Nathan Bedford Forrest recaptured the fort, storming it after its commanding officer refused to surrender. What the sign doesn't mention is that vicious fighting ensued, and, when Union soldiers finally tried to surrender, 229 black soldiers and some whites were massacred. Southerners for decades contested that it was a "massacre," but it "is now well established and generally accepted," writes the renowned Civil War historian James M. McPherson. The event later served as a rallying cry for African-American units in the Union who went into action at Petersburg and elsewhere yelling "Remember Fort Pillow."

Forrest was never brought to trial after the war for the Fort Pillow massacre, and he went on to found and lead the American terrorist organization, the Ku Klux Klan.

Figures 118, 119, and 120

Situated in central downtown, Cotton Row's "location enabled cotton merchants to be near the Mississippi River, where stevedores moved cotton for transport from the South to national and international markets," explains historian Charles Reagan Wilson. "Bales of cotton moved easily in and out of the spacious ground floors in these unadorned, simple structures whose clean lines and simplicity masked the power of the business they housed." Although Cotton Row is no longer the busy place it was when the author photographed it,

and many of its historic buildings have been razed or vacated, the area continues to support the largest spot cotton market in the nation. Home to three of the five world's largest cotton dealers, some forty percent of the nation's cotton is still graded and traded here.

FIGURES 121, 122, AND 123

Beale Street, starting at the Mississippi and running eastwards, was lined with pool halls, theaters, bars, whore houses, barbershops and beauty saloons, department and specialty stores, tailors' shops (the "zoot suit" originated on Beale), banks, and restaurants. "Merchants in an open marketplace hawked everything from vegetables, pigs feet, and live chickens to clothing, jewelry, and graveyard dust (needed for hoodoo spells)," writes Charles Reagan Wilson. In the 1930s, a WPA Tennessee guidebook described its atmosphere as "thick with the smell of fried fish, black mud from the levees and plantations, and whiskey trucked in from moonshine stills of swamps and hills." The lasting legacy of Beale Street is the music it fostered through the genius of artists such as W. C. Handy (1873-1958), "Father of the Blues," who arrived in the first decade of the twentieth century and successfully published sheet music in his Beale Street office from 1912 to 1918. Other great Beale Street musicians include Bukka White, Furry Lewis, Arnold "Gatemouth" Moore, B. B. King, Albert King, Bobby "Blue" Bland, Johnny Ace, and Rosco Gordon, among others.

By the 1950s Memphis authorities, sensitive to bad publicity, clamped down on Beale Street, forcing many of its businesses to close. Today, Beale Street has undergone significant historic preservation and commercial redevelopment, and it is rapidly regaining its stature as a "place to be," especially for tourists.

FIGURES 124, 125, AND 126

Once an outdoor marketplace, Handy Park was dedicated by former Mayor E. H. "Boss" Crump in 1931 to recognize W. C. Handy, who returned to Memphis from his home in New York City to attend the ceremony, witnessed by 10,000 people. The site had traditionally been the gathering place for blues musicians, jug bands, and gospel singers (as those pictured in Figures 125 and 126) and continues today as a center for music and street life. In 1909 Crump hired Handy's band to play at political rallies during his mayoral campaign. Handy favored the politician with a song, "Mr. Crump's Blues," which became the basis for the now classic "Memphis Blues."

FIGURE 127

Beyond the oxbow lies land that was once an island—Ship Island. It's near there, on a hot summer morning before the Civil War, where the steamboat *Pennsylvania*'s boilers exploded

and among those lives lost was that of Samuel Clemens's younger brother Henry, who died of burns from scalding steam several days later, with Sam at his side. Years later, Mark Twain recalled that only days before the disaster he spent a pleasant evening with his brother in New Orleans, during which the conversation touched on steamboat accidents. The two brothers vowed, if ever caught in one, wrote Twain in *Life on the Mississippi*, that they would "stick to the boat, and give such minor service as chance might throw in the way." Thus, the river that claimed the life of nineteen-year-old Henry would give it to his brother's name and work.

FIGURE 128

When Elaine's black sharecroppers and cotton workers (whom landlords had consistently cheated) agitated in 1919 for better wages and a labor union, angry whites sought to quash a union meeting. Shots were fired, two white men were killed, and soon whites from the countryside poured into the area. Vicious fighting between the races lasted for two days before the governor of Arkansas dispatched troops to Elaine, the town was put under martial law, and all blacks were arrested. Although both whites and blacks (historians estimate some 300 blacks) lost their lives, only African-Americans stood trial for the violence, of whom twelve were sentenced to death.

FIGURES 129 THROUGH 140

Until the 1880s, the Delta remained a wilderness of bramble thickets, woods, and cypress swamps. During Reconstruction, lumber interests drained the swamps to harvest the timber, then resold the land to cotton planters who continued draining the swamps. Soon the Delta emerged as the South's most important cotton land. With an overwhelming African-American majority population readily at hand, pervasive sharecropping developed as an economic system, entrapping blacks, and many whites, in poverty and backbreaking toil. This circumstance of misery infused African-American musical traditions and formed the blues, which is generally believed to have first arisen in the Delta (with some scholars even pointing to the plantation of Dockery Farms, near Cleveland, Mississippi, as its birthplace).

During the early twentieth century, Delta residents were known for their pride and keen sense of personal justice and retribution. "One did not turn the other cheek in the Delta," historian John M. Barry writes. "Neither black nor white turned the other cheek. The homicide rate in Mississippi dwarfed that of the rest of the nation, and the Delta's dwarfed that of the rest of Mississippi."

By the early 1950s, the Delta was undergoing change—both economically and socially: mechanization and corporate agriculture were superseding sharecropping and tenant farming.

Within a decade, the Civil Rights Movement waged frontline battles throughout the Delta with "Freedom Rides" and voter registration drives.

FIGURES 145, 146, AND 147

For more than three years, with no contact with the outside world, the Japanese-American internees were prisoners of war. Segregated by sex in barracks, they put in their own vegetable gardens, educated their children, and each day held flag-raising ceremonies, singing *My Country Tis of Thee*. At its peak, the camp housed 8,475 men, women, and children, and consisted of 620 buildings. After the war, the land and buildings comprising the camp were sold; consequently, its most salient remaining feature is the internees' cemetery.

FIGURE 148

In the pre-flood 1920s, Greenville was "The Queen City of the Delta," a thriving commercial center with a population of 15,000 people. In *Rising Tide: The Great Mississippi Flood of 1927 and How It Changed America*, author John M. Barry evokes its glory days:

"Downtown teemed with life. Barges piled with goods docked at the concrete wharf The city had one French and two Italian restaurants, twenty-four-hour coffee shops, bowling alleys and pool halls and movie theaters. The biggest entertainers, including Enrico Caruso and Al Jolson, regularly stopped at the Opera House or the even larger People's Theater. Enough Chinese lived in Greenville that a tong war erupted. The four-story Cowan Hotel was the state's finest. . . . Three cotton exchanges each had a wire to Liverpool, New Orleans, and Chicago. The Greenville Cotton Compress . . . baled cotton and sold it directly to international buyers. Fourteen trains a day arrived in Greenville at the Y&MV railroad station; six more trains arrived daily at the Columbus & Greenville station. Four oil mills, the smallest covering two city blocks, crushed cotton seed. Half a dozen sawmills worked the great masses of logs floated to them; the two largest each made 150,000 board feet of lumber a day."

Winterville Mounds State Park, a preserved Indian ceremonial site, is nearby. Greenville's population continues to ebb and flow from 40,613 in 1980, to 45,226 in 1990, to 41,633 in 2000.

FIGURE 149

In the early spring of 1863, Grant, with no means of supply or retreat, marched 22,000 Union soldiers thirty miles south through Louisiana's swamps and wooded briers, and then crossed over the Mississippi to move on Jackson and Vicksburg.

Realizing the depots' significance, Confederate General John C. Pemberton, who was defending Vicksburg, in early May requested that Confederate commanders in the Trans-Mississippi Department attack the Union bases. When, however, Confederates finally did so in June, insufficient and poor reconnaissance led to their defeat.

The Confederate general of the Texas brigade assigned the attack on Young's Point expected that he could approach the Union camp through woods. What he found instead was a level plain that was, as he wrote, "destitute of trees and brush, in full view of a large camp of the enemy, situated below Young's Point, about 1? miles distant from my lines." The Texans advanced, while they witnessed Union reinforcements arriving, along with gunboats to support them. Consequently, as the Confederates were already overheated and exhausted from an unexpectedly grueling march, outnumbered, and no longer able to surprise the enemy, they retreated, and Young's Point remained firmly under Union control.

FIGURE 150

Because Vicksburg overlooks the river at the downstream end of a hairpin curve, Confederate cannons threatened river traffic, which of necessity had to slow down to navigate the river's sharp turn. So crucial was the city to the South's defense, it was called the "Gibraltar of the Confederacy." Nonetheless, Confederate General John C. Pemberton surrendered Vicksburg on July 4, 1863 to General Grant, after a forty-seven day siege that left Pemberton's soldiers starved, exhausted, and short of ammunition, and the city's population reduced to eating rats. Pemberton's capitulation marked one of the most decisive campaigns of the Civil War, and allowed, in President Lincoln's words, "the Mississippi River to flow unvexed to the sea."

The National Battlefield Park at Vicksburg marks the battle lines of the opposing armies and contains the monuments and graves of 16,653 Union soldiers, three-fourths of them marked "Unknown." Vicksburg was also the site in 1862 of the first sinking of a warship by an underwater mine or "torpedo." In the 1960s, the National Park Service salvaged the ship, an ironclad steamboat designed by James B. Eads.

Vicksburg was incorporated in 1825, and within a decade it was shipping 30,000 bales of cotton annually from its docks, and 90,000 annually by the outbreak of the Civil War. Always a lusty frontier town, Vicksburg saw five individualistic newspaper editors killed by violence within a period of twenty-two years prior to the war.

FIGURE 151

Vicksburg, now just a few miles north of I-20, has transformed itself from a river port and railroad center into a place geared toward tourism. Many antebellum and shotgun houses still

abound. Settled first by the French in 1719 and later about 1790 by the Spanish, American settlement began in the early nineteenth century. Vicksburg served as an experiment station of the U.S. Army Corps of Engineers.

FIGURE 152

The Cotton Exchange was constructed in the 1870s for the Mississippi Valley Bank, and after the bank failed cotton brokers purchased it in 1886. When Sharp photographed it, the building served as a homeless shelter. He writes: "Its architecture entranced me; more than the old Vicksburg courthouse, or the panoramic views of the river, this structure—with its dignified columns and statuary—seemed to evoke everything I needed to know about Vicksburg." The statues atop it represent the four corners of the earth: Eurasia, Africana, Oceania, and Americana. Only a few months after Sharp photographed the building, a tornado "demolished it," according to a letter he received in 2004 from Gordon A. Cotton, of the Old Court House Museum at Vicksburg.

FIGURE 153

Built in 1902, the *Sprague* was historic for her nearly all-steel construction. Rivermen referred to the Sprague as "Big Mama." No other boat on the river in her day could out perform her. She once transported fifty-six coalboats and four barges in a single tow. For a steamboat, she had an unusually long-lived career of forty-six years before retiring in 1948 in the Vicksburg Canal, where visitors could board her and dream their own dreams (the author being one of them). She burned to her waterline in 1974 and in 1981 was destroyed altogether.

FIGURE 154

It is hard for many people not to associate U.S. 61 with Bob Dylan's classic album of 1965, *Highway 61 Revisited*. The album, which introduced the highway to a largely white middle-class audience of Baby Boomers, was the native Minnesotan's first foray into rock-n-roll. Branding rock with his own inimitable style, Dylan infused the album's music with a darkly surreal lyricism and the electrified blues that had only recently journeyed into American culture via Highway 61. In the album's title track, *Highway 61*—the road for misfits, rogues, and the doomed—is the place where anything is possible, from the absurdly inane to "the next world war."

FIGURES 155 AND 156

The four-story mansion, built with slave labor, between 1859 and 1861, by a thirty-four-year-old cotton grower, Smith Coffee Daniell, contained twenty-five rooms, twenty-five fireplaces,

and a cupola from which Confederates sent signals of approaching Yankees. Captured and used by Union forces as a hospital during the Civil War, it was saved from destruction but perished in 1890 when a party guest left his cigar burning on an upper balcony. A few weeks after his Greek Revival-Italianate-Gothic mansion was completed, Daniell died.

FIGURES 157 AND 158

During the Civil War the Union gunboat *Rattler*, whose sailors a Confederate cavalry captured while the former were attending a Sunday service at Rodney's First Presbyterian Church, shelled the town and church on September 13, 1863. (Note an embedded cannonball above the center upper story window.) In 1928, with a congregation of only sixteen, the church lost its pastor, and in 1966, after decades of neglect, the Mississippi United Daughters of the Confederacy gained title to the property, along with a grant to restore it. Funds to maintain the structure, however, have been insufficient over the years, and the church's survival is questionable. The Mississippi Heritage Trust placed it on a 2003 top-ten list of the state's most endangered sites in an effort to save it.

Before the Civil War, Rodney, chartered in 1828, was a prosperous riverboat town that nearly became the capital of the Mississippi Territory. Boasting an opera house, hotel, and ballroom, two banks, and two newspapers, it rivaled Vicksburg and Natchez as a river port. After the war, in the late 1860s the Mississippi River abandoned the town when its channel shifted, as it has done elsewhere. Now situated two miles east of the river, as Sharp writes, "a dozen ramshackle stores and cottages and the abandoned brick church, besieged by weeds, along with a handful of people, both black and white, and incessantly barking dogs, and bugs are all that exist of Rodney now."

Alcorn State University (1871), a traditional African-American college, is but a few miles away in nearby Lorman, Mississippi.

FIGURE 159

Built between A.D. 1250 and 1500 by the ancestors of the Natchez Indians, Emerald Mound was probably used by the Mississippians for political or religious ceremonies, including burials. These people erected thousands of mounds throughout the Mississippi and Ohio valleys and the Southeast. Archeologists believe the mounds were centers of urban life for the Mississippians, and Emerald Mound was likely one of several mounds that surrounded a plaza and village on the site. The mound is 235 x 771 feet and was first excavated in 1838. Acquired by the National Park Service in 1950, Emerald Mound is a rare survivor of overgrowth, erosion, European and American settlement and disregard, farming, and road construction, among other threats that have obliterated most of the Mississippians' great earthworks.

FIGURE 160

Stanton Hall encompasses an entire city block. It was built by Captain Thomas P. Leathers at a time when Natchez supported more millionaires than New York City, Boston, or Philadelphia. The defining hallmarks of antebellum architecture—classical front porticos and a blend of Federal and Georgian architectural styles—originated in Natchez around 1812 with a transplanted Yankee architect, Levi Weeks.

Although Natchez was mostly spared during the Civil War, the blockade of the Mississippi and the general prostration of business in the South during "the Rebellion" affected the city disastrously, and after the war as well, so that within ten years of its conclusion Natchez's population decreased from 13,500 to just 10,000.

The city is said to be the oldest continuous settlement on the Lower Mississippi, with communal roots tracing back to the Anna Mounds, a ceremonial center of the Mississippians. The French established a fort at Natchez in 1716, and later the British settled there (1763), followed by the Spanish (1779), who laid out the town around 1790. Americans took control of Natchez in 1798.

Leathers, who built and operated steamboats, is famous for pitting his boat *Natchez* against the *Robert E. Lee* in a legendary 1,200-mile race, in 1870. The two steamers raced from New Orleans to St. Louis. People in towns along the river and around the nation avidly followed the race's progress through newspaper reports and telegraph cables.

FIGURES 161 AND 162

Other bluff cities, such as Memphis, required riverside landings similar to Natchez-Under-the-Hill, which arose as a major river stop in the pre-steamboat era when keelboat and flatboat men floated their cargoes downriver. Those ending their run here would collect their money, often lose it, and then walk home to Kentucky via the Natchez Trace, located just outside of Natchez.

Inhabited by thieves, rowdies, outlaws, pirates, prostitutes, gamblers, drunks, and assorted rivermen, one nineteenth-century traveler labeled Natchez-Under-the-Hill as "the resort of dissipation." Murder was common. Another visitor in 1834, Joseph Holt Ingraham, described it thus: "The principal street, which terminates at the ascent of the hill . . . is lined on either side with a row of old wooden houses; which are alternately gambling-houses, brothels, and bar-rooms. . . . the low, broken, half-sunken side-walks, were blocked up with fashionably-dressed young men, smoking or lounging, tawdrily arrayed, highly rouged females, sailors, Kentucky boatmen, negroes, negresses, mulattoes, pigs, dogs, and dirty children. The sounds of profanity and Bacchanalian revels, well harmonizing with the scene, assailed our ears as we

passed hastily along, through an atmosphere of tobacco smoke and other equally fragrant odours . . . "Nellies" was a famous bordello well into the twentieth century."

Today Natchez-Under-the-Hill—that part of it that has survived flooding and erosion—caters mostly to tourists and provides legalized gambling on a dock-bound casino boat.

FIGURES 163 AND 164

In 1930, at the start of the Depression, Governor Huey P. Long strong-armed a special session of the state legislature into passing an amendment that funded construction of the new capital. He argued that the state would save money by housing its government in a modern office building, thereby increasing efficiency. The art deco structure was dedicated in 1932. Often called a rabble-rouser and a dictator, Long was assassinated in a corridor of the building in 1935.

Baton Rouge was named for a red cypress pole that marked a boundary between Indian tribes. Like Natchez, the city was by turns under the dominion of the French, English, and Spanish, and briefly part of the independent West Florida Republic, before being annexed by Louisiana in 1810 and joining the Union in 1812. The city was incorporated in 1817 and became the state capital in 1849. It has deepwater port facilities and is an important petroleum-refining center. Louisiana State University (1860) and Southern University (1880), a traditional African-American college, are located here.

The old capital housed the state legislature until 1862, when Union forces took control of Baton Rouge during the Civil War. Soon thereafter a fire gutted the interior and the building remained in disrepair until 1879 when the property was returned to the state, which restored it. The legislature resumed meeting there in 1882 until moving to the new capital in 1932. Today the building serves as a state archives for film and video and includes public exhibits.

FIGURE 165

Chemical Corridor was coined "Cancer Alley" in the 1980s by environmental activists alluding to a higher-than-the-national-average rate of cancer in this zone. Although many industry supporters dispute the designation and the claim that the area has a higher than normal incidence of cancer, what is undisputed is the high number of petrochemical industries (more than 138) in the region, which together release millions of pounds of toxins into the air and water annually. In 1909, Standard Oil kick-started the area's industrial economy by building a huge refinery at Baton Rouge. The geography was right: it was close to Texas oil fields and offered economical transportation nationally and internationally via the Mississippi and the Gulf of Mexico, features that have drawn other major industries since that time. Even as the petrochemical industry was well entrenched in the area when Sharp saw it 1953, it was further

bolstered during the late 1950s and 1960s by the allure of special industry tax breaks and attractive zoning regulations.

FIGURE 166

Levees help to hold the Mississippi's waters in check. "Although an eventual shift in the Lower Mississippi's course is virtually certain, given the river's past history," writes geographer John C. Hudson, "it would be an economic and political disaster for New Orleans and the Baton Rouge industrial district. For the past five decades, the U.S. Army Corps of Engineers . . . has sought to prevent the inevitable from happening."

FIGURE 167

Today one sees less sugarcane than Sharp saw, as oil refineries, strip malls, and industrial parks supplant the old sugar plantations. "The plantations that first produced granulated crystalline sugar were etched into the Louisiana landscape beginning in 1795," writes geographer John B. Rehder. "Sugar plantations persistently dominated the rural landscape from 1795 until about 1970. But today's plantations are vanishing. . ."

FIGURE 168

In what would be considered today an act of ethnic cleansing, the British in the 1750s forcibly expelled French-speaking Acadians from Nova Scotia, a cluster of whom eventually settled in Louisiana, arriving circa 1754. Several thousands of Acadians would eventually follow, sowing the seeds of today's vibrant Cajun culture, including Cajun food and music.

FIGURE 169

Because of the inherent vicissitudes of the Mississippi River, its natural levees and delta, the site of New Orleans is precarious. Much of the city lies at or below sea level, while the river itself flows ten to fifteen feet *above* sea level. One hundred twenty miles upstream from the river's mouth, New Orleans is built on a foundation of silt and clay—land that is sinking, some of it rapidly so. So long as the river doesn't change course, however, the situation of New Orleans prevails, as it guarantees the city gateway control of the river's continental interior and command of its national and international trade and commerce.

The French chose the site of New Orleans in 1699 after Choctow Indians showed them a water route to the Lower River that circumnavigated the treacherous and confusing mouth of the Mississippi where it flows into the Gulf of Mexico. That backwater route proceeded through Mississippi Sound and Lake Borgne to Lake Pontchartrain and up the Bayou of St. John. All it then required to reach the Mississippi was a two-mile portage. Accordingly the

French in 1718 laid out a seventy-two square military grid at that portage site, which gave rise to the French Quarter (Vieux Carré).

FIGURE 170

The equestrian statue of General Andrew Jackson, victor in the 1815 Battle of New Orleans, has stood, since before the Civil War, in Jackson Square—the *Place d'Armes* when under the French flag and in the heart of the French Quarter. The Saint Louis Cathedral, the oldest cathedral continually used in the nation, is the third substantial one built on this site. The first one, completed by the French in 1727, burned in 1788. The Spanish rebuilt the cathedral, which received its first bishop in 1793. Sixty years later, when New Orleans became an archbishopric, that cathedral was significantly remodeled into its current form.

In 1953 plans were underway in New Orleans to construct along the Mississippi River an elevated interstate highway, the "Riverfront Expressway," that would have ruined the essential character and appeal of the French Quarter, especially Jackson Square and the French Market, overshadowed, as it would have been, by such a monstrosity. The expressway pitted preservationists against developers and federal highwaymen, and the controversy was not settled until 1969, when U.S. Secretary of Transportation John Volpe finally cancelled the plan, making it one of the first times that the federal government scuttled an urban highway project.

FIGURES 171 AND 172

The preservation of the French Quarter was the result largely of neglect. "For most of the nineteenth century," writes geographer Peirce F. Lewis, "the Quarter was ignored by Americans who were too busy pushing their brash new city upriver to pay attention to the crowded old European town. Meantime, many old Creole families stayed in their familiar homes, sheltered against the world outside, but the years were taking their toll. . . . old buildings crumbled By the beginning of the twentieth century, much of the Quarter had suffered severely—not so much from rot, as from attrition by the city along the edges." By the 1930s, however, the city *was* paying attention to its historic core and in 1936 created the Vieux Carré Commission and granted it control over the Quarter's architectural integrity and preservation through the issuance of building permits. Tourism during the decade was bolstered by a program under the New Deal's Works Progress Administration that reconditioned parts of the Quarter, especially around the French Market and Jackson Square.

FIGURE 173

General Andrew Jackson and 5,000 men (chiefly militiamen and volunteers) decisively defeated 10,000 British redcoat regulars at the Battle of New Orleans on January 8, 1815. Many people

have since contended that the battle (which cost the British more than 2,000 casualties and the U.S. seven deaths and six wounded) was historically unimportant because it was fought after the Treaty of Ghent was signed in Belgium on December 24, 1814, thereby ending the War of 1812. News of the Treaty did not reach Washington, D.C., until February 17, and both the U.S. and Britain had yet to ratify it. For that reason Jackson maintained in later years that, if the British had captured New Orleans, they would have gained complete control of the Mississippi and, as Jackson reportedly said, "Great Britain would have immediately abrogated the Treaty of Ghent and would have ignored Jefferson's transaction with Napoleon" that resulted in the Louisiana Purchase of 1803. The victory also enhanced Jackson's stature as a national war hero and prepared his path to the American presidency (1829–37).

FIGURES 174 THROUGH 178

Venice is the last town along the Mississippi to be reached by a road (Louisiana Highway 23). About ten miles upriver is Fort Jackson; about ten miles to the south is the Delta National Wildlife Refuge. Venice, Louisiana, is not to be confused with Venice, Illinois, another Mississippi river town about five miles north of East St. Louis.

FIGURE 179

The most significant feature distinguishing the Mississippi from other major North American rivers is its delta; most of the continent's rivers lack one. In fact, rivers such as the St. Lawrence, Hudson, Delaware, Potomac, and so on, are *embayed*, meaning the sea floods *into* their mouths. By contrast, the Mississippi, rolling south 2,552 miles from its source, flows far out into the Gulf, through distributaries—deltaic fingers—that continue extending themselves further out into the sea through natural depositional processes.

The river's delta below Head of Passes is a confusing and dangerous place to navigate—especially so before James B. Eads and the advent of modern engineering. Mudflats, grassy sandbars, and dead-end bayous made it hard to discern the river's three shallow mouths, where they empty upon the rough, unsheltered waters of the Gulf. Eads, capitalizing on his fame and engineering success with his bridge at St. Louis, improved passage to and from the river by constructing at South Pass (1875–1879) a jetty composed of mats and pilings driven into a sandbar. The jetties force the river into a narrower channel that scours itself clear of sediment, and keeps the mouth open for deep-hulled ocean-going vessels. The U.S. Army Corps of Engineers duplicated Eads's methods at Southwest Pass between 1908 and 1923, the major shipping lane for large ships today.

Selected Bibliography

Aiken, Charles S. 1998. *The Cotton Plantation South since the Civil War.* Baltimore: The Johns Hopkins University Press, in association with the Center for American Places.

Ambrose, Stephen E., and Douglas G. Brinkley. 2002. *The Mississippi and the Making of a Nation, from the Louisiana Purchase to Today.* Washington, D.C.: National Geographic Society.

Anfinson, John O. 2003. *The River We Have Wrought: A History of the Upper Mississippi.* Minneapolis: University of Minnesota Press.

Barry, John M. 1997. *Rising Tide: The Great Mississippi Flood of 1927 and How It Changed America.* New York: Simon & Schuster.

Bird, Christiane. 2001. *The Ca Capo Jazz and Blues Lover's Guide to the U.S. (Third Edition).* Cambridge, Massachusetts: Da Capo Press.

Borowiec, Andrew. 2005. *Industrial Perspective: Photographs of the Gulf Coast.* Santa Fe and Staunton: Center for American Places, in association with Columbia College Chicago.

Davis, William C. 2001. *Portraits of the Riverboats.* San Diego: Thunder Bay Press.

Gillespie, Michael. 2001. *Come Hell or High Water: A Lively History of Steamboating on the Mississippi and Ohio Rivers.* Stoddard, Wisconsin: Heritage Press.

Hudson, John C. 2002. *Across This Land: A Regional Geography of the United States and Canada.* Baltimore: The Johns Hopkins University Press, in association with the Center for American Places.

Lewis, Peirce F. 2003. *New Orleans: The Making of an Urban Landscape (Second Edition).* Santa Fe and Harrisonburg: Center for American Places.

McPherson, Larry E. 2002. *Memphis.* Santa Fe and Harrisonburg: Center for American Places.

Merrick, George Byron. 1909, reprinted 2001. *Old Times on the Upper Mississippi: Recollections of a Steamboat Pilot from 1854 to 1863.* Minneapolis: University of Minnesota Press.

Neuzil, Mark. 2001. *Views on the Mississippi: The Photographs of Henry Peter Bosse.* Minneapolis: University of Minnesota Press.

Rehder, John B. 1999. *Delta Sugar: Louisiana's Vanishing Plantation Landscape.* Baltimore: The Johns Hopkins University Press, in association with the Center for American Places.

Reps, John W. 1994. *Cities of the Mississippi: Nineteenth-Century Images of Urban Development.* Columbia: University of Missouri Press.

Acknowledgments

THIS BOOK OWES MUCH TO THE FOLLOWING PEOPLE: Captain Carole Ware (deceased), Dorothy Warren, Captain Jim Blum, Nabile Baaklani, Paul Chen, Eric Stenberg, and Randall B. Jones, my editor and the book's project director. This is a far, far better book than it would have been without Randy's affective historical research, guidance, and contributions to the sequencing of the images, the writing of captions, and the notes on the photographs. My river odyssey seems from its beginning to have been a fateful one, even to its publication and editor. Many, many thanks, Randy. Thanks, also, to George F. Thompson, president and publisher of the Center for American Places, who believed in the book, improved it greatly, and made its publication possible.

I particularly wish to thank Frank and Beckie Meyer. Without their generous support it is probable that the images in this book, and accompanying notes, would have been forgotten, or lost. They raise an interesting question: Without publication, what societal benefit was my Mississippi River journey? Did it even happen?

About the Author and the Essayist

The Author

Charles Dee Sharp was born on a farm near Frankfort, Indiana, in 1928. His father's health failing, the family at the end of the Second World War moved to Arizona, where Sharp graduated from high school. Shortly afterwards, he worked as a copy-boy and then cub reporter on Anna Roosevelt Boettiger's *Arizona Times*. He attended the University of Arizona for one year and then hitchhiked to the University of Wisconsin-Madison, where he didn't officially enroll as a student but studied on his own. In the summer of 1950 he was on a student bicycle tour of Europe when the Korean War broke out. Drafted upon his return to the U.S., he served two years in the Army. After leaving the army, he conceived of his honeymoon raft project and made the two Mississippi River trips that form the basis of this book. Shortly after his Mississippi River odysseys, Mr. Sharp became an assignment editor for the Midwest bureau of CBS News. He later started his own documentary film company, producing films in the Soviet Union, Middle East, and South America. For fifteen years he was associate professor of cinema at the Institute of Design, Illinois Institute of Technology, until he was sidelined by multiple sclerosis for many years. He has since regained his health and turned to writing. His previous book is *The Wonder of American Toys, 1920–1950*. He has two grandchildren and lives in Chicago with his wife, Judy.

The Essayist

John O. Anfinson is a historian with the Mississippi National River and Recreation Area in St. Paul, Minnesota. For nearly twenty years he was the historian for the Saint Paul District of the U.S. Army Corps of Engineers. He is a founding board member of the Friends of the Mississippi River, an organization dedicated to improving the Mississippi's environmental health in the Twin Cities. He is the author of *The River We Have Wrought: A History of the*

The Center for American Places is a tax-exempt 501(c)(3) nonprofit organization, founded in 1990, whose educational mission is to enhance the public's understanding of, appreciation for, and affection for the natural and built environment. Underpinning this mission is the belief that books provide an indispensible foundation for comprehending and caring for the places where we live, work, and explore. Books live. Books endure. Books make a difference. Books are gifts to civilization.

With offices in Santa Fe, New Mexico, and Staunton, Virginia, Center editors bring to publication as many as thirty books per year under the Center's own imprint or in association with publishing partners. The Center is also engaged in numerous other programs that emphasize the interpretation of place through art, literature, scholarship, exhibitions, and field research. The Center's Cotton Mather Library in Arthur, Nebraska, its Martha A. Strawn Photographic Library in Davidson, North Carolina, and a ten-acre reserve along the Santa Fe River in Florida are available as retreats upon request. The Center is also affiliated with the Rocky Mountain Land Library in Colorado.

The Center strives every day to make a difference through books, research, and education. For more information, please send inquiries to P.O. Box 23225, Santa Fe, NM 87502, U.S.A., or visit the Center's Website (*www.americanplaces.org*).

ABOUT THE BOOK:
The text for *The Mississippi River in 1953: A Photographic Journey from the Headwaters to the Gulf of Mexico* was set in Adobe Garamond. The paper for the text is acid-free Chinese Goldeast, 140 gsm weight. The four-color separations, printing, and binding were professionally rendered in China.

FOR THE CENTER FOR AMERICAN PLACES:
George F. Thompson, President and Publisher
Randall B. Jones, Independent Editor and Project Director
Kendall B. McGhee, Publishing Liaison and Assistant Editor
Ernest L. Toney, Jr., Chelsea Miller Goin Intern
Purna Makaram, Manuscript Editor
David Skolkin, Book Designer and Art Director
Dave Keck, of Global Ink, Inc., Production Coordinator